Visual
Forces

Second Edition

Visual
Forces
An Introduction to Design

BENJAMIN MARTINEZ

JACQUELINE BLOCK

Prentice Hall
Englewood Cliffs, New Jersey 07632

Library of Congress Cataloging–in–Publication Data

Martinez, Benjamin, [date]
 Visual Forces: an introduction to design / Benjamin Martinez,
Jaqueline Block.—2nd ed.
 p. cm.
 Includes bibliographical references and index.
 ISBN 0-13-948290-3
 1. Composition (Art) 2. Design. I. Block, Jacqueline, [date].
II. Title.
N7430.M294 1995
701'.8—dc20 93-29027

Acquisitions editor: Norwell Therien
Editorial/production supervision: Edie Riker
Cover design: Maureen Eide
Cover photo illustration: Howard Hodgkin, *Goodbye to the Bay of Naples*, 1978–82.
 Oil on wood, 22 × 26¼ inches. Private Collection.
 Courtesy: Knoedler & Company, New York
Photo editor: Lori Morris-Nantz
Permissions editor: JoAnne McCormack / Mary Helen Fitzgerald
Production coordinator: Robert Anderson
Page makeup: Gail Cocker

© 1995, 1988 by Prentice-Hall, Inc.
A Simon & Schuster Company
Englewood Cliffs. NJ 07632

Printed in the United States of America

10 9 8 7 6 5 4 3 2 1

ISBN 0-13-948290-3

Prentice-Hall International (UK) Limited, *London*
Prentice-Hall of Australia Pty. Limited, *Sydney*
Prentice-Hall Canada Inc., *Toronto*
Prentice-Hall Hispanoamericana, S.A., *Mexico*
Prentice-Hall of India Private Limited, *New Delhi*
Prentice-Hall of Japan, Inc., *Tokyo*
Simon & Schuster Asia Pte. Ltd., *Singapore*
Editora Prentice-Hall do Brasil, Ltda., *Rio de Janeiro*

Contents

8 LINE

9 MOVEMENT

10 LIGHT

11 COMPONENTS OF COLOR

12 STRUCTURE OF COLOR 142

13 USES OF COLOR 161

14 UNITY & VARIETY 176

15 MEANING & COMMUNICATION 208

BIBLIOGRAPHY 224

INDEX 227

Preface

The first edition of this book began with the idea that this was a book about basics, those things at the heart of all serious study in the arts. The "basics" are not so much what you learn at the beginning, but those things which remain at the center of the process from start to finish.

In writing this book then, and now as we approach it for a second time, the difficulty that we've faced has been the same one with which teachers of design have to struggle. How do you treat the structure of visual art, a subject which is by its nature non-linear, in a sequential way? How can you break down into parts an activity whose first principle is unity and simultaneity? In the first edition, we began with the overarching concept of unity and progressed through a series of more narrowly focused discussions. For the second edition, we have reversed that sequence and placed the largest principles nearer to the end. The logic behind this change is that if, in the body of the book a vocabulary of words and concepts could be developed, that vocabulary could then be usefully applied to drawing a clearer general picture. In fact, it's a chicken/egg situation. Good arguments could be made for proceeding in either fashion (or perhaps in some other way altogether). Happily, this problem does not become a major one, as we do not insist that anyone read this book as if reading a novel, from beginning to end. Our hope is that readers will use it more flexibly, as a manual rather than a text, perhaps reading back and forth from particular to general, or even starting at the end. Each of the many short sections that comprise the book has been annotated with cross-references that we hope will take the reader through the contents along any number of useful routes.

Other matters of inclusion and sequence became more and more complicated as we tried to revise in the direction of order and clarity. Where should color properly fit? Not, we decided, at the end, as though it were an after-the-fact decorative addition to form. Like order and unity, color is fused with form at the core of things, and we wanted, at least symbolically, to put it at the heart of the book.

Further, we wanted to stress, particularly in a discussion at this level, that visual forces act on thinking regardless of such categories as "fine art" or "applied art" or "graphic design." Principles of design, the effects of visual forces on the perception of two- and three-dimensional form as presented here, apply equally to painting and posters, to computer-generated images and those scratched into wet clay. We'd like to distinguish between *technique*, which is most explicitly *not* dealt with in this brief book, and *concept*. To this end, we have tried to choose visual examples to illustrate the text from a variety of media and what might be called sub-disciplines in order to emphasize that the designer sitting at a drawingboard and the watercolorist out in the landscape all stock their larders from the same visual supermarket, and the very different meals they serve are made from the same ingredients. The necessary bureaucracy of schools, programs, schedules, and classes, like the artificial subdivisions of this book, encourage partitioning visual art into certain categories—painting, sculpture, graphic design, furniture, architecture, and so forth. Our effort here is to step outside of whatever differences in technique or audience separate the objects made under these categories and examine the visual forces that act in all of them.

The challenge and the pleasure in putting together this book has been in searching for and finding the many visual examples. Here we have also been guided by principles of inclusion and integration. We have tried to remember that art has a rich history that includes the work of women and men over many centuries and virtually everywhere in the world. We have tried to include a balance of recent and older examples. The common thread, we hope, is that all the illustrations are of first rate works of art. We have avoided the kinds of demonstrations that place a Titian next to a competent student drawing done the other day. We have resisted the practice of limiting graphic design examples to those that seem to suggest that communication design is a late twentieth century invention and distinct or separate from the rest of visual art.

We have tried to reduce the number of diagrams that appear in the book, and to make those that remain smaller, so that no one should be tempted to confuse a neat diagram with a work of the imagination.

Other changes have been made in this new edition. The text itself has been substantially revised

and is a little longer. We have discovered that despite Mies's wise dictum, less is not always more. We tried this time to come closer to just enough. Units and chapters have been re-named and re-ordered in response to readers and to our evolving understanding of an endlessly rich subject. We've tried to eliminate anything that now looked like jargon. A good many visual examples have been changed for myriad reasons. The book has been graced with a new visual look of its own.

The most substantial rewriting has taken place in what remains the final chapter, *Meaning*. Intended as a taste, a suggestion, of the many and wonderful complexities of reading meaning that may easily be taken for granted, the chapter will now, we hope, raise more questions than it answers and leave the reader with a sense of the delicious vastness that is visual art.

Making a book like this one is a complicated undertaking, and we couldn't have accomplished it without help at every stage. We'd like, first of all, to thank Norwell Therien at Prentice Hall for his enthusiasm and confidence in this project from its inception and throughout the process of revision. We are grateful as well for thoughtful and encouraging comments from a number of individuals who read all or part of what follows during its development, most especially: Pamela Lowrie, College of DuPage; Robert Purser, Bellevue Community College; Patrick James Shuck, St. Louis Community College at Meramec; Robert

Morton, Plymouth State College. We regret only that we were unable to incorporate, for all sorts of practical reasons, all the good suggestions received.

There were moments in the remaking of this book when the writing itself seemed a small task when compared to the massive administrative job of assembling the visual material. In this we were ably assisted by a number of people, most notably Edie Riker and JoAnne McCormack, and we thank them. Thanks also to the several attentive and responsive people involved in the visual design of this book, especially to Gail Cocker. Our deep gratitude to the many museums and galleries, and especially to the artists, who graciously made work available to us.

A special thank you must also go to our good and old friend, Laurie Berke-Weiss, whose help early on was invaluable.

For whatever we have learned about the language of design, we have to thank, first of all, our own teachers, who inspired by example a passionate love for the visual world and a commitment to the idea of giving it form in art, and our students who, over many years, have led us, by their enthusiasm, desire, and curiosity, to clarify our own thoughts.

It is important to acknowledge the support and love of family and friends in the success of any project; we have been aware of and grateful for such support throughout. Thanks especially to our parents and to our daughters, Chloe and Nora, who are the inspiration for all that's good in what we do.

Visual Forces

1 Introduction

Overview: Why Visual Forces?

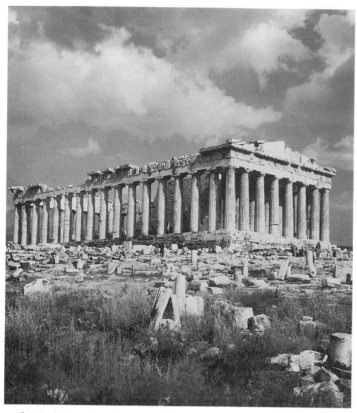

A. Parthenon, Athens, 447–438 B.C. (Greek National Tourist Office)

We are surrounded by a world of physical forces. Sometimes we can feel these forces at work inside ourselves, the pull of gravity when we ride on a swing or lift a rock, the weightlessness of swimming. Sometimes these forces can be seen at work outside and around us. The wind ripples the surface of water or carves sand dunes on the beach. Gravity makes a baseball travel in a gentle arc, a parabola from the batter to the outfield. To see and sense these things is to be alive.

But it's not necessary to be *in* the water to feel its motion or to lift a boulder to have a sense of its weight. We can feel a lot of this just by looking. The eye is a powerful tool for reaching out and experiencing the world.

When we observe a rubber band stretched and relaxed, or watch a dancer balanced on one leg, or follow a shark gliding by in the aquarium tank, a tension ripples through our bodies. The experience is shared imaginatively and physically. Even more, the forms of nature themselves seem purposeful. The graceful and efficient shape of a fish, for instance, looks as if it's been molded, designed to slide through the water, as indeed, it has.

Visual Forces & Physical Forces

Physical forces are real. Things like weight, motion, or the impact of a punch can be measured with scales or rulers. Visual forces are different. They aren't illusions, but neither are they measurable in the same way. Visual forces are those things felt in, or by the eye alone. We might say that an object is heavy looking or that a picture is full of movement, but a scale can't weigh that kind of heaviness. A styrofoam rock only looks as heavy as a real one, and everyone knows that the lines or shapes in pictures don't really move. An artist has to be conscious of these differences and know at the same time that visual forces are, in their way, as real as physical ones.

To see the difference, look at an example in which both physical and visual forces are clearly at work. The columns in **Figure A** form the front of a Greek temple. Each column has a structural function;

it has to be strong enough to hold up the massive upper section—the horizontal entablature, triangular pediment, and roof. Here real forces are interacting: the weight on top against the powerful, upward thrusting strength of the columns.

Look carefully at the column, and you will see that its sides are slightly curved. From bottom to top there is a clearly noticeable swelling and tapering. The architect designed this subtle shape into the column, even though a perfectly straight-sided cylinder would have worked just as well.

This swelling, called *entasis* by the Greeks, has no physical function. It doesn't make the column stronger, but it does make it *look* stronger. Entasis makes it look as though the stone is bulging under the weight of its load, swelling like a muscle.

Now physical forces become visual forces: The weight of the architrave, and the strain placed on the supporting column, can be felt by the eye. We begin to experience the building as a system of pressures and counterpressures in balance, a struggle between weight and strength, a drama about gravity.

Architects can give visual expression to physical forces in the structures they design. Buildings are subject to real stresses and strains; if a column isn't strong enough to do its job, the roof falls in. But sturdiness itself wasn't enough for the Greek architect. The building had to *look* sturdy. The forms of the building were shaped to create visual forces, and that shaping makes the viewer feel the temple more vividly.

Artists tend to be practical people, and this is a book about practical matters. The things that you will think about in reading through and around this book are questions that you will deal with in your work all the time. We may offer up theories, but theory has to earn its keep by being useful in the studio.

We sometimes run into students who believe that any kind of analytical approach is a mistake, that it is better to work intuitively or even to rely on the subconscious or the unconscious. To this we respond that visual forces are at work on everything that is designed, whether they are considered by the maker or not. The center of a design will always have a particular importance and power. Certain colors will always come together uneasily. Every mark you make on a page will affect every other. These things will not stop happening simply because an artist claims not to be interested in them.

It's true that an artist should be able to rely on intuition. There are subconscious and unconscious choices that operate in any potent work of art. It's also true that we should be able to use the conscious part of intelligence. Why should an artist be limited to using half of her abilities?

Visual Forces in Visual Art

Despite this emphasis on analysis and consciousness, we also know what every artist knows, that art contains things that are like magic. More than anything else artists want their work to come alive, not simply to look realistic. Gérôme's painting of the Pygmalion myth in **Figure B** is framed in a masculine language of need and sexual desire, but it also reminds us of another kind of desire. We want our work to have some of the qualities of the living, breathing world, the way Pygmalion's statue takes on the blush of warm blood.

Works of art are not alive, of course. They are only assemblages of materials: stone, a computer printout, paint, and paper. Still, we need to be able to see them inhabited by balance and gravity, tension and movement, those things associated with life. We do this by *shaping* form and color.

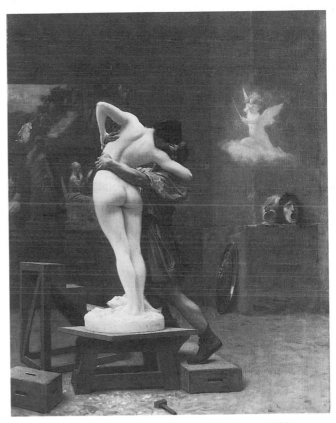

B. Jean Leon Gérôme, *Pygmalion and Galatea*, c. 1890. (The Metropolitan Museum of Art; gift of Louis C. Raeger, 1927)

Relationships

In the discussions that follow, the word "relationship" is used so frequently that it is worth examining its meaning before proceeding further.

In everyday usage, a relationship is some kind of connection between people or things. For example, members of a family are connected by blood or marriage. In art and design, relationships are basically visual connections—between one shape and another, between a shape and a line, between a group of color spots and the edge of the page. These connections can be easy to see, like two shapes connected by a line drawn between them, or they can be more subtle.

For instance, you could say that one shape is higher on a page than another, or that one shape is farther from the bottom edge of the page than the other. Such a connection—one that is invisible in one sense but also easy to see—is made by comparing distances or intervals between things.

A lot of what we do when we see is comparing. Your hair may be darker than your friend's and lighter than the color of the chair you're sitting on. A plum is not very round compared with an orange, but it does seem round when placed next to a potato.

A. Edgar Degas, "La Famille Bellelli." 1858-60. (Musée D'Orsay, Paris)

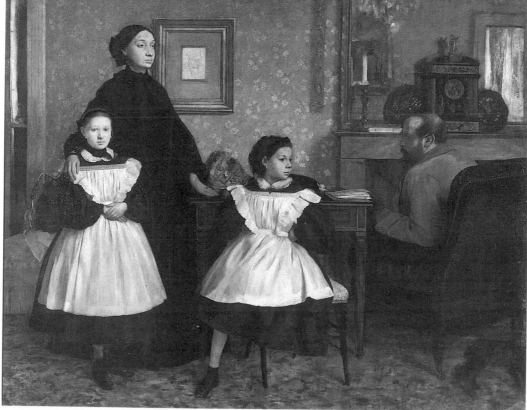

In the same way, we establish that a shape in a design is tilted at an angle by comparing it with the edge of the page, or that a color seems bright compared with surrounding colors in a painting.

In other words, the different qualities of a shape or form are understood in context, by seeing the shape in relation to its neighbors. In fact, we could say that the foundation upon which everything that follows here rests on the notion that the appearance of *any* shape, color, or other characteristic is *always* affected by the environment of shapes and colors of which it is part.

The other thing about relationships that concerns us is the sense of the larger whole. You and an uncle, for example, are connected in both being part of a larger family that may have a "character" of its own. In a work of art, there are different shapes, colors, and textures. These elements are individual, but put together they create a larger visual event that is different from all the bits and pieces.

All of these qualities—connecting, comparing, and relating to create a visual whole—are the materials of the artist, just as clay or paint are materials. Works of art are made of relationships between forms as much as of the forms themselves.

In his painting of the Bellelli Family **(Figure A),** Edgar Degas uses these kinds of visual relationships to describe emotional connections between people. Baroness Bellelli, Degas's aunt, had a tense and unhappy marriage. The emotional connections and separations in the family are made fiercely clear by the way Degas locks the figures of mother and daughters in a rigid leftward leaning triangle. At the same time, her husband is blocked, trapped behind the dark and heavy shape of the chair, separated from his family by a series of verticals—the edge of the mirror and mantle, the leg of the table and the chair. His face is in shadow. By asking ourselves about shape, placement, light, and color, we begin to pay attention to the painting itself, as well as the objects it depicts. What do the large areas of black and white do to the surrounding blues and warmer grays and yellows? The lovely hourglass shape of the pinafore at the center of the design is like a balance point between two sides of a scale. Does this tell us something about the child's relationship to her parents, or did Degas simply place it there because he liked the way it looked? The painting can tell a complex and subtle story that does not depend only on such details as facial expressions or the reading of captions. The forms and their relationships to one another are as eloquent as anything could be.

also see: Grouping
 Mark Making

Principles

Visual forces, like physical forces, are governed by laws or perhaps, more gently, principles that help us understand why certain forms evoke certain responses. Because it is form—marks and shapes and volumes—from which visual objects are made, it is necessary to understand how these principles work to effectively use materials, whatever they may be. Art is not an exact science, and no one need fear that rules will replace creativity, or instinct or inspiration. Understanding what it is we are doing as we push paint around, or move pieces of paper about, can only help us to proceed in the direction of giving form and life to ideas.

One of the most persuasive and coherent ways of looking at visual forces developed from the writings of a group of psychologists working in Germany and the United States in the early part of this century. They were not initially interested in art, but more generally in finding out how things are perceived, how information is taken in through the senses and organized in the brain. The theories drawn from their observations and experiments formed the basis of the Gestalt school of psychology. *Gestalt* is a more or less untranslatable word, usually rendered in English as "shape" or "form," but also including in its meaning the ideas of configuration, pattern, structure, and wholeness.

The basic premise of the Gestaltists is that a visual event is something different from the sum of its parts. The pieces interact, and the interaction changes them. Looking at a face, we see not only two eyes, a nose, a mouth, but a configuration, a gestalt; the pieces are put together in a certain order, and it's this ordering of the parts that is recognized even more than the parts themselves. The simple diagram in **Figure A** makes this clear. Thus when artists put things together, they always get something new, something different from a catalog of the shapes and colors used. This is why it's often so difficult for an artist to visualize a work of art before it is made.

We perceive visual events, then, as wholes, which are grasped all at once. Seeing is not a process of compiling bits of information. Instead, the eye is struck by big visual facts—not details, but the overall pattern that organizes the parts.

The Gestaltists demonstrated that the eye is an outpost of the brain, and that the information the eye collects is organized in certain ways by the brain whether we wish it to be or not. Visual perception, the partnership of eye and brain, is not simply a system of passive receptors, a blank slate continually being written on with new messages. Perception is

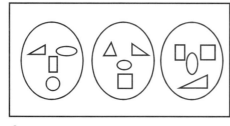

A.

B.

intelligent. It will organize sights, sounds, and events that objectively are not organized. For example, try tapping out a steady rhythm of single beats on the nearest tabletop. After a moment or two you will start to hear the beats in groups. Objectively, you are tapping one-one-one-one, but what you hear will be one-two-one-two-one-two or one-two-three-one-two-three. Or, look for a few seconds at **Figure B.** Objectively, not much is happening. There is a regular pattern of dots. But almost immediately shifting patterns of different-sized squares and rectangles, ghostly vertical and horizontal bars appear. Our perceptual equipment, the eye/mind, starved for some visual nourishment, begins to create visual events even where there are none.

Many of the visual phenomena examined in this book, such as grouping, closure, and simplicity, demonstrate Gestalt principles. This doesn't mean that this way of thinking about seeing was invented by or is the property of science. Artists had been making practical use of these principles for thousands of years before the word "gestalt" was coined. Because this book is about the conscious organization of visual forms, however, it is helpful to understand, in more conscious ways, the principles that artists have always intuited.

This book will examine visual relationships and visual forces. It will look at the ways in which shapes and compositions move; how forms bend, push, and rise; how areas expand and contract; how shapes, colors, and other visual elements affect one another. We will be referring to art in which none of these things actually happens, but the language of physical forces will help us to describe what we all see in a still image. Seeing means experiencing qualities like gravity, pressure, tension, and balance via the eye. Seeing, to us, as artists, means being conscious of those things that anyone can observe but that most people fail to notice.

2 Surface

Overview

Everyone senses the difference between looking out at the world around us and seeing something on a flat page. These are almost two different ways of seeing, and each is governed by its own laws.

The world of real objects is three-dimensional: Objects that appear to be extended, or spherical, or near or far, really are. The surface of a canvas or a page is, obviously, flat two-dimensional. Only rarely are we tricked or confused. Anyone who has seen an old-fashioned "3-D" picture or a hologram knows that a three-dimensional illusion is quite different from what is seen in a photograph or painting.

Each of us looks at the world through two eyes

that record two separate and slightly different images. These images combine in the brain to form something understandable as three-dimensionality. Close one eye and walk across a room. With the loss of binocular (two-eyed) vision, depth becomes muffled, and the ability to judge distance is weakened.

The painting by Peter Paul Rubens in **Figure A** is one artist's witty and knowing comment on flatness and how easily we are seduced into accepting a pictorial illusion of space. What at first glance appears to be a typical Baroque painting, full of movement and sculptural space, gradually reveals

A. Peter Paul Rubens, *The Meeting of Abraham and Melchizedek.* c. 1625. Wood, 26 × 32½. (National Gallery of Art, Washington; gift of Syma Busiel 1958).

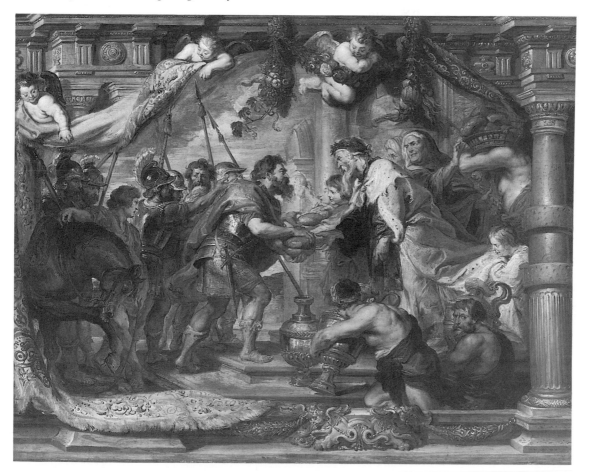

itself to also be a grand visual joke. The deep space of the central scene becomes, at the edges, a huge, flat tapestry, supported by angels, whom we then understand as three-dimensional in contrast to the "flat" painted tapestry. The folds of the tapestry itself sweep into and behind the "real" columns and moldings at bottom and on the right. Two figures at bottom right seem to emerge from a stairwell, or do they belong in the tapestry? It dawns on us that instead of viewing a painted scene, we have been looking at a painting of a tapestry, a picture of a picture. Of course, we have known all along that the whole is merely painted on a flat canvas. Rubens deliberately double-crosses us, confusing the way we understand illusions of space and flatness to make us more aware of the painter's role in manipulating these illusions. In painterly terms he asks, "What is real?"

To add another complication, when we see in the world, it is through eyes that continually jump about from one thing to another. You may look at someone's face, for example, then shift your eye to her hand, then glance over to the corner of the room, then back to your friend's nose, all in very quick, almost unconscious, succession. As the eye moves along, one object is ignored, and another becomes the focus of attention. We see primarily what we focus on at any given moment. In a drawing or a design, things do not appear and disappear in this way. The eye may travel in a path from one shape to another, but all the shapes and colors are present on the page at the same time. Although our eyes may wander around the picture, we sense that it is all one visual event. This sort of looking is quite different from the feeling we get looking at the sights that ebb and flow through our field of vision.

Furthermore, our eyes continually change focus as we look out at the world, so that an object seen clearly in the foreground may become a blur when focus shifts to something farther away. In painting, and even in photography using certain kinds of lenses, everything can be in focus at once, objects very near to the viewer or distant mountains. Artists can also direct and guide the eye by locking parts of the picture in or out of focus, as Jan Vermeer does in the painting in **Figure B.** Focus here cannot flicker

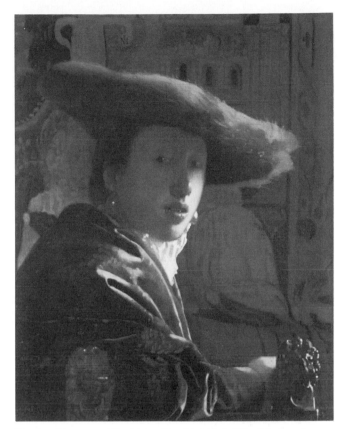

B. Jan Vermeer, *The Girl with a Red Hat*. (The National Gallery of Art, Washington; Mellon Collection)

back and forth between the near and the far. The elements on are frozen, fixed in relation to one another, forever in or out of focus.

Because things look so different when formulated on a flat surface, it is necessary to think about this two-dimensional vision as a way of seeing with its own set of rules, another language having its own vocabulary, grammar, and logic. The shift from the real world to the page involves a *translation* from one visual language, that of three-dimensionality, into the language of two-dimensions.

also see: Surface & Space
Time

The Field

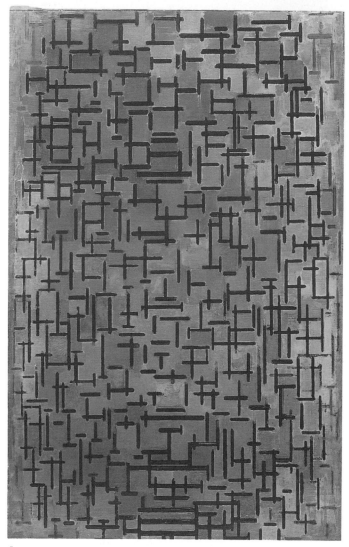

A. Piet Mondrian, *Composition, 1916*. 1916. (Collection, Solomon R. Guggenheim Museum, New York)

An important difference between the world we move through and most flat images is that shapes, colors, and lines on two-dimensional surfaces are usually framed by an enclosing edge. This frame defines what is called a *visual field*, a specific shape, a closed-off arena in which visual elements coexist, interact, and affect one another.

In contrast, the environment that surrounds us is a parade of visual events, one thing after another, an unframed and continuous fabric of impressions coming and going, extending in all directions as far as the eye can see.

Frequently the visual field that artists work on is straight edged and rectangular. Horizontal and vertical sides echo an important fact about the physical world: that the force of gravity pulls us downward, and that our bodies exert their own counterforce that enables us to stand up, move, and resist that downward pull. The rectangular field is solid looking, stable, somewhat static, and clear. It seems to sit sturdily on its bottom edge. It is also possible to repeat its vertical and horizontal movements inside the image in an orderly way and make a grid on which to hang shape and color. For an artist like Piet Mondrian (**Figure A**) this echoing and balancing of the horizontal and vertical were visual metaphors for body and spirit, life and death, an intensely expressive activity.

Artists need not limit themselves to making marks on rectangles. Fields of other shapes are also potential dishes on which to serve up color and form, and even as blank frames have their own characteristics. The oval or round field, for instance, may seem more dynamic, less likely to stay put visually than the square. It seems to roll, to rotate, or expand outward. The center of an oval or circular field is more strongly felt than the middle of a rectangle, and while the rectangle may be understood as embodying certain physical forces, the circle has often been associated with the spiritual, or with ideas of unity or centering, as it seems to in the Arabic bowl in **Figure B.**

But the field doesn't have to be geometric or even regularly shaped at all. A more complicated and irregularly shaped field, like the one in Elizabeth Murray's painting in **Figure C,** is lumpy with visual energy. The painted forms bulge, push out the edges, curl back, and jostle one another. The edge of the field pushes in and falls back. It seems to respond to the painted shapes and the pressures they generate.

In fact, whatever format the visual field takes, it will have its own special qualities, and therefore its own uses and limitations. An irregular field may be useful for an artist who aims for a certain sense of movement and expressive fragmentation, while a round or oval format may appeal because of the visual tension between center and edge. The rectangular field offers a sense of permanence. The important point to remember here is that each field is already charged with visual energy before the artist begins to work on it.

also see: Grids

Vertical/Horizontal/Diagonal

Simple & Complex Shape

Tension & Shape

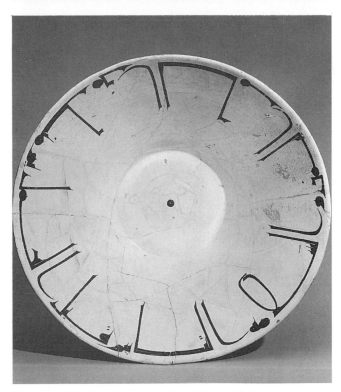

B. Slip-painted earthenware bowl. Iran, Nishapur, Tenth century A.D. (The Metropolitan Museum of Art; Rogers Fund, 1965)

C. Elizabeth Murray, *Popeye.* 1982. (Collection, The Museum of Modern Art, New York; gift of Abby Aldrich Rockefeller, by exchange)

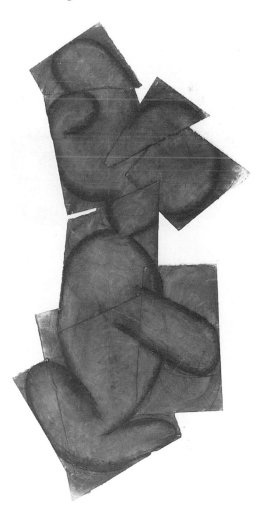

The Center

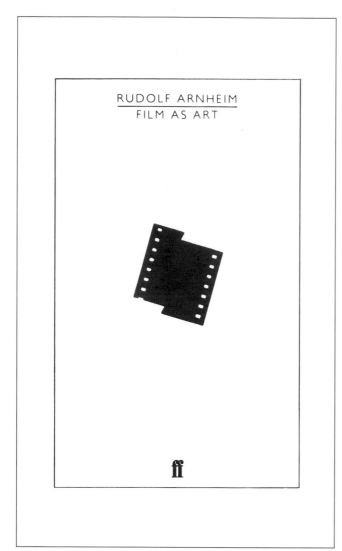

A. Pentagram Design, book cover. *Film as Art.*
(Courtesy of Pentagram Design, London)

Every shape has a center, sometimes easy to see and sometimes not. In a square or rectangle, the center is where the two diagonals cross; in a circle, it is the point where radii come together. In an irregular field it's more difficult to find, and you may have to look and feel more tentatively before deciding where the center seems to be. You could, of course, find the physical balance point of an irregular flat shape by cutting the shape out of cardboard and balancing it on the tip of a finger. This will locate the center of *balance*, equivalent to the center of the circle. But for any shape, the visual center and the balance point are not necessarily in the same place.

In a rectangle, for example, the point at which an element will feel comfortably centered to the eye is usually a little above the midpoint. In Pentagram's design for a book cover in **Figure A,** the central shape is placed slightly above the middle so that it does not look low in the rectangle. The shape has been *visually* centered.

The only way to find the visual center of any shape is by looking. It is the point at which our eyes tell us that all the forces built into a shape are balanced (**Figure B**).

The visual center of any field is also the most potent area of the design. An element placed at the center of a page or canvas has a special visual impact or force. Often a small element placed at the center of a composition becomes the most important one, and even when left empty, the center remains a visual magnet, exerting its pull on the forms around it.

When Edgar Degas places an open book at the center of a composition (**Figure C**), it becomes an actor at least as important as the man and woman who flank it. Even though it is a relatively blank form, without the visual interest and weight that the surrounding heads and hands have, the book becomes a major landmark in the composition.

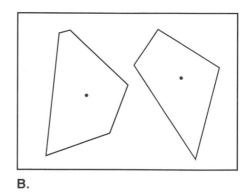

B.

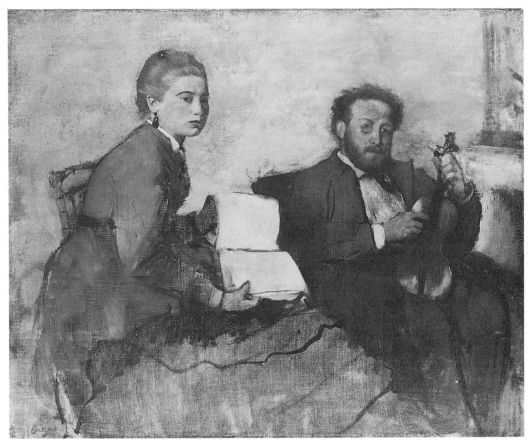

C. Edgar Degas, *Violinist with Young Woman*. c. 1871.
(The Detroit Institute of the Arts; bequest of Robert H. Tannahill. No. 70.167)

In another sense, each shape or group of shapes in a visual field forms its own center. Like planets in a solar system, each shape has its own attraction for the eye, and these subcenters compete with each other and with the visual center for importance. In the Degas, two penetrating portrait heads pull the eye to the left and right. The sum of all these competing forces is what we call composition.

Jean Hélion uses two competing centers in his *Circular Tensions* in **Figure D.** Four black vertical lines extend downward and end exactly at the horizontal midpoint of the square canvas. The gap bracketed by the two central lines marks the vertical midpoint. The center of the field having been established, a second, "off-center" center is set up, implied by the circular arcs. A tug of war is set up between these two forceful centers and the visual center of the square itself, slightly above the other two. The visual tension that results is the theme of the work.

also see: Top & Bottom
Symmetry

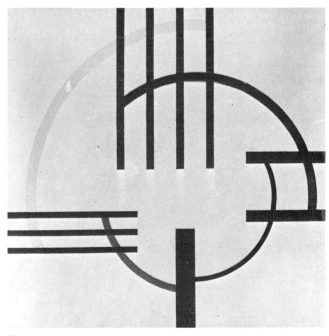

D. Jean Hélion, *Circular Tensions*. 1931-31. (Center for Art and Communication; Valduz, Liechtenstein)

The Edge

Often, we as viewers are especially aware of forms placed close to or at the edges of a visual field. As a shape or a line comes closer to the edge it seems drawn to that edge. Visual tension increases, and there is a viselike closing of the gap, as form and edge come together (**Figure A**).

The special magnetism of the edge has led some artists to work close to these boundaries rather than placing things in the center of the composition. Edward Weston's photograph in **Figure B** uses the edge in this active way. The camera's viewfinder crops the figure and encloses it in a tight rectangle. The narrow black spaces to the left and right seem to pulse and caress the almost transparent and ghostly torso. The frame forms a contrasting straight line against which the gentle in and out movement of the torso can be easily seen.

Paying careful attention to placement of forms in relation to the edges can help to emphasize the enclosing power of the frame to reinforce the self-contained quality of an image. In the painting by Pieter de Hooch in **Figure C,** everything appears at first to be casually placed, and yet there is a sense that center and edge are carefully balanced. A large dark picture hangs from the top; an open door and a figure press against the right edge. The nearest form, a chair leg, approaches the bottom edge, and the seated man's shoulder leans close to the left. Nothing is cropped by the framing edges, and all the forms are placed carefully inside them. The vertical and horizontal edges are echoed by forms throughout the painting. Here the edge acts as a container, suggesting the intimacy and feeling of enclosure of a quiet room.

B. Edward Weston, *Neil, Nude.* 1925. (Collection, The Museum of Modern Art, New York; © 1981 Arizona Board of Regents, Center for Creative Photography)

A.

The street scene by Felix Vallotton in **Figure D** also emphasizes the edge but in a very different way. Most of the visual action and most of the forms are placed away from the center. A sort of visual centrifugal force results, and everything, even the buildings, pushes out from the center. Forms seem rather casually to ignore the containing force of the edge. Shapes poke right through the boundaries of the rectangle, implying that space continues. The cropping is active and creates new shapes out of, for example, the predictable hourglass silhouette of the black dress. The central zone that remains is anything but blank. It contains an airiness and a generosity of space that reminds us of both the busyness and the large scale of urban space and has an exuberant, pinched-waisted shape that matches the vitality and character of the figures themselves.

also see: Top & Bottom
Open Space
Scale/Size Comparisons
Intimate Scale
Tension

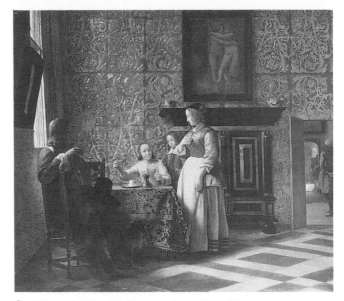

C. Pieter de Hooch, *Conversation*. 1665. (The Metropolitan Museum of Art, New York; Robert Lehman Collection)

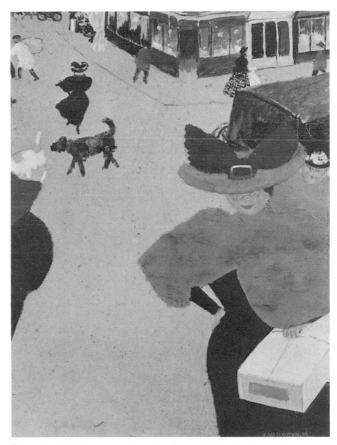

D. Felix Vallotton, *A Street in Paris*. (The Metropolitan Museum of Art, New York; Robert Lehman Collection, 1975)

Top & Bottom

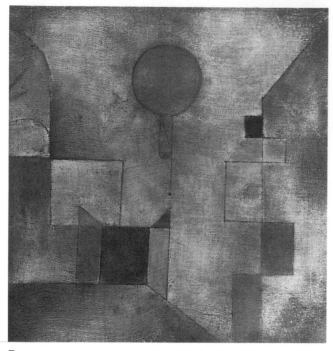

D. Paul Klee, *Red Balloon*. 1922. (Collection, Solomon R. Guggenheim Museum, New York)

The upper and lower parts of a visual field are different. Experience teaches that forms are usually heavier and more numerous near the ground, and progressively fewer and lighter as vision moves up. An intuitive sense of gravity is also involved. When we see things rise—an athlete jumping or a ball thrown in the air—what is "seen" is energy and power being released, gravity overcome. Watching something sink to the ground is seeing a relaxation or surrender to the downward pull.

Similarly, and perhaps as a result of these well-learned visual habits, the top of a visual field feels a little different from the bottom, and shapes look a little different when placed high and low. Divide a square horizontally into two exactly equal rectangles, as in **Figure A,** and the upper one will seem slightly larger or heavier.

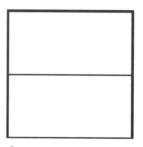

A.

B.

C.

Artists can place shapes to achieve a neutral balance, or a visual evenness, between top and bottom. For example, imagine cutting a rectangular opening in a mat to frame a drawing. When all four sides of the mat are the same width, the opening seems to be placed too low. If the bottom margin is made slightly wider than the one above the opening, the placement of the drawing will feel more comfortable (**Figure B**).

Typographers designing letterforms try to give more weight to the bottom part of the letter when possible to avoid an appearance of top-heaviness. This is especially important for letters that appear to be symmetrical from top to bottom. When the characters in **Figure C** are turned upside down, it's easy to see that top and bottom are different sizes.

The circle in the painting by Paul Klee in **Figure D** can be a buoyant balloon tethered by a delicate string, pulled upward by the visual magnetism of the upper edge, straining to rise to the top of the picture, filled with energy. Turn the picture upside down, and the same form hangs heavily, a dead weight now pulled downward by gravity and the bottom edge.

Moving a form closer to the top will make it seem to have more energy, potency, and importance. We can see this in the silhouette of three-dimensional objects as well. Compare the Egyptian jar in **Figure E** to the Syrian bottle in **Figure F.** In one, the pressing upward of the form gives a sense of lift, of lightness and energy, whereas in the other, the concentration of volume close to the bottom suggests stability, relaxation, and weight.

Equality between top and bottom isn't always necessary. For situations that require extreme legibility and visual clarity, the most delicately and precisely balanced arrangement may be best. In other situations, however, an unequal relation between bottom and top may offer the potential for an unstable and tensely expressive image.

also see: The Center
The Edge
Depth Cues: Vertical Location
Weight

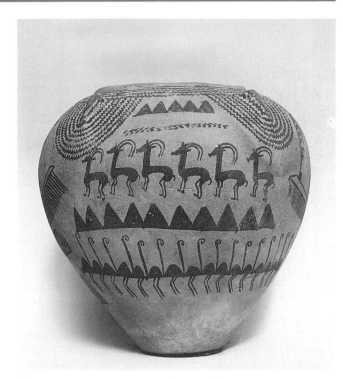

E. Pottery Vessel: Decorated Ware, Egyptian. 3200-3000 B.C. (The Metropolitan Museum of Art, New York; Rogers Fund, 1920)

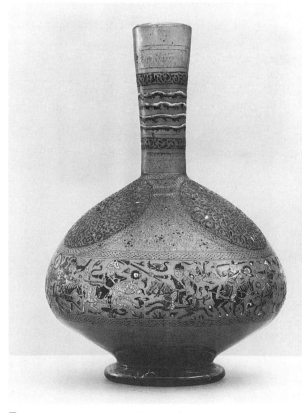

F. Bottle, Syria, Mamluk period, c. 1320. (The Metropolitan Museum of Art, New York; Rogers Fund, 1941)

17

Left & Right

Like the top and bottom of a visual field, left and right look and feel different to the viewer. If two identical shapes are placed on the left and right sides of a field, as in **Figure A,** the right-hand shape will generally seem slightly larger or more powerful. The importance of this for printmakers, for instance, whose work is usually reversed when transferred from plate or stone to paper, or for the book designer, whose single page will become half of a larger composition, is obvious.

Most people have a tendency to scan visually from left to right. This may be, in part, the result of a lifetime of reading and writing from left to right; it may be an effect of the common dominance of the left eye in right-handed people. Whatever the reason, the left-to-right scan has a role to play in much visual art. Hokusai uses it effectively to reinforce the subject matter in his print of a landscape buffeted by a gust of wind in **Figure B.** The composition is weighted on the left, with two trees and the mass of Mount Fuji anchoring it. The rightward movement of the wind is aided by the angle of the trees, the long, downward slope of the mountain, the blowing leaves and paper, and especially the left-to-right scanning of the viewer. If you look at it in a mirror, however, you will see these forces dramatically changed. Instead of riding the wind, a left-to-right glance now bumps into or moves against the composition, and our eyes are forced to climb the long background slope.

The painting by Camille Corot in **Figure C** also has a generous horizontal format. The more massive foreground is on the right, and the eye finds itself suddenly airborne as it enters on the left. Traveling to the right means scaling the hill. The hill itself slows the eye and gently turns it back into the picture. In both the Hokusai and the Corot, the eye travels through the distance as it moves from left to right. Hokusai pushes it along a path with irresistible force; Corot brings it to rest on the nearby hill.

Sometimes artists use this left-to-right current to create movement in an image or to counter one. On other occasions it becomes a tool to balance the inequality of left and right. In Lori Wynn and Dennis Thompson's letterhead in **Figure D,** a strong left-to-right flow is aided by the long horizontal format and by the way the words are read. The momentum generated by this movement might cause the eye to slide off the right edge, but instead that momentum is gently slowed down and stopped by the progressive turning in of the figures on the right side. They face left, redirecting the viewer back into the image in much the same way that Corot's hill does.

A.

also see: Open Space
Isometric Perspective

B. Hokusai, *A Gust of Wind at Ejiri* from *The 36 Views of Fuji.* c. 1831-33. (The Metropolitan Museum of Art, New York; Rogers Fund, 1936)

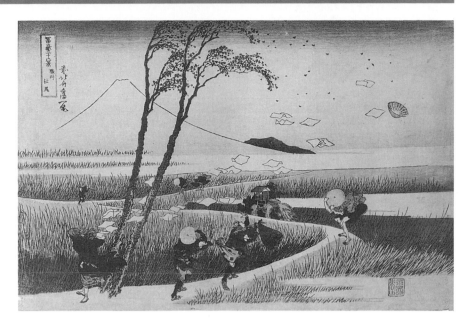

C. Camille Corot, *Volterra*. 1834. (Louvre Museum, Paris)

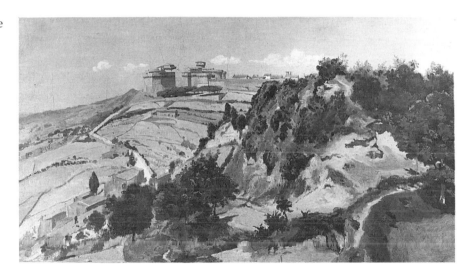

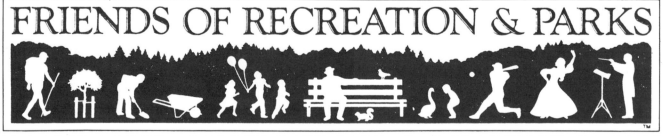

D. Lori Wynn and Dennis Thompson, Letterhead: *Friends of Recreation and Parks*. (The Thompson Design Group, San Francisco)

Grouping

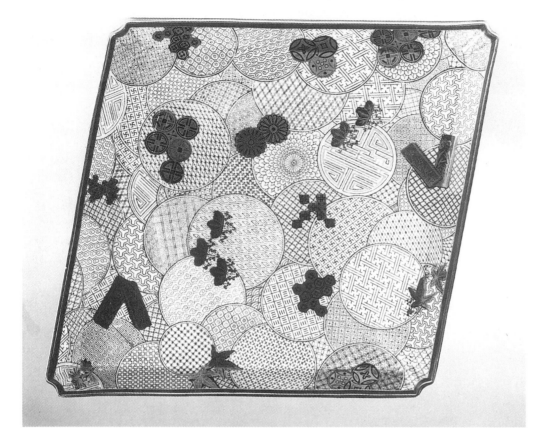

A. Royal Worcester Porcelain Company (manufacturer), *Tray, for a Tête-à-tête*. 1884. (The Metropolitan Museum of Art, New York; purchase, Robert L. Isaacson Gift, 1989)

Grouping is one of the ways by which pieces of visual information can be organized into graspable visual patterns. This organizing is often done unconsciously and automatically. Pieces of a design are perceived as members of a group when they share a similar shape, color, value, or orientation in space. This grouping can also be accomplished by proximity: forms clustered together may be seen as belonging to the same group even if the forms themselves are different from one another.

The porcelain tray in **Figure A** is a casual study in grouping. Against a background of pale patterned circles, smaller darker shapes stand out. Among these, sister shapes can be seen, like the broad *V*s left and right, or groups like the little three-lobed patterns. Clumps of circles and delicate leaf shapes make their own families.

Piet Zwart's type layout in **Figure B** also uses grouping to create visual connections that extend across the page. The lines group by direction—diagonals in one group, verticals in another. Circular forms make another group, while individual letters above and below the large *O* make a squarish constellation that holds the *O* in place.

In the painting by Georges Braque in **Figure C**, still-life objects are arranged in a roughly circular composition on the tabletop while groups of dark and light shapes form scattered constellations of their own across the surface of the picture. Forms group in other ways. A series of slightly tipped diagonal shapes march forward through the space, small circles repeat and change color, black circles becoming grapes. Similarity of shape connects the rectangular passages of light to the background. Grouping is used here to break up the usual relationships between objects and to create connections based on light and dark, shape and direction.

also see: Principles
 Hierarchy and Subdivision

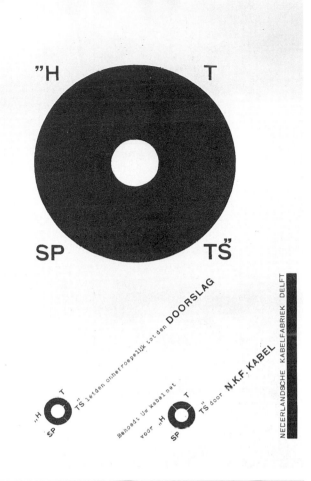

B. Piet Zwart, *Hot spots irrevocably lead to a blown fuse/Protect your cable network by N.K.F. cable/Dutch cable factory Delft*. 1926. (Collection, The Museum of Modern Art, New York; gift of Philip Johnson)

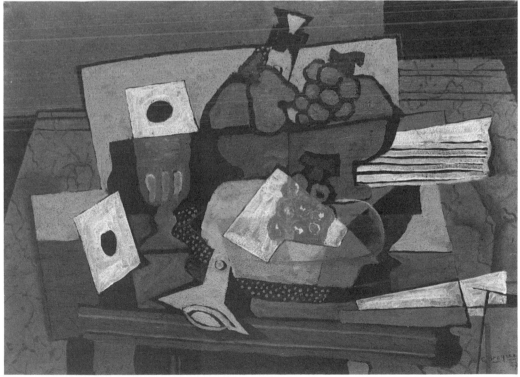

C. Georges Braque, *Still Life with Grapes*. 1927. (The Phillips Collection, Washington, D.C.)

The Picture Plane

This chapter has examined a flat, two-dimensional surface onto which shapes, drawn lines, and marks can be placed or moved from top to bottom, left to right, and so on. Even though forms on this surface may look three-dimensional, they are organized on what is called the *picture plane*, that frontal plane or actual surface on which shapes sit.

This sounds obvious. No one expects to walk up to the Mona Lisa and poke a finger into the space it depicts. At the same time, pictures are often thought of as windows, as though the picture plane were only a threshold, something it is possible to ignore, to pass by on the way into the picture's depth.

The picture plane and its flatness cannot be ignored, but the role given to it in a work of art can vary considerably. An artist can treat the surface as just that, a flat opaque wall on which to serve up flat elements. At the other extreme, an artist can create a feeling of depth, implying that the surface *is* only a transparent screen. The painting by David Hockney in **Figure A** pokes fun at this traditional Renaissance painter's way of perceiving the picture plane.

Hockney's figure exists in a shallow but three-dimensional space "box" and reminds its audience of the picture plane through an old, familiar sight gag, by actually placing a sheet of real Plexiglas over the painted man.

In the twentieth century, Cubist painting marked a startling shift in emphasis in the treatment of the picture surface. Western artists had for hundreds of years stressed a feeling of depth in painting. Although they paid close attention to the arrangement of forms on the surface, the surface itself was more hinted at than actually present. In Cubism, the surface became explicit, and Cubist-influenced pictures tend to look flatter than, say, Impressionist or Old Master painting. In contrast to the roundness and generosity of space in the painting by Chardin in **Figure B**, the forms in the Picasso in **Figure C** seem to be pressed against that sheet of glass, the same picture plane alluded to in Hockney's painting.

There are smaller, interior planes that are seen behind the frontal plane. These planes may be parallel to the picture plane, near, as in the Cubist paint-

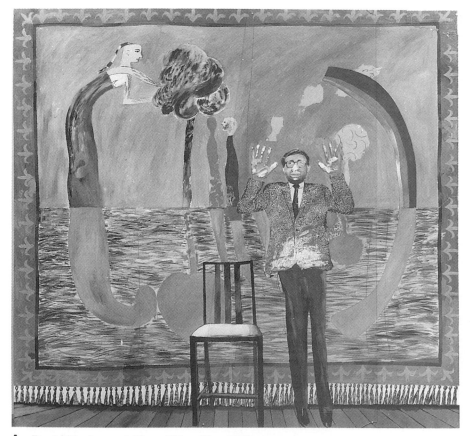

A. David Hockney, *A Play within a Play*. 1963.
(Courtesy of David Hockney, London)

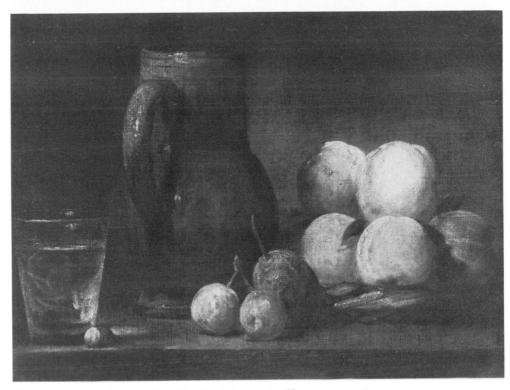

B. Jean-Baptiste-Simeon Chardin, *Fruit, Jug, and a Glass.*
c. 1755. (National Gallery of Art, Washington;
Chester Dale Collection)

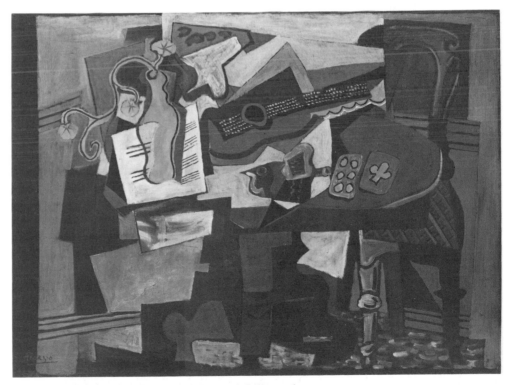

C. Pablo Picasso, *Still Life.* 1918. (National Gallery of
Art, Washington; Chester Dale Collection)

D. Eugène Atget, *Magasin, avenue des Gobelins*. 1925. (Collection, The Museum of Modern Art, New York; The Abbott-Levy Collection; partial gift of Shirley C. Burden)

ing, or farther away, but echoing it. They may sit at an angle to it, or thrust in and out of the picture. Interior planes may be straight or curved, may be created by the surfaces of objects in a still life or by diagonal shapes, parallel lines, or the construction lines of perspective. The structure of interior planes acts out a spatial play behind the curtain of the picture surface. We see this in the photograph by Eugène Atget in **Figure D.** Here, a space can be read that is as complex as any Cubist invention, of superimposed planes, at the same time shallow and deep, each set at a clear angle from the picture plane.

For some kinds of images, the flatness of the surface is essential. **Figure E,** for instance, is a beautiful example of the "flat page" tradition of typographical design. The page is unified, elegant, and, above all, legible. Space is limited to two-dimensional movements because any strong three-dimensional effects would make the text more difficult to read. Some modern typographers, in contrast, have broken with that tradition and created more complex interactions between the flat vocabulary of letterforms and the spatial possibilities of the page (**Figure F**), but even when typographers dig deep into the picture space, it is always with regard for the presence of the surface plane.

also see: The Pictorial Box
Isometric Perspective

E. Ashendene Press, Pages from *Les Amours Pastorales de Daphnis et Chloé*. Published in London, 1931.

F. Stéphane Mallarmé, pages from *Un Coup se Dés*. 1897.

Mark Making

A. Jasper Johns, *Between the Clock and the Bed*. 1981. (Collection, The Museum of Modern Art, New York; given anonymously)

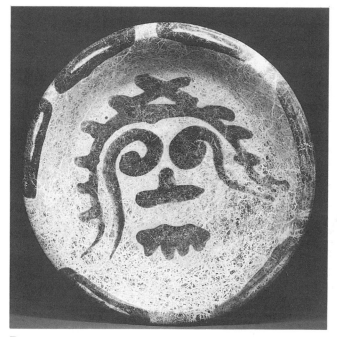

B. Tripod Plate, Mexico (Mayan). Ninth-tenth century. (The Metropolitan Museum of Art, New York; gift of Arthur M. Bullowa, 1989)

A simple mark made with a brush, pencil, or any other tool can be a surprisingly important element in a work of visual art. The soft, wet blob of paint made by a heavily loaded brush, the hairline of an etching needle, the pointed comma produced by a sharpened pencil, though simple and easily made, can become the basic units of complex visual structures. Just as many tiles can be put together in a mosaic to produce complex patterns, a simple mark can be used as a visual building block. The same mark can be grouped, change color, direction, and position in the composition. This handful of possibilities becomes the framework for an entire composition.

Jasper Johns used a straight painted stroke as the basic building block for his painting in **Figure A**. The mark is clearly handmade. When a mark is large enough to be read as handwriting, it becomes a reminder that the surface itself is an object, a flat area with paint on it, as well as being a window onto an illusionistic space. A mark used in this way tends to draw the eye to the surface. In works of art in which there is an emphasis on the surface it is sometimes important to use an easily visible mark.

One of the qualities of traditional media like oil paint or clay is their ability to preserve the smallest and most fleeting traces of the maker's hand. This sense of an intimate, silent, but palpable physical presence can make a two thousand-year-old painting seem as fresh and lively as if it were still wet (**Figure B**). This quality has the effect of closing the gap between the viewer and a work of art that may come to us across the span of centuries.

In some forms of visual art, the visible mark of the hand at work is eliminated. In the mechanical reproduction of books and magazines, in tightly rendered precisionist painting, like that of Charles Sheeler in **Figure C**, and in much communication design, a cooler, more neutral surface is preferred. Here the hand of the artist might interfere with the careful shaping and polishing of the form.

In Roy Lichtenstein's painting in **Figure D** the tiny dots of color used in magazine and newspaper reproduction, the small strokes and hatch marks that create light and shade in the repertoire of realism are magnified until each mark becomes an easily visible shape. It is as if the artist wanted to confront the viewer with the paradox that art is, in one sense, "just lines on paper" while taking exceptional pleasure in all the magical effects that marks can produce.

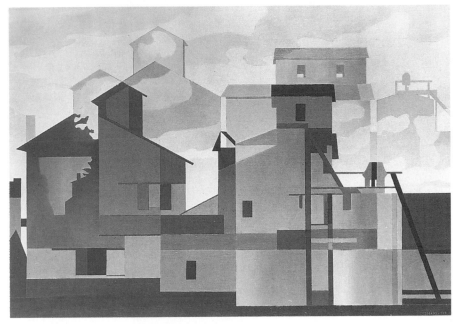

C. Charles Sheeler, *Architectural Cadences*. 1954.
(Whitney Museum of American Art, New York)

D. Roy Lichtenstein, *Big Painting* (#6). 1965. (Private collection)

also see: Materials & Line Qualities
Weight of Value
Making Light
The World of Appearances

Texture

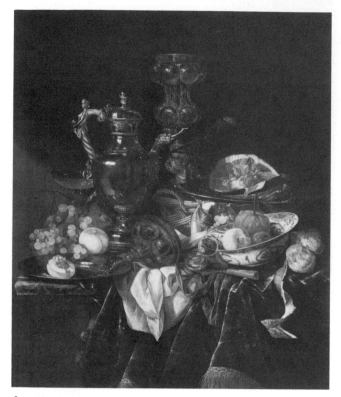

A. Abraham van Beyeren, *Still Life with a Silver Wine Jar and a Reflected Portrait of the Artist.* 1655. (The Cleveland Museum of Art; Mr. and Mrs. William H. Marlatt Fund)

Fur, fabric, or the surface of tree bark seem to the eye as soft or as rough as they feel to the touch. You do not need to run your fingers across a slab of polished marble to feel its smooth and slippery surface. The eye alone can evoke the sensation of texture. Although there is obviously a difference between illusions of texture and a texture that really can be felt with the hand, a visual texture in a work of art gives the means to touch surfaces using only our eyes.

Texture adds visual weight to shapes. It is useful in helping us to see the solidity, roundness, or heaviness of a form. Textured surfaces may feel slow to the eye, clogged, or difficult to move across. Texture invites a more measured, more focused examination of forms. In the Dutch still life in **Figure A,** a variety of dense surfaces gives a real physical presence to objects, encourages lingering and a meditative kind of looking. Massimo Vignelli's poster in **Figure B** uses the camera to summon up texture in a literal way as a reminder that letters are also objects.

Painters often focus on the texture of the paint itself, contrasting its reality with the illusion of the picture space. Sometimes, an artist may contrast the heaviness of a layer of paint with the delicacy of objects depicted, or make the weight of pigment an expressive device as in the painting by Georges Rouault in **Figure C.**

To experience one sense through another, in this case touch through sight, is to experience imaginatively. It is a mistake to think of visual texture as being only an indirect way of enjoying a particular sensation. Looking at a page of type like the one by Herb Lubalin in **Figure D,** we see a variety of sizes, weights, and densities of text. Our eyes become like fingers running over various surfaces—coarse, smooth, rubbly, scratchy. We scan quickly and slowly, easily and with difficulty, over the different blocks of type. Here texture becomes a visual element like color or value. It lends richness and variety.

also see: Packed Space

Structure & Scale

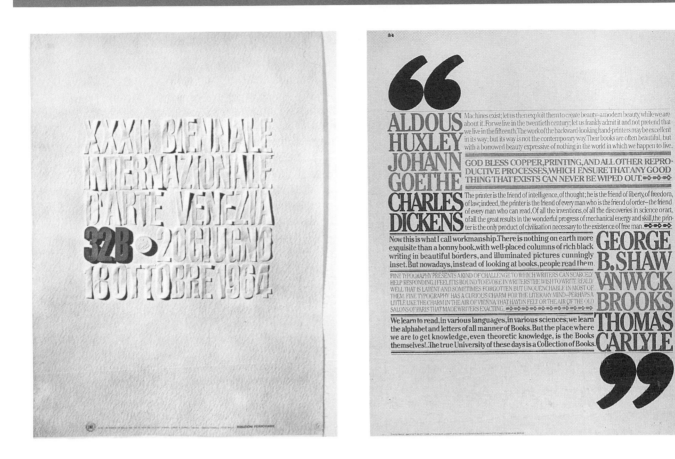

B. Massimo Vignelli, *XXXII Biennale/Internazionale/D'arte Venezia/32B.* 1964. (Massimo Vignelli, Vignelli Associates, New York)

D. Herb Lubalin, Type specimen from *U & lc.* 1978. (Courtesy of the Herb Lubalin Study Center of Design and Typography, New York)

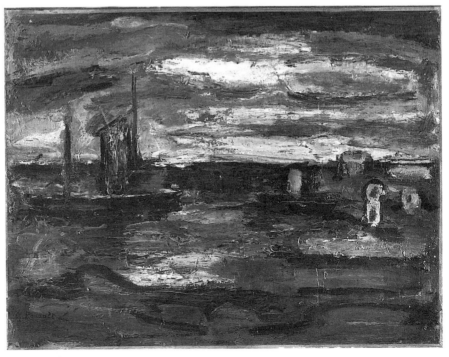

C. Georges Rouault, *Afterglow, Galilee.* Before 1930. (The Phillips Collection, Washington, D.C.)

Pattern & Ornament

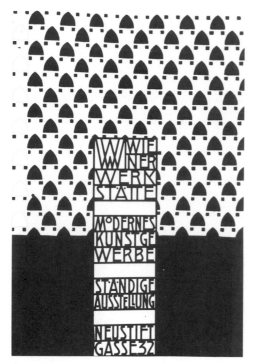

B. Josef Hoffmann, *Wiener Werkstatte exhibition poster.* 1905.

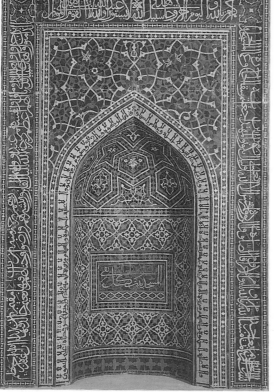

C. Mihrab, Iran. c. 1354. (The Metropolitan Museum of Art, New York; Harris Brisbane Dick Fund, 1939)

When speaking of *pattern*, we may use the term in a fairly general sense—pattern as opposed to texture, decorative motifs organized as opposed to marks placed randomly across a field. Like texture, pattern creates unity across a surface, embellishes, and adds weight to shapes. Using pattern is a way of emphasizing the surface and denying the eye access into the deep space that might exist behind it. Pattern can be visually stimulating just for the richness and variety it offers, satisfying a need for event and novelty in our visual experiences.

Pattern must include the idea of repetition. Thirty-two identical squares scattered about do not make a pattern. Place them parallel to one another, or corner to corner, or in any regular arrangement, and you see a pattern (**Figure A**). Recurrence of shapes or motifs need not be exact, but we must recognize forms or rhythms reappearing as part of a larger structure. We think of repetition as happening in time, one event after another. Repetition, in this sense, is a linear idea. Pattern expands this idea laterally, across surfaces and across two-dimensional space.

Pattern can be thought of in several ways. It can mean the breaking down of a large field into smaller units in which shapes repeat in an orderly way. Geometric patterns, for example, are often based on underlying grids that create uniform compartments into which modular components can fit. The whole surface is taken into account at once. The lively army of rising shapes in Josef Hoffmann's poster in **Figure B** is arranged in this way.

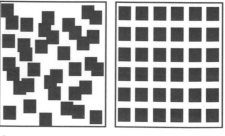

A.

A more complicated grid, or layers of grids, govern the patterns in the Islamic decoration in **Figure C.** Here the structure is so visible and powerful that exact duplication of shapes is not needed to be able to sense an overall order. If you look carefully, you will see that there is constant variation within the pattern. Furthermore, you can see how the arabic letterforms around the edge seem to extend the pattern by continuing its energetic rhythms and echoing its gestures, marks, and color. Strictly speaking, the characters do not form a pattern at all but certainly contribute to its effect.

In the beautiful and delicate floral ornament of William Morris's illustrated page in **Figure D,** forms evolve and change like growing things. At the same time, the sense that there is a governing and unifying force behind them is never lost. Here patterns don't seem to be hung on a preexisting grid but to have grown from a point until they filled all available space. Although there are internal symmetries and repetitions, it is the overall rhythmic pulse or energy that repeats, a specific kind of movement, a particular repertoire of forms, curves, and gestures that form the structural armature under these patterns.

It's easy to imagine the pattern in the Hoffmann continuing endlessly without changing. The pattern in the Morris is contained, limited by the edges of the shapes that are nowhere crossed. Forms in the pattern must constantly turn back on themselves.

There appears to be no regularity at all in the organic cascade of leaves, flowers, and fruit in the manuscript page in **Figure E.** This might be more accurately described as a decorative scheme than as pattern, but some of the feeling of pattern emerges from the musical continuity of curves echoing curves, and from the way they hold the surface together to make a splendid if relatively flat frame for the deeper picture space carved out of the middle of the page.

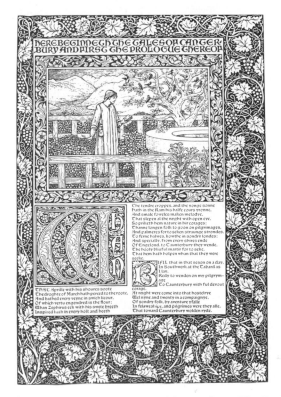

D. William Morris, illustrated page from *The Canterbury Tales.* 1896.

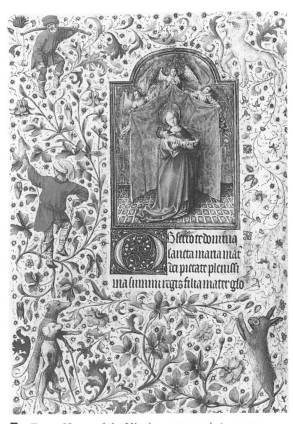

E. From *Hours of the Virgin*, manuscript page. Luxembourg, about 1430-40. (The Pierpoint Morgan Library, New York)

31

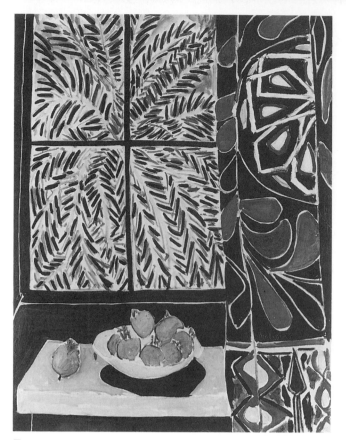

F. Henri Matisse, *Interior with Egyptian Curtain*. 1948. (The Phillips Collection, Washington, D.C.)

Technically, it could be said that pattern is distinguished from ornament by the nature of the guiding structural principle. The stronger the principle, the stricter and more easily recognizable the pattern. A geometric pattern can be built on a regular grid, or a fluid pattern can be based on large symmetries or the repetition of complicated sections, inverted and reversed, as in floral patterns printed on fabric. There can also be patterns in which organic forms grow logically and with controlled rhythms from a point or line. Pattern can be easily visible or difficult to see, but what is always sensed is something different from the random quality of texture. An order is imposed on elements or elements are fitted into a preexisting order.

Pattern is used in a relaxed and luxuriant way in Henri Matisse's painting in **Figure F.** There is nothing random in the arrangement of marks forming the leaves of the palm tree. This relatively tight, if not geometric, pattern is contrasted with the softer shapes on the drawn and folded curtain on which a fragment of a larger pattern is transformed into a composition of bright and varied color shapes.

also see: Grids

Geometric & Organic Shape

Symmetry

Repetition & Variation

Arabesque

Grids

A grid is a kind of proportional system that helps to organize forms on the surface. Grids are widely used in communication design and found in the work of visual artists in every medium.

A simple grid, as in **Figure A,** can divide a rectangle into sixteen equal smaller rectangles. Rather than allowing vision to penetrate into an imaginary three-dimensional space, the lines of the grid shunt the eye up and down and from side to side, keeping the viewer aware of the flat surface of the page.

The grid also encourages the division of attention evenly over the entire surface. Each rectangle is identical in size and shape to every other rectangle. Each contains the same percentage of area, and the differences between areas are minimized.

Finally, the smaller subdivisions here all have the same proportions as the large rectangle. Like echoes, they repeat the height/width ratio over and over. The small rectangles are the seeds out of which the large one grows. Grids, then, organize flat space by creating a scaffolding or skeleton on which to hang and keep track of shapes, lines, and marks A grid creates a sameness across the surface that can be used to organize differences.

Figure A is the simplest kind of grid, but grids do not have to be checkerboards, nor must they be symmetrical, or strictly vertical and horizontal. Max Bill used two very different kinds of grids to order the shapes in his posters in **Figure B,** and the possible variations are infinite. Every grid, however, divides the surface in a regular and easily comprehended way, and the location and relationship of every form to every other form is made clear and logical.

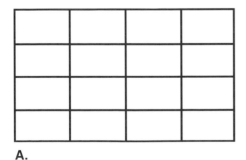

A.

B. Max Bill, *Exhibition Posters.* 1945 and 1951. (Courtesy of the Library of Congress)

C. David Smith, *Untitled II.* 1961. (Collection of the Whitney Museum of American Art, New York; gift of Candida Smith)

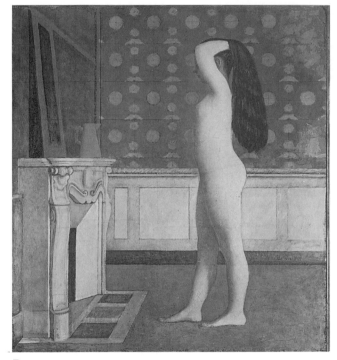

D. Balthus, *Nude in Front of a Mantel.* 1955. (The Metropolitan Museum of Art, New York; Robert Lehman Collection, 1975)

The main characteristic of a grid, in fact, is its clarity. As an organizing device, the grid provides the means to give maximum legibility to many different kinds of visual information. It is an obviously useful tool for the graphic designer, industrial designer, or architect, infinitely flexible and orderly.

Like any tool, the grid can be used imaginatively or unimaginatively. It can produce a regimented-looking, repetitive organization if the artist doesn't know when to break out of it. Sometimes the authoritative look of a grid challenges artists even more to rely on the judgment of their eyes rather than trusting to systems.

The grid on which forms have been arranged is quite visible in the David Smith drawing in **Figure C.** Here the grid provides an underlying framework on which flickering brushwork is hung, rather like a trellis supporting the organic growth of a grapevine.

In the standing figure by Balthus in **Figure D,** the logic of the grid seems to inform the decisions. The chair rail divides the painting into two almost equal horizontal bands, and the nude's forward toe very nearly marks the vertical center. The sense of carefully considered intervals seems a response to the literal grid that governs the patterned wallpaper. Simplified and architectural, the curving profile of the figure contrasts with the straight edges of the interior. Her solid vertical stance and carefully positioned feet echo the vertical and horizontal engineering of the composition.

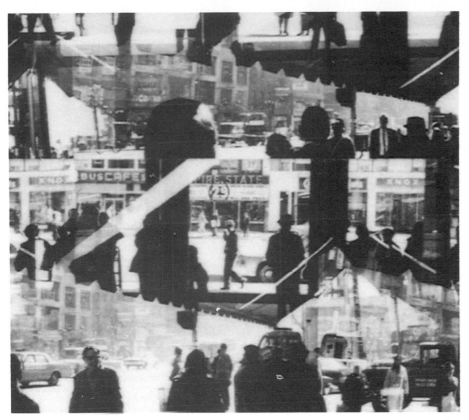

E. Ray K. Metzker, *Port Authority* (detail). 1966-67. (The Metropolitan Museum of Art, New York; Purchase, Stewart S. MacDermott Fund, Nancy and Edwin Marks Gift, Mary Martin Fund, Joyce and Robert Menschel Gift and The Horace W. Goldsmith Foundation Gift, 1990)

In the figure by Balthus, the implied grid helps to impart clarity and stillness to a severe and monumental composition. Forms seem locked in place. Ray Metzker uses a grid to do something very different in his photograph in **Figure E.** Here a transparent grid of verticals, horizontals, and diagonals unify what might otherwise be a jumble of spaces, rhythms, and textures. The feeling of a cacaphony of sights and sounds is retained without becoming incomprehensibly chaotic.

In fact, close examination might reveal that a grid, real or implied, is built into the construction of almost every work of art or design. The sense of order, controlled interval, and sensitivity to the simplest elements—surface, horizontal, vertical, and diagonal—that a grid makes concrete, lies behind much of what all artists do.

also see: The Field

Space Moving In

Proportional Systems

Vertical/Horizontal/Diagonal

3 Making Depth Happen

Overview

The previous chapter considered the surface and how looking at a flat image differs from looking at the three-dimensional world. Examining some of the ways shapes, lines, and tones behave when put together on a flat plane reveals pushes, pulls, and tensions across, up, and down the surface. Although the surface is, by definition, flat, it never feels empty and it is never static.

But there is another way to think about what happens on a flat page. The surface has what an artist once termed "a mysterious desire to contain spaces, objects, and forms." A sense of depth, a feeling of three-dimensionality is irresistible in any flat image whether it intends to depict three-dimensionality or not. This sensation of space is at the heart of the visual arts, whether the image is aggressively realistic or not figurative at all.

There seems to be a contradiction in the notion that the same thing can be looked at in two different ways, as though it were possible to choose to see flat *or* to look for depth. In fact, the two go together, and in two-dimensional art you can't have one without the other. The third dimension inevitably creeps into two-dimensional images. The challenge then, is to control, balance, and relate the forces of depth and surface, using one to complement the other.

The three-dimensional effect seen in so much visual art is obtained by organizing and using flatness. Put simply, we see space by looking carefully at the surface.

Figure & Ground

The smallest mark, placed on a sheet of paper, will create a feeling of space. Try it. Place a dot on a page, and you'll see that you can read it as an object, floating in front of a large, empty background, or you can see it as a tiny hole in the page, revealing the darkness behind. This most basic illusion creates a very simple kind of space: one thing in front of another. This is called a *figure/ground relationship*. Figure is the shape in front of the ground, which appears to be behind. Foreground and background, near and far, are other words often used to express similar simple ideas about how we understand picture space.

Of course what is known about depth and distance in the real world gives a great many clues about how to read space in a realistic image. For example, in the Rembrandt etching in **Figure A,** the lowest zone reads as foreground, the three trees step more deeply into the space, and the rest, the landscape on the left, recedes easily back to the distant city. Similarly, the high clouds on top are behind the slash of light on the left, and distant clouds rise from behind the city. But these kinds of clues are less helpful in a work of art that deals with a nonrealistic space. In the painting by Jean Hélion in **Figure B** the sense of one thing in front of another is created entirely by the way shape, color, texture, and other formal qualities are read. A group of smaller, more complicated shapes is seen in front of a larger, simpler background. Some forms seem to overlap others, or cast shadows, or curve and bend in space. The ingredients that Hélion uses seem complex and precisely arranged.

Figure and ground shapes have their own particular characteristics and play different roles in a visual configuration. Generally, a figure area looks heavy and self-contained. A ground area, conversely, tends to look empty, visually lighter, or less loaded. Put another way, the figure is the main visual event (the actor) and the ground is a supporting element (the stage). Figure areas tend to be mobile looking, while the ground seems to stand still. The actor moves across the stage; the stage does not move around the actor. Nonetheless, in any theater, the stage, even when it is bare, is an integral part of the drama.

There are several fairly straightforward ways of making one shape in an image read as figure and another as ground. If we look at them, separately and diagrammatically, we see the following.

Convex shapes, with boundaries that curve outward, tend to be seen as figure, while concave shapes, those with outlines bending inward, often

A. Rembrandt van Rijn, *The Three Trees*. 1643. (The National Gallery of Art, Washington; Rosenwald Collection)

B. Jean Hélion, *Standing Figure*. 1935. (Albright-Knox Art Gallery, Buffalo, New York; Room of Contempory Art Fund, 1944)

37

D. Henri Matisse, *Venus*. 1952. (National Gallery of Art, Washington; Ailsa Mellon Bruce Fund)

read as ground areas, or holes in the picture plane (**Figure C/1**).

Figure is created by texture. Textured areas seem dense, and are generally read as positive shapes. A lack of texture creates the visual emptiness of ground. In **Figure C/2** areas become solid looking or empty looking as texture is applied.

Value and color also affect our reading of figure and ground. More contrast of color or value usually results in a stronger separation of figure from ground (**Figure C/3**). In general, a darker value or more brilliant color appears to be visually heavier and more positive than a lighter or duller color.

Lines that are close together will visually attract one another and create a positive or contained-looking, figure-like space between them. As lines move further apart, the space between them becomes emptier and less compact, more like ground (**Figure C/4**).

It's not necessary to assume, as the diagrams do, that a single element (texture, or line, or value) will be used to create a figure/ground relationship. In most situations several of these elements will combine, and the force of one may counterbalance the tendencies of another. For example, in Henri Matisse's collage in **Figure D** the shapes that are figure in the literal sense, the dark paper painted and glued onto the white page, become, for the eye, ground shapes against which the image of a nude is

C/1 C/2

C/3 C/4

C.

seen, her form made of a convex shape, its edges drawing together to create a full, swelling volume. The cut paper shapes, their dark and brilliant blue animated by the texture of visible brushstrokes, still retain enough figural quality to make for a lively exchange between these two sets of shapes, competing for the front of the picture space.

The poster by Will Bradley in **Figure E** sets two figures against a strongly patterned background. Their unpatterned cloaks look empty, almost like holes cut in the surface of the image. If you cover over some of the holly leaf pattern in the middle of the lighter figure, this feeling becomes even stronger. Visualize, if you can, how this balance of figure/ground would change if the shapes of the cloaks were convex instead of softly concave. As is, the background reads so strongly as figure that even the bands of type at top and bottom appear to be slightly behind the patterned rectangle.

In Gustav Klimt's painting in **Figure F,** a varied sequence of figure/ground relationships creates a rhythm of open/closed, positive/negative, empty/full areas. The central zone, made up of scores of shapes clotted together, is obviously in front of the more finely textured background. Still, the background has enough texture to seem on the verge of becoming foreground, and the whole image seems tightly pressed against the surface. Try squinting your eyes as you look at this reproduction. You will see that as the background texture blurs and disappears, the right- and left-hand areas dissolve into the background again.

also see: Texture

Shape: Overview

Positive & Negative Shape

Space & Volume

Making Space

Hierarchy & Subdivision

E. Will Bradley, *The Inland Printer Christmas*. 1895. (Collection, The Museum of Modern Art, New York; gift of Joseph H. Heil)

F. Gustav Klimt. *Hope II*. 1907-8. (Collection, The Museum of Modern Art, New York; Mr. and Mrs. Ronald S. Lauder and Helen Acheson Funds, and Serge Sabarsky)

39

Depth Cues: Gradients

A. Hendrick Avercamp, *A Scene on the Ice*. c. 1625. (National Gallery of Art, Washington; Ailsa Mellon Bruce Fund)

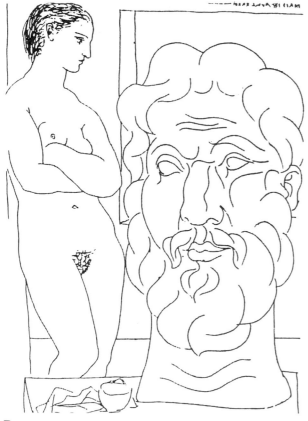

B. Pablo Picasso, *Model and Large Sculptured Head*. 1933. (Museum of Modern Art, New York; Purchase Fund)

There are a handful of simple ways to create a feeling of depth in a two-dimensional image. Easy to understand and use, these cues are important space makers. Used alone or in combination, they are signals that can create the most refined and sophisticated sensations of depth and volume on a surface.

A *gradient* is any gradual, orderly, step-by-step change in some visual quality. It might be the change from darker to lighter gray along a scale, or the smooth swelling and tapering of an oval, or a change from large forms to medium sized to small ones.

Gradients are effective tools for creating pictorial space. A gradual size change from large to small, for example, can create a series of clear visual steps into the picture space. This kind of gradient is used in Hendrick Avercamp's scene in **Figure A.** The diminishing sizes of the skaters against the expanse of ice turns them into stepping stones toward a distant horizon. What is called vanishing-point perspective is simply a set of rules for creating this kind of gradient with straight lines.

To be effective, the change in a gradient must be a change of degree and must happen in a fairly even series of steps. There must be enough steps so that the eye does not have to jump, and the intervals between them must be reasonably smooth. As on a flight of stairs, any step that is shallower or deeper than the others will cause accidents.

When the eye is asked to move from foreground to background without a sufficient number of steps, the sense of depth is weakened, and when this happens, the tendency is to see a small form next to a large one, instead of a distant and near form. This kind of flattened space can be seen in Picasso's etching in **Figure B.** Rather than seeing the head as close and the model farther away, a small figure seems to stand next to a gigantic head. It is only the table overlapping the model's legs on the bottom left that gives a clue to the size relationships.

Generally, as more and clearer gradients are added, the illusion of depth and volume is strengthened, as in **Figure C.** A classic and very effective combination of gradients can be seen in Laszlo Moholy-Nagy's poster in **Figure D.** The letters, which form a gradient of large to small, are part of another gradient, a curve. A third gradient, one of diminishing weight as the letters progress from the bold and heavy *p* to the lightness of the final *k*, increases the effect.

also see: Space Moving In

Vanishing-Point Perspective

Movement & Change

Stroboscopic Motion

Space & Volume

Making Space

D. Laszlo Moholy-Nagy, *Poster (Photomontage)*. 1923. (photograph courtesy of The Museum of Modern Art, New York)

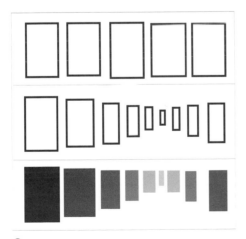

C.

Depth Cues: Overlap

A. Painter from the Circle of Duccio, *The Virgin and Child Surrounded by Angels.* c. 1300-25. (The Metropolitan Museum of Art, New York; Robert Lehman Collection)

Perhaps the most elementary of the depth cues is overlap, the illusion of one shape seeming to interrupt or block our view of another.

In the early Renaissance painting in **Figure A,** overlapping forms are the only guides to reading depth from foreground to background. The more distant figures are not smaller than those in front as they would be in a perspective drawing. Here overlapping makes possible the untangling of what might otherwise be visually ambiguous. By allowing the eye a way to step into the space, overlapping keeps a shallow, packed space from becoming flat.

In **Figure B,** a Japanese textile, overlap is purposely avoided, and the image *is* flattened. Very few depth cues for a three-dimensional reading are given. We tend to look up and down the surface, but have difficulty seeing one thing in front of another. The forms look like pressed flowers.

By contrast, the depth in Edgar Degas's painting (**Figure C**) is generous, with a feeling of air and space around each form. The bottom hat overlaps both the edge of the table and the hanging ribbon, clearly putting it in front of the group of hats on stands. They, in turn, overlap the woman's head and shoulder, locating her in the middle distance, and so on. By reading each form behind the one overlapping, the eye is able to pick its way through a rational space. Each form has a secure place in this space even though, like so many flying saucers, the hats themselves are airborne.

In El Lissitzky's *Proun 3 A* in **Figure D,** overlap clues are used to give slightly different and mixed signals. There are forms that clearly overlap as well as shapes that may or may not signal overlap, shapes that appear to be superimposed on other shapes, and shapes that read as holes. The space that Lissitzky creates here is precisely engineered to be at the same time exact, and just a bit shifty or ambiguous.

also see: Surface & Space

B. *Futonji*, Okayama Prefecture. Early Nineteenth century. (Honolulu Academy of Arts; Purchase, 1937)

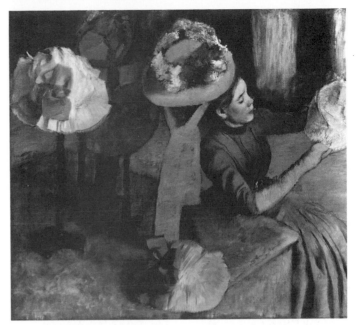

C. Edgar Degas, *The Millinery Shop*. 1879-84. (Collection, Art Institute of Chicago; Mr. and Mrs. Lewis Larned Coburn Memorial Collection, 1933.428; all rights reserved)

D. El Lissitzky, *Proun 3A*. c. 1920. (Los Angeles County Museum of Art; purchased with funds provided by Mr. and Mrs. David E. Bright and the bequest of David E. Bright)

Depth Cues: Size Change

B. Meindert Hobbema, *The Avenue, Middelharnis*. 1689. (The National Gallery of Art, London)

D. Balthus, *André Derain*. 1936. (Collection, The Museum of Modern Art, New York)

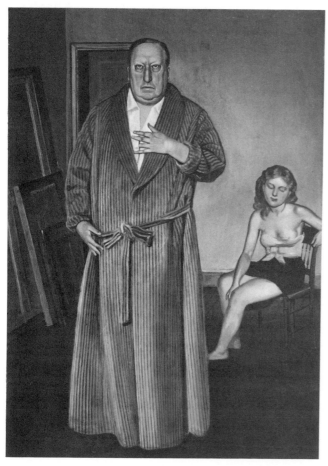

e is one more of the basic tools used for creating a sense of space. In **Figure A,** the shapes are identical, only their sizes are different. Yet with no other space cues, the size change alone creates a feeling of distance, near and far.

When size changes are very orderly, as in the landscape by Meindert Hobbema in **Figure B,** the sense of space becomes extremely clear, almost architectural. The equal distances between similarly tall trees create a compelling illusion of depth. As in a line of columns down the nave of a cathedral, the regular shrinking from one tree to the next makes the landscape space seem geometrically precise.

Bruno Munari's poster in **Figure C** uses size change along with overlap. Multiplied many times, the changes create visual action, a staccato shifting from near to far. The size differences here make a rhythmic image as vivid and rapid-fire as rush-hour traffic in Rome.

The painting by Balthus in **Figure D** uses size change as the main visual cue to reading the space of the picture. Although you could probably guess the height of the seated woman fairly accurately by comparing her to the standing man, and based on what we know about size, distance, and human beings, the small overlap of the woman's foot by the man's robe offers assurance that this reading of size change as a measure of distance is correct.

Figures are placed behind one another in the painting by Alex Katz in **Figure E,** but the sense of depth is very limited. The artist has eliminated size changes. The figures behind are the same size as the figures in front. The overall effect, despite overlap and the strong three-dimensional lighting, is of a shallow space, compressed and close to the picture plane.

also see: The Picture Plane
Gradients
Size & Scale Relationships

A.

C. Bruno Munari, *Campari*. 1965. (Collection, The Museum of Modern Art, New York; gift of the designer)

E. Alex Katz, *Place*. 1977. (Collection of the Whitney Museum of American Art; gift of Frances and Sydney Lewis. Acq. #78.23)

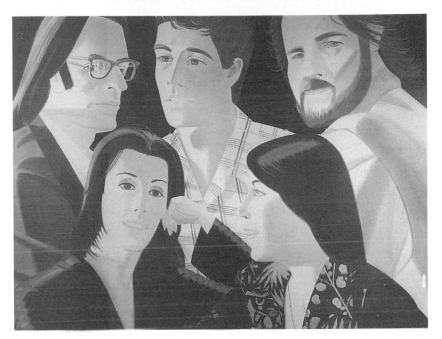

Depth Cues: Vertical Location

-KEEPS LONDON GOING

A. Man Ray, *Keeps London Going*. 1932. (Collection, The Museum of Modern Art, New York; gift of Bernard Davis)

When looking at a realist painting or a photograph, the usual expectation is that the foreground will be in the lower part of the visual field, and the forms in the distance will occur higher up. Even without using perspective, artists sometimes manipulate space in accordance with this tendency (or habit) to read the bottom of the field as near and the top as farther away.

Man Ray's poster for the London Underground in **Figure A** nearly eliminates all space cues *except* vertical location to create a sense of infinite distance. Turn the poster upside down and notice the difference in the way you read the space. You are now likely to perceive the smaller form as nearer to the viewer.

Chinese painters were able to give an effect of large-scale space in a long, narrow format by using vertical location as an important depth cue. In the landscape by Lu Chi in **Figure B,** forms pile up and back with little overlap, creating a bird's-eye view. Small islands of landscape climb back and up into the vast distance. A flock of cranes, getting smaller as they fly into the landscape, enhances this delicate effect.

Artists can disrupt or even reverse expected relationships and in doing so produce fresh and unexpected spaces. To avoid the heavy, overloaded look that might result from placing all the foreground forms along the bottom of the canvas, Pieter Bruegel, in his painting in **Figure C,** designed a landscape space of hills and valleys. Bruegel lifts up the foreground and pulls down the background. Foreground figures at the top of the hill are placed as high on the canvas as background figures. The result is a space that is both convincingly real, and satisfying as a design of symphonic richness, full of contrast, harmony, and movement.

also see: Top & Bottom
Vanishing-Point Perspective

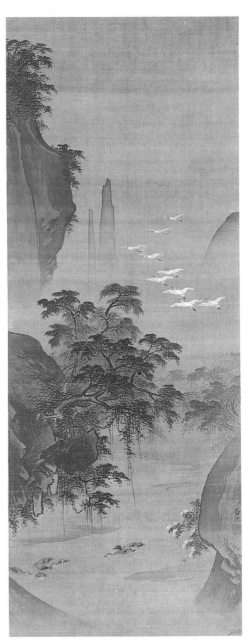

B. Lu Chi, *Autumn Landscape with Herons and Ducks*. c. 1488-1505. (The Metropolitan Museum of Art, New York; Dorothy Graham Bennett Fund, 1980)

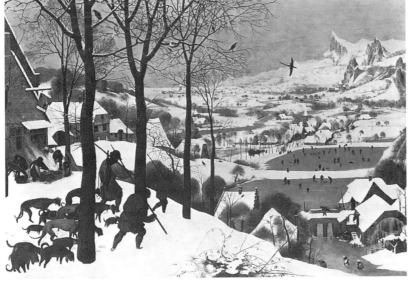

C. Pieter Bruegel, *Hunters in the Snow*. 1565. (Kunsthistoriches Museum, Vienna)

4 Using Depth

The Pictorial Box

It's possible to imagine and visualize many kinds of depth in a flat surface, from the thin, discrete layers of stage scenery to the deep flowing space of aerial perspective. There are always choices and options for an artist who wants to design with space.

One way of organizing space in Western art has been by thinking of the page as a *pictorial box*. **Figure A,** a painting by the Renaissance artist Antonello da

Messina, is a good example of this. The picture's surface or *picture plane*, is like a stage proscenium, a window or door through which open space is visible. Here, the artist, by stressing the beginning of the space, makes this effect of passing through, or entering, all the more obvious. He paints a stone doorway, its threshold (the threshold of the picture space) marked by a splendid peacock, and then carefully

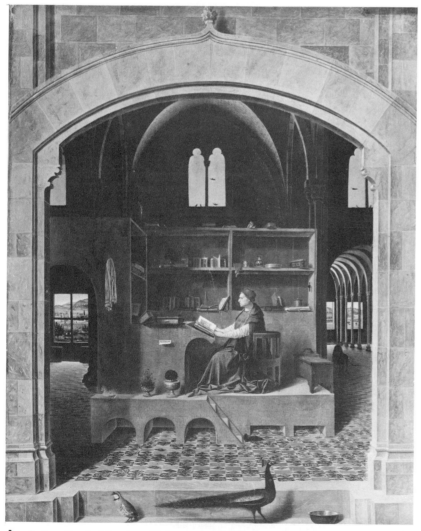

A. Antonello da Messina, *St. Jerome in His Study.* c. 1475.
(Reproduced by courtesy of the Trustees, The
National Gallery, London)

constructs a floor pattern that leads the eye inward to arrive finally at the walls that form the back, or outer limits of the space. The figure of St. Jerome is placed on a large, cube-shaped platform/study, a space within the space. The carpentered, right-angled feeling of the interior (so different from the space of an undulating landscape) is reinforced by the boxlike forms of books and furniture.

The habit of seeing the picture surface as the entry point into a deeper space is one of the most familiar in the history of Western art, but despite its limitations, or because of them, this approach has been a useful one. It keeps things clear—front, top, bottom, back, and sides are easy to see. It creates a controllable, measurable space that can be as deep or as shallow as required.

The pictorial box in John Frederick Peto's painting in **Figure B** is so shallow that it is hardly a space at all. The eye's movement inward is stopped by a wall, a plane parallel to the picture surface and seemingly just behind it, and the larger objects in the still life seem almost to hang in front of the picture plane. In this kind of painting, called *trompe l'oeil*, forms appear to poke out into real space, literally mimicking real objects. Harnett uses the pictorial box, and the strategies for building space into it, as a means to push forms forward and fool the eye.

The sense of a box space is not only found in illusionistic art and perspective drawing. This kind of space is also seen in the work of artists like Louise Nevelson (**Figure C**), work that relies on the containing quality of the box. Layers of form overlap, and smaller elements are contained in spaces that have the intimate, precious feeling of a mysterious display cabinet.

also see: The Picture Plane

Intimate Scale

B. John Frederick Peto, *The Old Violin*. c. 1890. (The National Gallery of Art, Washington, D.C.)

C. Louise Nevelson, *Black Wall*. 1964. (Hirshhorn Museum and Sculpture Garden, Smithsonian Institution; gift of Joseph H. Hirshhorn, 1966)

Space Moving In

A. George Caleb Bingham, *Fur Traders Descending the Missouri*. (The Metropolitan Museum of Art, New York; Morris K. Jesup Fund, 1933)

B. Juan Gris, *Fantomas*. 1915. (The National Gallery of Art, Washington; Chester Dale Collection)

Frontal Recession

Sometimes pictorial space is created by a series of overlapping layers that are parallel to the picture plane, like cut-out layers of scenery set parallel to the front of a stage. This way of moving into and through a space is called *frontal recession*. It reminds the viewer of the flat surface even while leading the eye past it into the picture. Each layer of space marks a step into depth and echos the two-dimensional surface.

The delicate landscape by George Caleb Bingham in **Figure A** is organized in this way. A series of horizontally placed forms, as solid as the boat itself or as fragile as the ripples on the water, move the eye into the space as though through a series of transparent planes. Even the distant trees align and separate in accordance with this rule. Like the boatman and even the cat in the bow, the forms themselves seem attentive to the viewer.

In his still life in **Figure B,** Juan Gris uses much the same approach to create a complex shallow space out of flattened layers placed parallel to the frontal plane. The main forms are colored rectangles and squares, their flatness reinforced by lettering. The illusionistic wood graining of the large central rectangle is as literal as a sheet of veneer glued onto the painting. It is a reminder that, on one level at least, the art of the Cubists was "just paint on canvas." Gris's painting is neither realistic nor three-dimensional in the sense that the Bingham is, but both works share the feeling of quiet orderliness and of being carefully constructed in space.

C. El Lissitzky, *Cover design for Vesch/Gegendstand/Object*. 1921-22.

Type reinforces the distinctly flat flavor of the Gris, and frontal recession can be a useful way to control shallow spaces for artists who work with type. Letterforms lend themselves to this kind of organization. The blocks of type in El Lissitzky's page design in **Figure C** each establish their own level of depth. Instead of pushing into the depth of the design they run parallel to the picture plane, zigzagging up and down.

Diagonal Recession

When planes are arranged to move into the picture space at an angle to the front plane itself, the image looks quite different. It seems to have more visual motion and to feel less enclosed. This way of proceeding through space, sometimes called *diagonal recession*, can give drama and movement to the most ordinary subject matter.

Edouard Vuillard, in his portrait in **Figure A,** used diagonal recession to create visual excitement in what might otherwise be a static picture. His image of an elderly man sitting in his study is dominated by the diagonally placed rectangles that thrust through the picture space generating a swirl of movement, like a carousel with the sitter at its (slightly off-center) center. Where frontal recession creates a step-by-step layering of space, diagonals can zoom from foreground to background in one smooth movement. It is a quicker moving space.

Charles Sheeler's photograph of conveyors in **Figure B** uses two huge diagonal forms to create a dramatic space that both rushes toward the viewer and flees into the distance. This violent and disjointed motion, made even more unsettling by its elevation, is stopped and stabilized only by the strong verticals of the distant smokestacks.

In Laszlo Moholy-Nagy's brochure cover in **Figure C,** diagonals of type also cross in space and move in and out of the picture depth, creating an animated visual puzzle, difficult and engaging to figure out. These are headlines, places where the bold impact of strong diagonals gives a visual punch to things. Reading long columns of copy placed in such a dizzying relationship to the picture plane would be difficult, but here the pushing back and forth through space enhances the already three-dimensional effect of the photographs and creates a space that is muscular without being realistic.

also see: Left & Right
Depth Cues: Overlap
Isometric Perspective
Vertical/Horizontal/Diagonal

A. Edouard Vuillard, *Theodore Duret*. 1912. (National Gallery of Art, Washington; Chester Dale Collection)

B. Charles Sheeler, *Crisscrossed Conveyors, Ford Plant, 1927.* (The Metropolitan Museum of Art; Ford Motor Company Collection, gift of Ford Motor Company and John C. Waddell, 1987)

C. Laszlo Moholy-Nagy, *Brochure cover for "14 Famous Books."* 1929. (Bauhaus Archiv, Berlin)

Space Moving Out

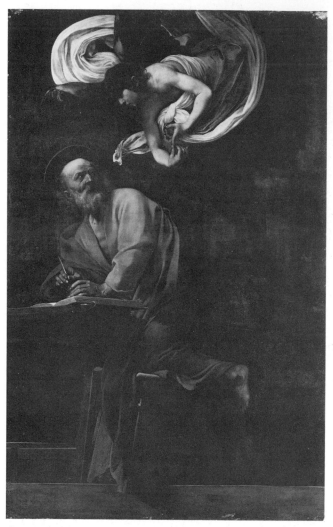

A. Michelangelo Carravaggio, *St. Matthew and the Angel.* c. 1595. (Cheisa di S. Luigi dei Francesi, Rome)

Renaissance artists dug into the picture plane, thrilled with the illusion of distance. Some Baroque artists began to change the emphasis, stressing movement toward the viewer and creating spaces that related to real space, the space outside the canvas, in ways not seen before.

St. Matthew and the Angel by the Italian painter Caravaggio (**Figure A**) limits distance with an impenetrable black background, a solid wall of darkness that prevents the eye from probing deeply into the space. The front of the picture space seems clearly marked by the painted ledge at the bottom of the canvas. But Caravaggio moves forms beyond that front. The diagonally set wooden bench has one leg falling off the ledge, casting a shadow behind it as it moves toward the viewer, almost like an object in a *trompe l'oeil* painting.

This startling invasion of the viewer's space, with an impact like a fist thrusting out of the canvas, creates a visual drama that appeals to twentieth-century sensibilities as much as it did to those of seventeenth-century viewers. The poster by April Greiman and Jayme Odgers in **Figure B** uses a similar kind of organization to move beyond the frontal plane. As in the Caravaggio, movement into the picture is limited by a flat wall of color in front of which forms seem to fly forward through the air. Separate planes at the lower left and upper right break out of the framing rectangle, appearing to come off the surface of the page.

Another impressively forward-moving space is found in Mary Cassatt's painting, *The Boating Party*, in **Figure C**. There is a violent foreshortening in the angle of the rower's arm and right leg, and a sweeping curve to the boat's upper edge. Standing in front of it, the viewer becomes a third passenger, looking up at the rower and the woman from somewhere in the bow of the boat.

also see: Value Contrast

Making Space

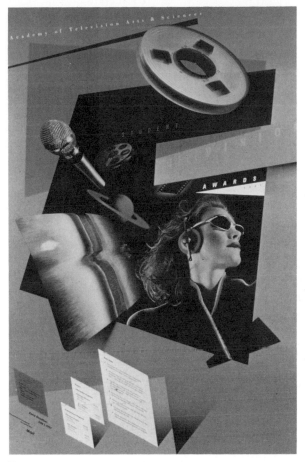

B. April Greiman and Jayme Odgers, *Academy of Television Arts and Sciences Student Television Awards*, 1981. (Courtesy of April Greiman, Inc., Los Angeles)

C. Mary Cassatt, *The Boating Party*. 1893-94. (National Gallery of Art, Washington, D.C.; Chester Dale Collection)

Enclosed Space

A. Joseph Cornell, *Shadow Box*. Mid-1950s. (The Hirshhorn Museum and Sculpture Garden, Smithsonian Institution, Washington, D.C.)

Enclosed space, the sense of containment, with its overtones of mystery, its sense of the hidden, intimate, and private, has always had a special fascination for the viewer. Artists have found many ways of using enclosed space expressively.

Literal enclosure is the theme of Joseph Cornell's construction in **Figure A.** In this small box, ordinary objects take on an unexpected importance and relate to one another in unexpected ways. Form echoes form without regard to scale. The enclosed world in the box seems to refer to the most enormous spaces.

But enclosed space can be more than a box. Enclosure is also the theme of Van Eyck's painting in **Figure B.** Depth is progressively and gently fenced in. The high viewpoint closes off the picture, eliminating sky, cutting off the horizon, cradling the figures in a ball of space. The figures are enclosed again by the curved wall, which embraces a smaller volume of space. Finally, the figure of the Virgin is framed, enclosed, in the rectangular doorway and arched portal of the church. The interior space behind her is closed off by shadow and a heavy wall, and the space in front of her limited by the angel with his outstretched wings. The enclosure here seems protective and intimate.

Tina Modotti's photograph, *Number 30/Staircase*, in **Figure C** uses diagonals, light to dark gradients, and a composition that rotates like a snail shell around its center, to move the eye from larger foreground units to smaller background ones. Here, the sense of enclosure is created by the composition turning in on itself and contrasts with the openness beyond suggested by the light.

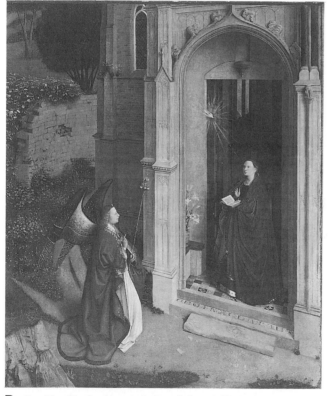

B. Jan Van Eyck, *Annunciation*. (Metropolitan Museum of Art, New York)

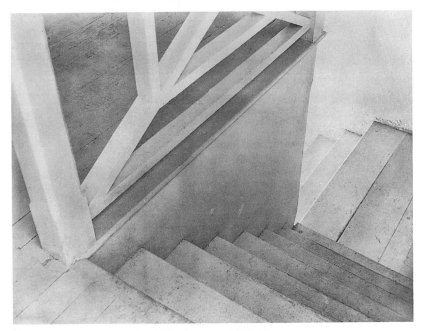

C. Tina Modotti, *Number 30/Staircase*. c. 1923-26.
(Collection, The Museum of Modern Art, New York;
Given anonymously)

In the Carolingian ornamental letter in **Figure D** the sense of enclosure doesn't result from framing, nor do the forms seem to rotate around a single central point. Here there are many levels of enclosure. The muscular curve of the large initial, like a living thing, seems to sense its own limitations, and turns in on itself when it reaches the edge of the page. The initial itself is a treasure chest of compartments and smaller compartments.

A page of this kind was intended as an object for slow meditation, able to stand up to a long look. Even a modern viewer, accustomed to the parade of colors and shapes found in any magazine, is sucked in to the richness of this design, an endless and self-contained feast of visual experiences.

also see:	The Edge
	The Pictorial Box
	Size/Scale Relationships
	Monumental Scale
	Intimate Scale
	Arabesque

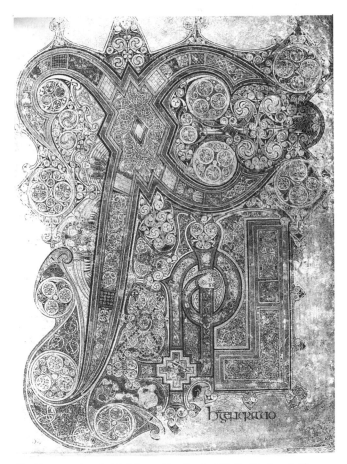

D. Incarnation initial from the *Book of Kells*. Early ninth century. (The Board of Trinity College, Dublin)

55

Open Space

Thermo Electron Corporation Annual Report Year Ended June 27, 1981

A. Thomas Laidlaw and Michael Weymouth, *Annual Report Cover for Thermo Electron Corporation.* 1991.

Visual elements can be organized to create a sense of unenclosed space, space that seems to continue beyond the boundaries of the page.

Thomas Laidlaw and Michael Weymouth's cover design for an annual report in **Figure A** effectively evokes this kind of space, suggesting a small slice of a much larger system. The edges of the page are de-emphasized, while heavier dark bars lead the eye in from the left and off the page on the right. Unenclosed space encourages the viewer to imagine a larger world outside the page.

The Japanese painted screen by Ogata Korin in **Figure B** describes a similar, unenclosed, picture space. The flowing stream moves through and across the picture, and continues on its longer journey. This kind of composition, in which the endless format of the picture scroll is continually unrolling from left to right, is common in Eastern art.

Both of these examples are essentially unenclosed two-dimensional spaces, compositions of unbounded flatness. Pieter Bruegel's landscape in **Figure C** is an unenclosed deep space, a generous three-dimensional construction of panoramic distance. The eye travels, unobstructed, until it is lost in the infinite depths of the heat haze on the horizon. Rather than a pictorial box containing the three-dimensional structure of the picture, this is a picture in which space dissolves into distance, and distance dissolves into light.

also see: Isometric Perspective

Space & Volume

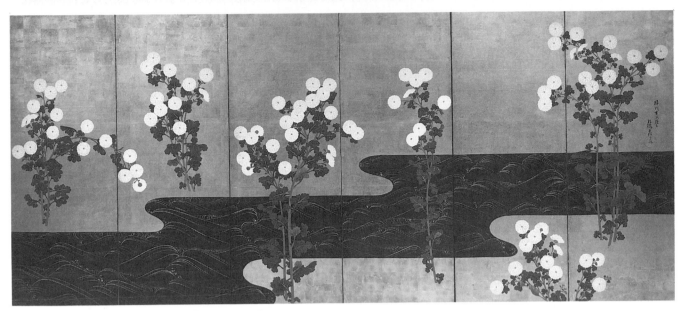

B. Ogata Korin, *Chrysanthemums by a Stream*. Japan,
Tokugawa period, 1653-1716. (The Cleveland
Museum of Art; gift of Hanna Fund)

C. Pieter Bruegel, *The Harvesters*. (The Metropolitan
Museum of Art, New York; Rogers Fund, 1919)

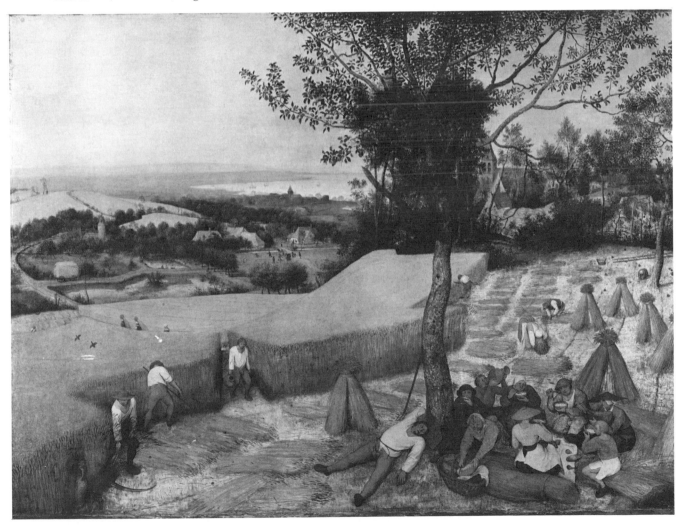

Packed Space

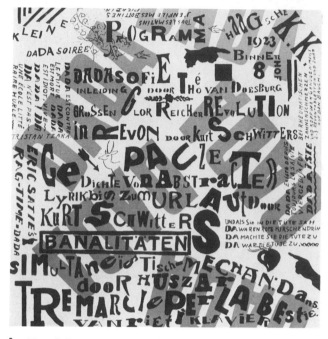

A. Kurt Schwitters and Theo van Doesburg, *Kleine Dada Soiree*. 1923.

Some of the most effective and dramatic images are crowded with forms. When the picture space is packed with shapes, colors, and textures, the visual overload can be expressive.

Kurt Schwitters's flyer, in **Figure A,** for an evening of Dada poetry and performance is just such a packed space. The letterforms, jammed together on the page, create a visual image that captures the gleeful anarchy of an evening at a Surrealist nightclub.

Figure B is a tapestry that tells many stories. The space is packed with figures, dramatic details and visual events. The artist is intent on getting more and more in so that the resulting image is dense with activity. While the framing may help in organizing this cornucopia of visual information, it does not relieve the crowding. If anything, it increases the sense of compression. Costumes rich in texture and patterns, embellished with silver and gold threads, add to the feeling of visual abundance. Here crowding moves to another level and becomes an image of opulence and splendor.

In Lee Stolier's relief sculpture in **Figure C** the spaces are packed with swollen forms, expanded according to their importance in the visual drama. The heavy framing seems barely able to contain the pressure of this composition. Space is replaced by volume that fills it, and even the figure of the sleeping man on the right becomes an active, undulating form. Details are transformed into important characters in the visual drama. Objects are eroticized and enlarged until they seem about to explode.

In each of these examples, the artist has loaded the space in a particular way. Schwitters relies on the subtle vertical-horizontal grid that underlies the seemingly casual scattering of letterforms. The tapestry maker loads texture, pattern, and volume into the design. Stolier expands volumes until they threaten to burst the frame.

also see: Texture

Directed Tension

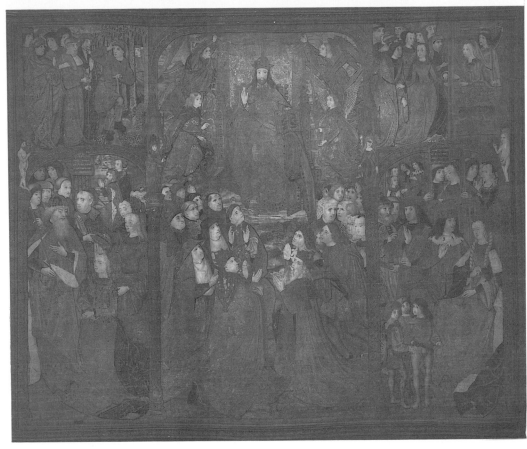

B. *The Triumph of Christ.* Tapestry. c. 1650 (The
National Gallery of Art, Washington, D.C.)

C. Lee Stolier, *Feeder.* 1988.

Empty Space

A. Jacques-Louis David, *Death of Marat*. 1793. (Musée Royaux des Beaux-Arts de Belgique, Brussels)

Empty space may seem like a nonquality, something that isn't there, but dealing with it requires a knowledge of the visual field, an understanding of special properties and visual tensions built into different areas of the surface, and a sensitive and intuitive eye.

Emptiness is essential to the expression of the subject in David's *Death of Marat* in **Figure A.** The upper part of the rectangle, conspicuously void of anything except the slight vibration of small, even brushstrokes, creates an eloquent visual silence that hovers over the dying figure.

Alina Wheeler and Charles Menasion use emptiness in an entirely different way in their design in **Figure B.** A generous white space creates a feeling of openness and airiness that reinforces the image of the airborne kite. At the same time, the type and photographic elements are placed so that empty space is consciously shaped. The rectangle is carefully split by the diagonal kite string to form two facing, similarly shaped areas, and blocks of type are gracefully positioned near the edges of the page.

In the painting by Georgia O'Keeffe in **Figure C** the vast empty space is not empty at all, but rather a volume filled, not with objects, but with the delicate vibration of light and the exhilarating sense of distance uninterrupted. Emptiness here allows the richness of black to speak without being laid over form. We experience something of what we see in the night sky, but are reminded as well of the space of the white page referred to earlier, no longer blank.

Emptiness, then, can be expressively shaped. It requires a sense of interval and proportion. The spaces left untouched in an image can be as important as the objects that fill it.

also see: Making Depth Happen: Overview

Figure & Ground

Mark Making

Space & Volume

Making Space

Balance

B. Alina Wheeler and Charles Menasion, *Pennsylvania Hospital Annual Report Cover*. 1982. (Courtesy of the designers)

C. Georgia O'Keeffe, *Wave, Night*. 1928. (Addison Gallery of American Art, Phillips Academy, Andover, Mass.; gift of Mr. Charles L. Stillman)

5 Surface & Space Together

Vanishing-Point Perspective

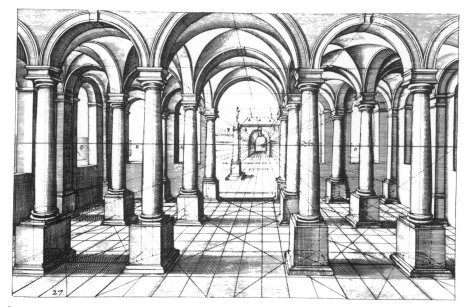

A. Jan Vrederman de Vries, Plate from *Perspective*.1604-5.

Vanishing-point perspective is a system, a set of rules for drawing that enables an artist to create an illusion of deep space on a two-dimensional surface. Essentially, it provides an orderly way to create size changes as forms move into the distance. All of this is based on an imaginary viewpoint and therefore an imaginary viewer.

Because visual art is viewed through eyes that have been, to a large extent, conditioned by this system, it is useful to stop and look at vanishing-point perspective again, examine its assumptions, and ask what really happens in a drawing organized in this way.

Most art students are familiar with the basic principle. Lines that are parallel in the real world are drawn on the two-dimensional page as converging lines that meet at one or more points, which we call *vanishing points*. The angle of a line in relation to the vanishing point can make objects (especially cubic forms) seem to march neatly into the distance, as in **Figure A.** The effect is powerful and, if used without some thought, a little mechanical.

What else can this system do? Perspective allows us to see a shape in many different ways.

For example, a rectangular tabletop may become any one of the shapes shown in **Figure B** and many others, without losing its identity as a rectangle. This enlarges the vocabulary of shapes available to the artist.

Using vanishing-point perspective, an artist can put the viewer in a specific place, creating the impression that the picture is being viewed from one eye level and position, and the effect can be quite dramatic. In Piero della Francesca's *Flagellation* in **Figure C,** the viewer sees the scene from a low viewpoint, looking up. The figures in the foreground loom

B.

62

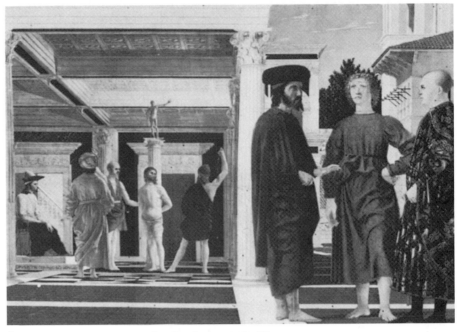

C. Piero della Francesca, *The Flagellation*. 1456-57. (Galleria Nazionale delle Marches, Urbino)

up like the columns behind them. The action itself, the violent theme of the picture, is a distant event caught in a still web of visible and invisible diagonals radiating from hidden vanishing points.

At first glance, perspective used in this way looks foolproof, as clear as a well-worked-out math problem. But even a perspective drawing done according to the rules has certain built-in problems.

A difficulty arises in that perspective distorts shapes in the foreground and at the edges of the design. In **Figure A,** the squares that mark out the floor begin to lose their squareness as they get nearer to the edges. The bottom row and the extreme left and right rows are stretched out into rectangles. Imagine what these squares would look like if the drawing was wider and deeper.

Another limitation is that vanishing-point perspective works best with square and cubic forms. When applied to nongeometric forms, like figures, the results can be a little stiff. Luca Cambiaso's drawing in **Figure D** reshapes bodies into simple mannequins to be able to construct them, robotlike, in perspective.

One more problem has to do with the way seeing happens. Walking down the street, you turn your head from left to right as you move along. Vision constantly knifes outward to investigate the world all around, like spokes radiating from the hub of a wheel. Vanishing-point perspective does the opposite. It makes you focus on one point, creating a tunnel that draws the eye inward to a single point in the distance. An early engraving by Albrecht Dürer in **Figure E** shows an artist, using a perspective aid, tracing a model's outline on a sheet of glass while

D. Luca Cambiaso, *Martyrdom of St. Lawrence.* Before 1581. (National Gallery of Art, Washington, D.C.; Ailsa Mellon Bruce Fund)

63

E. Albrecht Dürer, *Draughtsman of the Sitting Man*. From *A Course in the Art of Measurement with Compass and Ruler*. 1527. (Library of Congress, Washington, D.C.; Lessing J. Rosenwald Collection)

G. Pieter Saenredam, *Interior of St. Odulphus' Church at Assendelft*. 1649. (Rijksmuseum, Amsterdam)

F. Rackstraw Downes, *The View from Morningside Heights*. 1977. (Private collection, courtesy of the Kornblee Gallery, New York; photo by Robert Brooks)

looking, with one eye only, from a fixed point at the opposite end of this visual tunnel.

This natural, shifting curve of vision is seen in the painting by Rackstraw Downes in **Figure F.** The center of the picture appears to be laid out as a proper perspective construction, but the issue is then forced by the stretched-out shape of the rectangle, which includes the far left and right, the problem areas of perspective vision. The space that Downes works out curves gently at the edges and conveys something of what it feels like to scan a landscape from left to right.

We see with two eyes. What is called *binocular vision* is actually the combination of these two slightly different viewpoints. You can demonstrate this by closing first one eye and then the other while staring at a near object. As you blink from your left to your right eye, you will see the object shift back and forth. Perspective cannot account for such things.

In general, the use of vanishing-point perspective tends to create more visual weight at the bottom of the picture plane. In most simple perspective drawings, the foreground, filled with larger forms, is at the bottom. As the eye moves up the page, it is drawn toward the smaller forms of the background.

Any number of strategies can modify this imbalance: tall forms in the foreground to fill the upper area of the picture plane, very large forms in the background, a low vanishing point or a strongly horizontal format, an empty foreground and a crowded distance, even a conscious distortion of sizes, would all tend to diminish the overloading of the bottom. Sensitively and appropriately used, vanishing-point perspective can be the means for constructing spaces of mathematical clarity and grace, three-dimensional grids filled with air, as in the painting by Pieter Saenredam in **Figure G.**

Vanishing point perspective is one of the many systems that may be limiting or may be a stimulus for inventive thinking. Perspective systems can always be adjusted, fine-tuned, and even fudged to address these built-in problems; most artists discover that the rules must be broken, or at least bent a little from time to time, but the attractions of perspective are many.

Isometric Perspective

In contrast to the vanishing-point perspective familiar to Western eyes, the perspective system most commonly found in Eastern art—in China, Japan, and India—is *isometric perspective*, a system of linear perspective without a vanishing point, in which things do not get smaller in the distance.

Isometric perspective also favors straight edges and geometric forms, but its basic principle is that lines or edges that are parallel in nature remain that way in the drawing. Parallel lines do not come together at a distant point. A cube drawn in isometric perspective feels entirely different from one drawn in vanishing-point perspective (**Figure A**). Objects appear to be always the same distance away from the viewer, whether they belong to the foreground, middle, or background. This ambiguity is often reinforced by a flatness in the painting itself, a de-emphasis on modeling, light and shade, and cast shadow as we see in the Japanese landscape in **Figure B**.

The idea of viewpoint is treated differently as well. There is no single viewpoint. Instead, the viewer floats above the scene, seemingly able to see everywhere, equally well, at once. The space seems to be infinite as the eye moves up, down, and across, but it is also flatter; it seems to move forms sideways in a zigzag rather than into the picture.

This flatter space allows for an easy interaction between the two-dimensional surface and the three-dimensional feeling of space. It constantly acknowledges the flatness of the picture and returns the eye to the picture plane and the rhythms moving across it. For this reason, the logic of isometric perspective has been a preferred device of many modern artists working in ways that emphasize surface over deep space. The magical quality of isometric perspective that allows near and far to alternate is gracefully exploited by Milton Glaser in his poster in **Figure C**.

B. *Battle of Genji and the Heike*. Detail from Japanese painted screen. (The Metropolitan Museum of Art, New York; Rogers Fund, 1957)

C. Milton Glaser, *One Print, One Painting*. 1968. (Courtesy the Library of Congress)

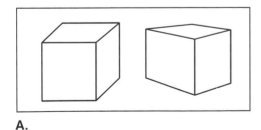

A.

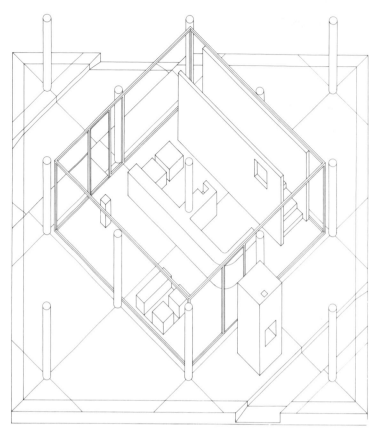

D. John Hejduk, *Project A: House; Axonometric Drawing of Ground Floor*. 1967. (Courtesy of the artist)

The image seems both deep and strangely flat; front and back reverse, and forms are drawn apart at the same time that they are pulled together.

Isometric perspective is also much used by architects, for the practical purpose of presenting a clear overview of the sizes and positions of spaces, rooms, corridors, and so forth. The isometric system distorts shape less than vanishing-point perspective does. Look back at **Figure A.** An isometrically drawn cube keeps the parallelness of its edges; parallel lines do not become converging lines. Rooms of the same size stay the same size on paper rather than getting smaller as they approach a vanishing point. The drawing by John Hejduk in **Figure D** is an elegant example of a finished isometric architectural construction. It is also a beautiful and delicate composition in space.

also see: The Picture Plane

Open Space

Surface & Space

Surface & Space

Designing on a surface can be done in different and complementary ways. Imaginary space can be organized behind the picture plane, creating a feeling of depth through size change, perspectives, shading, and so forth, and, at the same time, shapes can be manipulated on the flat surface itself, a field of forces that we subdivide into smaller areas of line, tone, and color.

Imagine, first, that three-dimensional space rides on a horizontally placed wheel, turning into and out of the distance, from near to far to near again, like a carrousel. Alternatively, two-dimensional space can be visualized as a ferris wheel viewed from one side, a flat circle slowly rotating across, from bottom to top, always at the same distance from the viewer (**Figure A**). Combining these two images, we might form a third, the two kinds of space seen at once.

Artists have always worked with both of these visual models. For example, painters who have built compositions in a deep box of space have, at the same time, carefully composed the surface. Sometimes

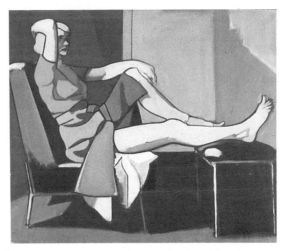

B. Leland Bell, *Ulla at the Cite des Arts (I)*. 1978. (Collection of Shelley and Chris Dark). (Photo courtesy of Salander-O'Reilly Gallery, New York)

doing this involves using three-dimensional elements to create two-dimensional movements across the surface of the picture. Leland Bell's monumental painting in **Figure B** shows a convincingly three-dimensional figure, made more sculptural by the strong contrasts of light and dark. At the same time the picture is organized with a strong side-to-side movement. The main axis of the figure sweeps horizontally from left to right rather than from foreground to background. The profile of the furniture is emphasized, adding to the play of flat, rectangular shapes in the composition. A flat wall behind the reclining woman further limits the depth.

Perspective systems affect the surface in their own special ways. **Figure C** demonstrates how different vanishing points and eye levels create perspectives that divide the surface into different-sized and -shaped zones. Varied though they are, these shapes all share some characteristic qualities—tapering, focusing, and digging into the depth.

Isometric perspective creates a space that is flat at the same time that it is deep. It also allows subdivisions to move evenly across the surface rather than in the focused tunnel of vanishing-point perspective (**Figure D**). Such spaces suggest quite different possibilities for surface composition.

Artists have invented numberless strategies to link the depth of the page with its surface. Sometimes these linkages can be so casual looking that we may not notice how controlled they are. In Paul Cézanne's view of Mont Sainte-Victoire in **Figure E,** a generous

A.

C.

D.

E. Paul Cézanne, *Mont Sainte-Victoire*. 1886-87.
(The Phillips Collection, Washington, D.C.)

F. Alina Wheeler and Charles Menasion,
Pennsylvania Hospital Annual Report, 1982.
(Courtesy of the designers)

landscape space is laid out. As the eye moves into the depth of the picture, from the foreground at the bottom edge, across the valley floor that fills the center of the image, to the mountain and finally the distant sky at the top, it runs into a piece of the foreground again, a pine branch overlapping the deepest point in the picture. Cézanne reinforces this link between foreground and background by another means. The up-and-down curve of the mountain range is repeated by the gentle bend of the tree branch. Background (depth) and foreground (surface) are made to rhyme.

In the paintings by Bell and Cézanne, and in the perspective constructions, an effort is made to harmonize two dimensions with three-dimensional illusion. Sometimes, however, an artist has to design two- and three-dimensional elements that are clearly separate, that answer one another in a kind of visual counterpoint. The page layout by Alina Wheeler and Charles Menasion in **Figure F** is an example. Photographs create three-dimensional windows into the page, which contrast with the flattened right-to-left movements generated by columns of type and headlines. The combination also creates a pattern of lighter and darker shapes across and up and down the page, a flickering arrangement of solids and voids, contrasting sizes and type weights, combined with an orderly and legible look.

In the end, regardless of the medium or function of a work of art, the goal is always to seek an appropriate balance between surface and space, just as we seek one between tension and equilibrium, between the formal and the real, between the subjective and the universal.

also see: The Picture Plane

The Pictorial Box

Vanishing-Point Perspective

Isometric Perspective

Space & Volume

6 Scale & Size

Overview

A. Pyramid of Cheops at Giza, Egypt. c. 2570 B.C.

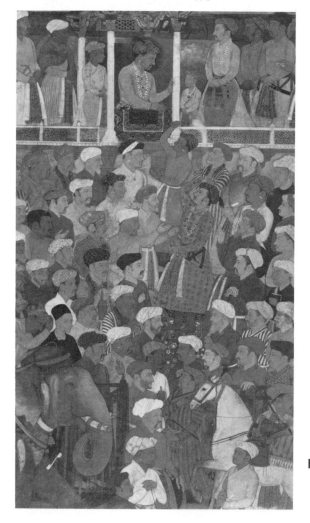

B. Darbár of Jahāngīr, from a Jahāngīr-nāma manuscript. *Mughal School*, c. 1620. (Courtesy, Museum of Fine Arts, Boston; Francis Bartlett Donation of 1912 and Picture Fund, 14.654)

The words *scale* and *size* are often used interchangeably, but the two terms have subtly different meanings. It is important to understand the difference between the actual size of a work of art and the scale, the *feeling* of largeness or smallness that can be conveyed by a page in a book or by a skyscraper.

Real size, large or small, can be impressive. The pyramids at Giza (**Figure A**), mountainlike avalanches of stone set in an enormous open space, are an unforgettable symbol of royal power. The miniature intricacy of the Indian Painting in **Figure B,** draws the eye in and concentrates attention. When artists work at extremes of size, the results can be startling.

But size can affect us in other ways as well. A seven-foot-tall number (**Figure C**) is not just a small thing magnified: Its character is changed. Rather than being just another number, this nine seems more like architecture than print.

In part, our sense of big and small is related to our own size. Consciously or not, we often use our own bodies as rulers. Objects bigger than we are may seem large, those smaller, small. But it is not as simple as that. There are also visual habits to be taken into account, expectations about the normal sizes of familiar objects. An ordinary housecat seems neither large or small, but a cockroach the size of a cat would be a monster. A twenty-inch-wide flower may be called enormous, but a tree that size is obviously tiny.

Scale is another matter. Something is said to have a large or small scale not so much on the basis of its real size, but on the feeling of space that it seems to project. A small design may give an impression of bigness and open space, as does the little painting by Albert Bierstadt in **Figure D.** At the same time, a huge form may be small in scale. The

skyscrapers in **Figure E,** viewed in the context of surrounding buildings, reminded one viewer of over-sized packages of staples, curiously out of scale with everything else.

Art students in particular have to be aware of this distinction between size and scale when they turn the pages of books, like this one, full of reproductions. Photographic reproduction takes works of art that are wildly different in size and remakes them, uniformly, at snapshot size. The Great Pyramid and the ivory book cover on these pages each come from a different universe of size, but here, in a book, they become similar. Reproductions, useful though they are, blur these critical distinctions. Scale, on the other hand, is built into a design and remains even when size changes.

also see: Structure & Scale

Biases

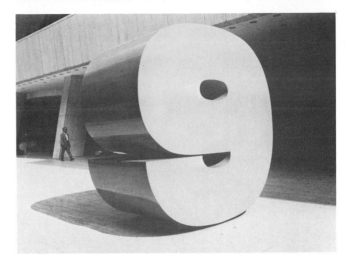

C. Chermayeff and Geismar Associates, *Nine 57th Street, New York.*

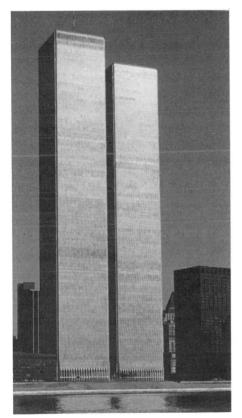

E. Minoru Yamasaki, World Trade Center Towers.

D. Albert Bierstadt, *Scene in the Tyrol.* 1854. 9 ½ × 13" (Hirshhorn Museum and Sculpture Garden, Smithsonian Institution, Washington, D.C.)

Scale/Size Comparisons

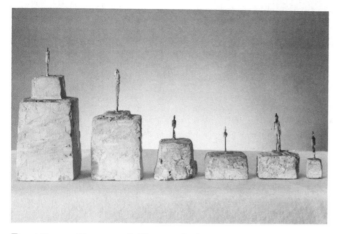

B. Alberto Giacometti, Six untitled miniature figures, c. 1945. (Museum of Modern Art, New York). Gift of Mr. and Mrs. Thomas B. Hess.

C. A. M. Cassandre, *L'Atlantique.* 1931.

One of the several ways in which we determine the size of things in our own minds is by comparing them with other, like or adjacent things. When we say, "That woman is tall," we mean tall compared with most other women. To say, "The Great Pyramid at Giza is huge" is to say that it is bigger than most other forms in its visual environment; it's quite small compared with a mountain. If we could imagine the pyramid floating alone in an outer space without stars or planets, then it would have no size; it would be neither large nor small, because there would be nothing else with which to compare it.

Judgment of relative size in a work of art is made in the same way. A shape, letterform, or color area is seen as part of a web of relationships and size comparisons within the work, and so a work of art establishes its own scale. In **Figure A,** the size of the central shapes remains the same. They seem different, have a different scale, because in each case we see the shape in relation to its surroundings. Whether looking at a drawing a few inches high or an image the size of a billboard, the size comparisons that are set up within the work create the sense of scale.

Alberto Giacometti's sculpture in **Figure B** is so tiny it carries around its own spatial context in an unlikely way. The figure itself is a mere inch tall and to focus on it means to put everything around it, literally, out of focus, a little like what happens when you thread a needle. In this context of a kind of nonspace, Giacometti's minuscule figure takes on the proportions of a monument.

The contrast between the tiny tugboat and the looming hull that seems to swallow it evokes the huge scale of an ocean liner in A. M. Cassandre's poster (**Figure C**). This is strongly felt despite the size of the reproduction in this book and without knowing the size of the original. Similarly, Piranesi contrasted antlike humans with the cavernous spaces of imaginary architecture to create colossal scale in his etching in **Figure D.**

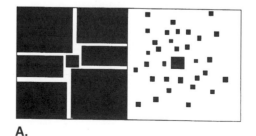

A.

The central importance of size comparisons, for establishing scale becomes clear in James Rosenquist's painting in **Figure E.** In it, there is deliberate confusion about size. Every object is given its own size, independent of its neighbor. Normal size is abolished, and the usual comparisons between objects no longer seem to work.

Thomas Eakins uses ordinary expectations about size to create a strange size and scale displacement in his portrait in **Figure F.** The intricate scribblings and notations of the scientist have been enlarged in the wide painted frame that encloses this seven-foot-tall picture. The discontinuity in scale is startling and arresting, counterposing the active and complex inner workings of the professor's mind as revealed on the frame, with the matter of fact presentation of the portrait.

D. Giovanni Battista Piranesi, *The Prisons* (plate 10). 1720-78. (The Metropolitan Museum of Art, New York; Harris Brisbane Dick Fund, 1937)

E. James Rosenquist, *Farenheit 1982 Degrees.* 1982. (33¼ × 71¾") (Collection, The Museum of Modern Art, New York; gift of the Lauder Foundation)

F. Thomas Eakins, *Professor Henry A. Rowland.* c. 1897. 82½ × 53¾". (Addison Gallery of American Art, Phillips Academy, Andover, Mass.; gift of Stephen C. Clark)

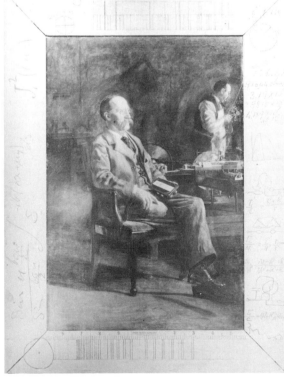

also see: Relationships
Enclosed Space
Packed Space
Empty Space

Structure & Scale

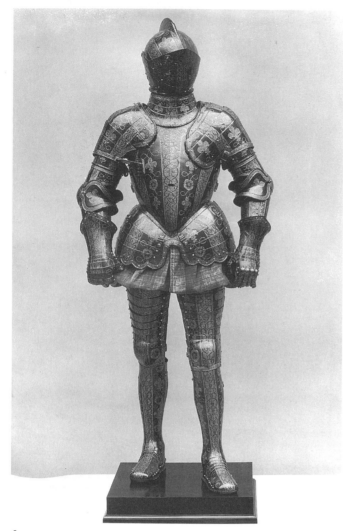

A. Suit of Armor for Sir George Clifford. c. 1590. (The Metropolitan Museum of Art, New York; Munsey Fund, 1932)

Scale is built into objects in several ways. We can look at most forms and images both in terms of a larger structure, the masses that are seen first, at a glance, and in terms of the small structure, sometimes called *microstructure*, made of details, textures, and small forms fitted together. The sixteenth-century suit of armor in **Figure A** uses the human body to articulate both a large and small structure. Each segment of the body is smoothed out and simplified, then outlined by the metal seams, edges, and rivets. Each subsection—arms, torso, legs—is broken down further, into smaller compartments, and each of these, in turn, contain tiny units of decorative pattern and shape. The whole thing has the organic logic of a tree, in which the eye goes from larger to smaller and more intricate forms, trunk to limbs, to branches and twigs. The secondary structure of delicate ornament doesn't correspond to the kinds of details found on a human body, but it does follow logically from the same large structure.

In a tiny painting only a few inches tall, Jean Fouquet develops a large structure clear and orderly enough to allow him to describe a huge vista (**Figure B**). Arranged in horizontal bands, the space moves in a stately way back to a distant horizon. At the same time, Fouquet builds a substructure of smaller and smaller forms that makes the journey through this space an adventure full of discovery.

An emphasis on the small structure of things, the detail within the whole, tends to bring the viewer closer, make the audience a participant in the action. Things seem smaller; we, viewing them, seem to play a more important role in what's going on.

When the large structure of things is emphasized, forms themselves take on greater importance, and we become spectators to a public event. Monumental forms like the pyramids have a silence and distance that seems oblivious of any audience.

Of course few works of art are only about big structure, all initial impact with nothing for the viewer to discover after the first moment. Such a work would lose our interest too quickly. A work that was all small structure, all detail with no larger organization, would be tedious as well. Most works of art balance the big structure that "grabs" the eye, and the smaller forms and relationships that "keep" us engaged. Where that balance is found depends on the nature of the artist and the intent of the work. A poster for the subway might want a strong and unified visual impact. A book illustration might allow the viewer to untangle its structure more slowly.

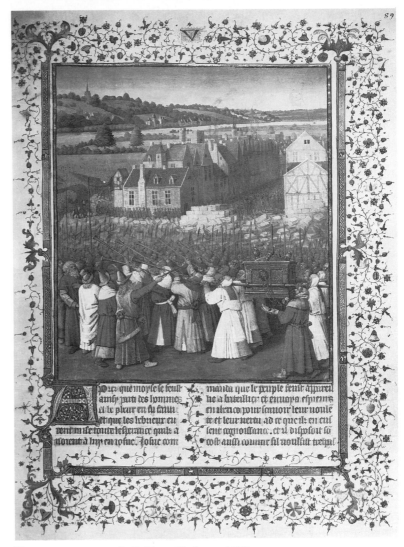

B. Jean Fouquet, *The Taking of Jerico*, c. 1470.
(Bibliotheque Nationale, Paris)

Proportional Systems

A. John Tenniel, *Alice with a Long Neck*. (From *Alice in Wonderland*)

B. Amedeo Modigliani, *Chaim Soutine*. 1917. (National Gallery of Art, Washington, D.C.; Chester Dale Collection)

Proportion is about size differences. It refers to the relationship between different sizes and shapes in an image, and how these differences fit into the whole structural pattern.

For example, when Alice grows a long neck in Wonderland, it could be said that her neck is "out of proportion" when compared with the rest of her body (**Figure A**). The system of proportion that suggests this is the familiar one that applies to the bodies of most human beings. Alice's neck here seems to be governed by some law of growth different from that which governs the rest of her body. A long neck in the painting by Modigliani in **Figure B** is, instead, part of a general stretching that operates throughout the whole picture, and so we accept it; it fits in with the elongated proportions of the whole. Proportional systems allow for the creation of differences and variations in the size of things based on a consistent set of rules.

Such systems are based on simple numerical ratios that can be strung together, halved, or multiplied to grow complex combinations of form. What is not clear, however, is *which* numbers will result in "good" proportions. The Greeks often used a ratio, sometimes called the *Golden Section*, in which a small line is to a larger line as the larger line is to the sum of the two. This proportion can be seen in **Figure C** where line A is to line B as B is to the sum of A and B.

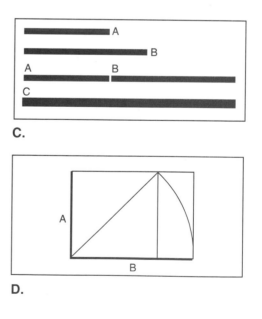

C.

D.

A Golden Section rectangle in which height and width follow this proportion can be made by drawing an arc with a compass from the diagonal of a square (**Figure D**). The Greeks thought it worth the trouble, because the rectangle formed that way had, for them, just the right amount of height for width. Something as simple as a rectangular doorway or as complicated as the sculpture of a man in **Figure E** could be designed using this proportion. The length of this torso relative to the length of the legs, for example, was probably worked out according to the Golden Section. For the Greeks, numbers were the unifying understructure of the world, and could be used in carving a nude or figuring out the height/width ratio for a temple. Compare the proportion in this figure with the one in **Figure B** and imagine a temple built to Modigiliani's proportion.

A different kind of proportional system, based on a square and the rectangle made from two squares, is found in Japanese architecture. The size and shape of the rooms in a classic Japanese house were based on woven floor mats, called *Tatami mats* (**Figure F**), whose long side is twice the short side. Out of this simple proportion, an entire floor plan could grow, based on the number of mats per room.

Probably the most common set of proportional systems, used in many variations today, can be found in the two-dimensional grid, which has the triple virtue of controlling proportion, unifying surfaces, and imparting order on the organic sense of growth in forms.

also see: Grids

Tension & Shape

F.

E. After Polyclitus, *Spear Carrier*. c. 450 B.C. (Museo Nazionale, Naples)

Monumental Scale

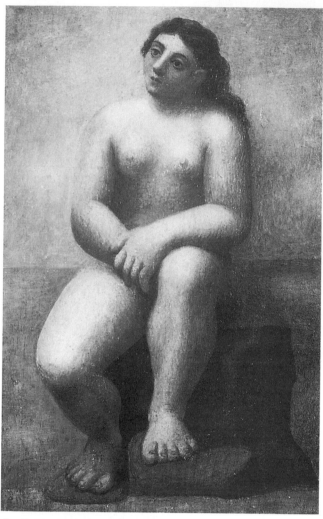

A. Pablo Picasso, *Nude Seated on a Rock*. 1921. (6¼ × 4⅜").
(Collection, The Museum of Modern Art, New York;
James Thrall Soby Bequest)

B. Georges Seurat, *The Stone Breaker*. c. 1884. 6⅜ × 10"
(The Phillips Collection, Washington, D.C.)

Anything seen is recognized first by its large, general organization, whether it is the pointy silhouette of a pine tree or the characteristic posture of a friend coming down the street. As the friend draws nearer, details begin to appear—hair, clothing, small gestures. Smaller and smaller features become visible as forms get closer and as we look more carefully, but a sense of the big, first impression is always retained.

In works of art, impressions of large scale can be created by de-emphasizing detail and emphasizing larger, simpler forms. This can be accomplished even in a tiny work. Pablo Picasso's painting in **Figure A** is slightly more than four by six inches. Here different parts of the body flow smoothly into one another, seams eliminated or hidden. Picasso simplifies the body by editing out the smaller wrinkles, bumps, and folds where he can. This simplification, and the emphasis on roundness, creates a powerful impression of weight and solidity.

Large scale, like large size, can be used to signify importance, to communicate to large audiences and to bridge distances. For example, imagine an actor on a stage trying to perform a simple action, such as drinking a glass of water. If he does it naturally, as he would do it offstage, the audience might not be able to see what is happening. For the action to be visible over a distance, his gestures must become simpler and bigger. The tilt of his arm or head might be exaggerated, or he might arch his entire body.

In the visual arts, this sort of exaggeration can create an atmosphere all its own. The gesture of the figure in *The Stone Breaker* by Georges Seurat (**Figure B**) has the simplified drama of stage acting and the force of pantomime. Detail is suppressed in this tiny painting, and simple forms become massive and powerful.

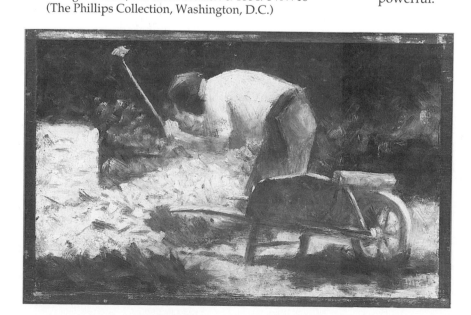

C. Robert Motherwell, *Elegy to the Spanish Republic, 70.* 1961. 69" × 114". (The Metropolitan Museum of Art, New York; anonymous gift, 1965)

A large gesture, with its heroic overtones, can be made in nonrepresentational images as well. Robert Motherwell's painting in **Figure C** is dominated by huge, dark shapes that hover like thunderclouds in the composition, barely contained by the edges of the canvas. One might guess that this is large painting even before knowing its actual size.

A form as tiny as a single piece of type can convey a sense of monumental scale. The typeface in **Figure D** is static and massive looking, as dense and weighty as a line of cinderblocks. The casually graceful typeface in **Figure E** is, by comparison, small in scale, miniature looking, full of delicate and lightweight lines that evoke handwriting.

Monumental scale is no longer restricted to important or heroic subjects. The small and the ordinary can be made available for this kind of treatment. When Georgia O'Keeffe paints a flower three feet high (**Figure F**), it is transformed from something delicate to a composition of powerful and muscular forms, its petals as heavy as blankets and as rhythmic as ocean waves.

Movies, with their ability to enlarge small details and make them visible to the most distant viewer, will sometimes focus on a close-up of the actor's face, challenging our ordinary sense of scale. Something as small as a facial tic, normally visible only to one or two nearby observers, becomes a public monument, visible to a crowd. Advertising has also made oversized images familiar, such as billboard-size soda cans or gigantic hands holding cigarettes. For some modern artists, this technique has suggested new ways to approach subject matter.

also see: Weight

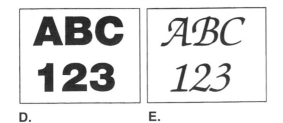

D. E.

F. Georgia O'Keeffe, *The White Flower*. 1931. (The Whitney Museum of American Art, New York)

Intimate Scale

A. Paul Klee, *Around the Fish*. 1926. 18⅜ × 25¾ (Collection, The Museum of Modern Art, New York; Abby Aldrich Rockefeller Fund)

Some art evokes a close-up or private feeling different from the public manner of monumental art. Images can have an intimate scale, a one-to-one relationship with the viewer. Again, a work of art may have this feeling regardless of its size.

This kind of art might be called antimonumental. It may at times tend toward the whimsical or casual looking, in contrast to what is often seen in monumental images. The painter Paul Klee was often fascinated and inspired by tiny things—the pattern of fish scales, forms of seed pods and small plants, tendrils and the wiry forms of growing things (**Figure A**). The private, hand-held size of these forms, observed as though through a magnifying glass, seems suited to the essentially dreamy, secret, and self-absorbed feeling of a charming puzzle.

It is the very casualness of the gestures that lend a feeling of intimacy to the wide, windswept beach in Eugène Boudin's painting in **Figure B**. Intimate scale does not necessarily mean enclosure, but the feeling of informality, fluidity, and impermanence that is generally associated with private rather than public experience.

Camille Corot's painting in **Figure C** treats the viewer to an intimate view of private life. The figure seems deliberately posed, in fact, it conforms to a monumentally simple shape, a triangle. It is the unstudied feeling of the small gestures, the implied reserve of the averted glance, the concentration, the tender attention given to the painting of details of clothing and objects, and the softness of the light that make the viewer feel part of this small but resonant event.

Page design, by its very nature, can lend itself to an antimonumental approach. A book is viewed closely by a single reader, and reading is basically a private activity requiring focused attention. The artist can therefore work with small and fairly complex forms, certain that the viewer will be able to take it all in. Delicate script, complex ornament, and precise forms can work well in this context, as they do in the Mughal album page in **Figure D.** Each succeeding rectangle, framed and reframed, focuses our attention more closely on the central text, and the transition from the world of action described in the hunting scenes along the outer margins to the world of private meditation is made explicit.

also see: Enclosed Space
Geometric & Organic Shape

B. Eugène Louis Boudin, *Beach at Trouville.*7¼" × 13¾". (The Phillips Collection, Washington, D.C.)

C. Jean-Baptiste-Camille Corot, *Italian Girl.* 25⅝ × 21⅛ (National Gallery of Art, Washington, D.C.)

D. Album page, attributed to Aka Riza and Dawlat, India, Mughal. c. 1609. 16⅛ × 10½" (Nelson-Atkins Museum, Kansas City)

7 Shape

Overview: What Shape Is, How It Is Generated

D. Raphael, *St. George and the Dragon*. 1505-6. (National Gallery of Art, Washington, D.C.; Andrew W. Mellon Collection)

Anytime a mark is made, a shape is made at the same time. The shape may be deliberately formed or accidental, but there it is. Easily available and endowed with tremendous power to communicate, shapes have instantly recognizable visual personalities, the result of structures of internal forces, thrusts, and countermovements. Shape can exist independent of object. Viewers recognize the soft and yielding form of an **S** curve before noticing that it belongs to a swan's neck or a model posed in a drawing class.

Shape is a visible record of the way forces are organized on the flat surface. In this sense, it really *is* a universal language. As a trademark, a shape may be used to communicate the image of a corporation. In a print or painting, a shape may evoke a sense of dread or the power of growing things. As a symbol, a shape may give visible form to an action such as running or jumping. In most cases, it is shape itself, more than the object depicted, that communicates the idea.

Shape is generally thought of as something defined by a clear edge, but shape can be seen even where there is no edge at all. In **Figure A**, a shape is visible without outline. The small shapes and marks in the diagram form a pattern of visual forces that group and compress to create a triangle. We see this triangle because shape is generated not by outlines but rather by a *structural skeleton*, the pattern made by

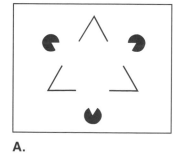

A.

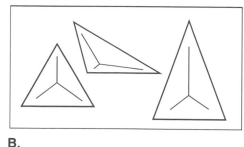

B.

C.

the main structural landmarks. These landmarks in a triangle are the three thrusts that push out in different directions. By changing the force of any of these thrusts, different kinds of triangles can be generated, as in **Figure B.** The outline becomes the skin formed around the structure beneath, but it is the result and not the cause of these internal patterns of force.

Whenever shape appears, whether in diagrams like these or in complicated works of art, visual tension always exists between an inner structure and a skin or outline stretched over that structure. When the skin seems pulled tautly around a stiff skeleton, as it does in geometric shapes, shapes feel hard. When the skin seems instead to bulge and bag over an indeterminate skeleton, the shape seems soft and relaxed. That is why a shape can feel soft despite a crisp, sharply drawn edge or hard even when an outline is blurry (**Figure C**).

A clear shape can be seen, also a triangle, in the complicated group in Rapheal's painting in **Figure D.** Here the same configuration of forces as in **Figure A** may be noted, a stable and broad base with a focal point at the top.

The eye and brain work together, organizing the information they receive. Large patterns of force influence the smaller parts. Just as triangularity is easily seen in the complicated outline of a group of figures, shape is recognized with only a minimal amount of visual information. The tendency for the eye to fill in the gaps, to string together separate shapes or lines and see a larger structural pattern, to complete an incomplete pattern is called *closure.*

In the poster by Leo Lionni in **Figure E,** five separate shapes are joined by the eye to form a larger, more complex shape. Seen together, they add up to a figure seated at a typewriter. Both this image, and the lively tensions within each of the five original shapes, can be seen and enjoyed at the same time.

This tendency to see completed shapes is remarkably strong, even where no line defines an enclosing contour at all. Fairfield Porter's drawing in **Figure F** is an image of a landscape broken into six roughly rectangular patches. The divisions are clear enough and each rectangle is far enough away from its neighbor, so that the page almost breaks up into six separate views. The overall image, on the verge of falling apart, knits itself back together again as the eye follows, irresistibly, the long vertical connections of the tree trunks.

also see: Principles
Grouping
Implied Line

olivetti
Lettera 22

E. Leo Lionni, *Olivetti Lettera 22.* 1956. (Collection, The Museum of Modern Art, New York; gift of the Olivetti Corporation)

F. Fairfield Porter, *Study.* (Collection of The Whitney Museum of American Art, New York; gift of Alex Katz. Acq. #77.63)

Simple & Complex Shape

B.

Simple shapes have a structure easily grasped by the eye. In fact, one way to test a shape for simplicity would be to try drawing it from memory. A simple shape will have a clear order to its parts, angles, and directions. It will be remembered at a glance. Simple shapes are often geometric, with an easy-to-see and forceful quality. They may have many parts, but if the parts are arranged on a simple structural skeleton, simplicity will be preserved.

Complex shapes have complex structures. This difference can be seen by comparing the two shapes in **Figure A.** Which would be easier to draw from memory? Each has the same number of sides and angles, yet the one on the left is regular and graspable, with equal angles, lengths of side, and parallel directions. The one on the right describes a more varied and less simple interaction of forces. So simplicity and complexity do not depend on the *number* of parts, but on how they are organized. Simplicity is a quality, not a quantity.

A designer faced with working out a system of signs might use simplified shape, clear and quickly legible, as the vehicle. By fusing simple shapes into configurations representing actions, **Figure B** gives us memorable and instantly understood icons distilled from gestures.

Because a shape is a container full of two-dimensional movements, a more complicated shape contains a more complicated structure of internal thrusts. This complexity, which can bring with it an increased sense of movement, is part of the reason for the continuing interest in the human figure as a subject. In Leland Bell's drawing in **Figure C** it is the richness and variety of complex shape and interaction that dominate. In the more cerebral and simplified forms that Alexander Archipenko (**Figure D**) finds in the body, the same anatomy is reinvented by a Cubist-influenced modernist. In a sense, a living creature is the most interestingly complicated shape of all, a sack of bone and muscle put together differently with every change of position.

A.

also see: Monumental Scale

Intimate Scale

Directed Tension

Modes of Presentation

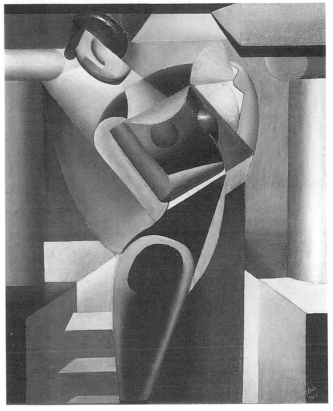

D. Alexander Archipenko, *Woman with Fan*. 1915. (Hirshhorn Museum and Sculpture Garden, Smithsonian Institution; gift of Joseph H. Hirshhorn, 1966)

C. Leland Bell, *Ulla (I)*. 1951. (Photo courtesy of Salander-O'Reilly Gallery, New York)

Positive & Negative Shape

B. Albrecht Dürer, *Construction of the Letter G.* c. 1525.

Whenever a single shape is put onto a flat field, as in **Figure A,** at least two shapes are created. The figure shape is the one placed on the field, (often called a *positive shape*), and the shapes around and between, formed by the rest of the field are called the *negative shapes*. The idea of positive and negative shape is really an aspect of the figure/ground relationship discussed earlier.

In general, people notice only the shapes of objects. They are less aware of the shapes of intervals between things. Obviously, each of these kinds of shapes depends on the other. If the angle of the legs of a model in a drawing class change, so will the shape of the space left between them. Whenever one is changed, so is the other. Sometimes it's difficult to see this mutual dependence because the tendency is to focus so much on positive shape without considering the negative. When negative shapes are *designed*, emptiness is given form. Intervals between things are *created*.

An illustration from Albrecht Dürer's book on the proper formation of letters in **Figure B** gives a glimpse into the way he thought about shaping a letterform. Dürer seems to have worked at least as carefully on forming the negative shapes as on the letter itself. Measurements, subdivisions, and curves are plotted in the space around the character, and in the resulting letter the interior space is beautifully formed.

When negative shape competes for attention with positive shape, interesting double readings can occur. Pentagram's design for a logo for London's National Theatre in **Figure C** is a witty use of this now-you-see-it-now-you-don't effect. It creates a shape that appears to be constantly in motion, not only on its fluid outside edge, but in the flickering back and forth between one reading and another.

Convexity and concavity affect the reading of figure/ground relationships. Swelling outward tends to create positive shape, while shapes whose boundaries curve inward are read as negative shape.

C. Pentagram Design, *National Theatre Logo.* (Pentagram Ltd., London)

A.

D. Henri Matisse, *The White Jabot*. 1936. (Baltimore Museum of Art, Cone Collection)

A drawing made with a bulging outline, like the Henri Matisse in **Figure D,** visualizes form as expanding, actively pressing against the surrounding emptiness. Here, positive shape, the powerful look of a solid volume, a swollen sack of forms covered with a single skin, triumphs over negative shape.

The relationship is reversed in Alberto Giacometti's painting in **Figure E.** Here the surrounding space is not passive and empty but invades the shape of the figure. Negative space filled with brush strokes seems to eat away at the figure, dissolve and overpower it until it becomes a sliver of form surrounded by immensity.

also see: Figure & Ground
The Line as Edge

E. Alberto Giacometti, *Tall Figure*. 1947. (Courtesy of the Pierre Matisse Gallery, New York)

Geometric & Organic Shape

A.

Geometry is a branch of mathematics that deals with measurements, distances, and relationships by turning them into points, lines, planes, and shapes. It is different from other branches of math that deal with the same concepts by turning them into numbers and symbols. Geometry is number given a physical form, made concrete.

All geometric shapes seem to have been made by some process of the intellect. The straight edge, the mechanically smooth curve, and the sharp angle found in geometric shape look deliberate, uncontaminated by accidents, outside of any style, and universally understandable. Even geometric shapes in nature—in seedpods, seashells, or mineral crystals—have a timeless look, as if engineered rather than grown (**Figure A**).

However perfected-seeming, geometry can be made to feel lively and immediate. This was one of the reasons that it appealed to so many artists and designers in this century who were optimistically seeking a universal visual language. In **Figure B,** a painting by the early Russian modernist, Kasimir Malevich, geometry has a legible, clean, and harmonious look. Still, even as the forms themselves seem to be drawn with ruler and compass, their placement in the rectangle seems to be the result of intuitive choice on the part of the artist, and this adds a personal and poetic element to the composition.

The legibility and clarity of geometry can make it appealing to designers whose work often marries geometric letterforms with uncluttered organization of information. Paul Renner's poster in **Figure C** is a good example. The variety of rectangles echo the rectangle of the poster itself. Contrasts, such as the large curves of the **B** against the straight lines of the composition, stand out with the brightness and impact of a traffic signal.

Organic shapes have neither precisely straight edges nor regular curves, and are what people usually have in mind when they speak of natural forms. Even in forms made by nature, it is easy to distinguish what we call organic forms by their lively and less regular shapes (**Figure A**). Organic shapes look grown rather than made. The term *biomorphic* (meaning having a shape that lives) is sometimes applied to shapes of this kind. The gradually changing profile in Jean Arp's *Torso Fruit* in **Figure D** seems to be transforming itself spontaneously. The form appears to expand, contract, and change direction during a process of development and growth. This feeling of having been produced by living forces is part of the fascination of organic shape.

C. Paul Renner, *Fachschulen Bayerns*. 1928. (Kunstgewerbemuseum de Stadt, Zurich)

B. Kasimir Malevich, *Suprematist Composition with Trapezium and Square*. After 1915. (Stedelijk Museum, Amsterdam)

D. Jean Arp, *Torso Fruit*. 1960. (The Hirshhorn Museum and Sculpture Garden, Smithsonian Institution, Washington)

E. Lan Ying, *Red Friend*.
(The Metropolitan Museum of
Art, New York; gift of Mr.
and Mrs. Earl Morse, in
honor of Douglas Dillon, 1979)

Figure E is a painting of a fantastically shaped rock, a kind of form much prized in Chinese art for its complicated shape, and used as part of an ornamental garden. It has been pockmarked and hollowed out by endless bites of empty space; it presents a new and unexpected profile to the eye with every change in the viewer's position. Its strangely evolved shape appears to embody a passage through time, growth, and decay.

The perfected feeling of geometric shape and the lively energy of organic form are made to blend, contrast, and reinforce one another in **Figure F**, a beautiful brush drawing. It is a surprising example of a combination of geometric form with the organic and calligraphic style of Oriental art, an image both casual and perfect.

also see: Monumental Scale

Intimate Scale

Materials & Line Qualities

Straightness

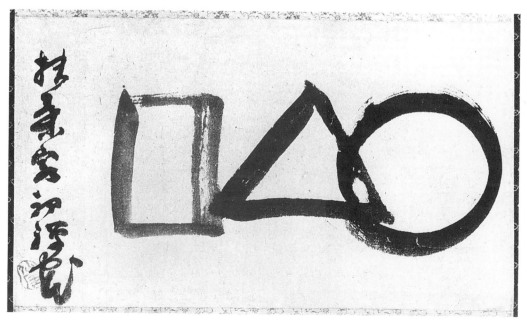

F. Sengai Gibon, *Circle, Triangle, Square*. 1800. (Idemitsu Museum of Arts, Tokyo)

Weight

Visual weight cannot be measured with a scale. Its heaviness or lightness is felt by the eye. Even so, there are some simple principles through which artists can control the sense of visual weight. Squarer shapes seem heavier than rounder ones and regular or geometric shapes tend to look heavier than irregular shapes. In **Figure A,** the circle, square, and triangle seem visually weightier than their more organic counterparts. Symmetrical shapes or arrangements may seem heavier than asymmetrical ones. Darker tones seem heavier than lighter tones.

Compare the weight of Kurt Schwitters's collage composition in **Figure B** with the buoyant feeling created by the Joan Miró in **Figure C.** At the same time, notice the way the dark triangular shape at the bottom of the Miró adds weight and stability to a composition filled with movement.

Notice too that the weight of a shape may be affected by its position in the composition. A shape placed in the center of a field or in the upper part of a composition will seem heavier than the same shape off-center or lower down, so the small square in the upper right of the composition by Schwitters is sufficient to balance the larger one on the lower left, and the small button is able to visually balance the larger round stamp.

Texture and value also affect visual weight. Compare the paler and less ornamented shapes in the Miró or the Schwitters with the darker, more modeled and varied ones. As texture and light-to-dark values move across the shape, we notice an increase in the sense of density and in the feeling of three-dimensionality.

also see: Top & Bottom

Left & Right

Weight of Value

Weight & Balance

Balance

A.

B. Kurt Schwitters, *Merz Drawing.* 1924. (Collection, The Museum of Modern Art, New York; Katherine S. Dreier Bequest)

C. Joan Miró, *Woman and Little Girl in Front of the Sun.* 1946. (Hirshhorn Museum and Sculpture Garden, Smithsonian Institution, Washington, D.C.)

Tension & Shape

C. Geometric forms based on shapes by Ivan Klium, c. 1917.

D. El Greco, *Madonna and Child with Saint Martina and Saint Agnes.* 1597-99. (National Gallery of Art, Washington, D.C.; Widener Collection)

Is it possible to imagine shapes that are simpler than the circle, square, and equilateral triangle? Even complex shapes are often seen as combinations of these simple forms. For instance, a rectangle might be thought of as constructed of squares. Circles and triangles are understood to be built into the shapes in **Figure A.** But for the most part, basic shapes, like primary colors, don't seem to be made of anything but themselves. They have a completeness and a purity, a sense of balanced forces and order that make them, visually, seem to be at rest.

Even so, shapes like these are not necessarily ends in themselves. Geometric shape may be only a starting point. A shape can be bent, stretched, expanded, and compressed to describe a range of sensations beyond the tranquil and pure. By pushing shapes around, the enlivening dimension of visual tension can be added.

This sense of tension is something like what is felt when a rubber band is stretched. There is a tension between the shape of the taut band and the shape into which it wants to relax. Just as the physical sensations of tension and relaxation are understood by the hand, something similar is experienced via the eye. The oval in **Figure B** looks like a circle stretched in one direction. The shape next to it might be interpreted as a square pulled out vertically and at the same time pressed in at its sides. In each of these

A.

B.

shapes we see a force that seems to change or deform a more basic shape, adding tension. When more than one force is at work on a shape, this visual tension increases.

A simple but effective vocabulary of tension in deformation can be seen in the shapes in **Figure C.** We can sense or remember the "normal" shape of each figure, and, at the same time, feel it pushed and pulled. Visual tension results from the several forces that seem to stretch and bend things.

In the painting by El Greco in **Figure D,** a tense transformation of shape is also visible, a stretching out of the proportions of each figure as if some tremendous vertical force were pulling the figures upward. The strange elongation extends through details like the drapery. This distortion of shape is often found in the work of expressionist artists, from El Greco to Van Gogh.

Tension can be an element even in a static design. Vitality doesn't necessarily mean movement. The portrait by Rogier van der Weyden in **Figure E** is quite still, and the expression of the sitter serene. Yet we are struck by the curious elongation of the back of her head, and the way in which that shape is echoed by the similar stretched shape of the neckline of her dark dress. The flat white rectangles of her headdress extend stiffly and at uncomfortable angles creating a pair of long, knife-edged dark triangles hanging down from the top. These, again, are answered by the tense arrows of black formed by the edge of her scarf against her dress. The resulting image is still without being at all relaxed.

Another way of increasing the sense of tension in a shape is by changing its orientation, its position in relation to the vertical and horizontal. The type composition in **Figure F** demonstrates how dramatically the character of a letter can be changed by this kind of distortion as well as by forces of compression.

Looking again at the El Greco, we can see that the stability and clarity of its composition comes in large part from the solid, symmetrical triangle on which it is built. Its base is formed by the heads and shoulders of the two saints and its apex by the head of the Virgin. But that stable triangle is upended in a second triangle that teeters upward from the foot of the lamb. It stands on point, performing a balancing act full of tension. The balance is precarious—it could collapse at any moment—the once stable shape of the triangle is here filled with the potential for motion and change. Other, smaller triangles, tilting at precarious angles, join in throughout the composition adding to a lively and elastic design.

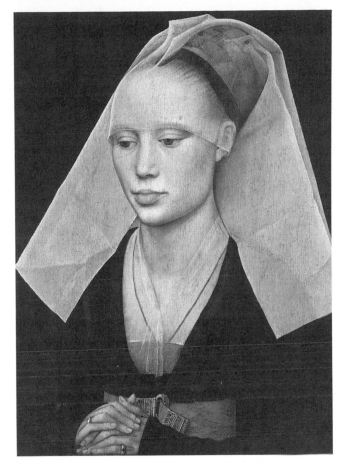

E. Rogier van der Weyden, *Portrait of a Lady*. (National Gallery of Art, Washington, D.C.; Mellon Collection)

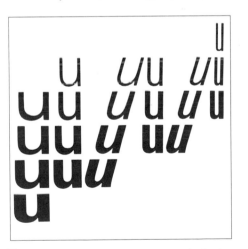

F. Bruno Pfaffli, composition with the letter *u*. c. 1960.

also see: Symmetry

Asymmetry

Proportional Systems

Directed Tension

Harmony & Dissonance

Tension

8 Line

Overview: What Line Is, What It Can Do

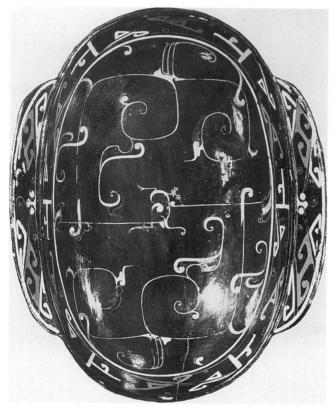

A. Cup with "Ear" Handles, Chinese, late Chou dynasty (1027-256 B.C.). (Nelson-Atkins Museum of Art, Kansas City)

Line, whether long, thin, straight, or curvy, is in many ways the simplest of all the graphic tools. It can also be the most sensitive and useful means of translating thought into something concrete.

As children we all experienced and understood the pleasure of drawing lines. Using them, a frozen record of the arm's motion across a page could be created. This line, sometimes fluid and rhythmic, sometimes choppy and rapidly changing direction, expressed body movement in a two-dimensional language. As lines crossed, one over the other, they even created a magical-seeming illusion of space and volume. By making a line return and connect back to itself like a snake biting its tail, each of us learned that closed shapes suggesting objects could be created and that the surface could be organized and the tangle controlled, by outlining, isolating one part from the rest.

These several needs—to express movement on a flat surface, to define, organize, and contain—are basic and essential to all two-dimensional design.

By itself, line can capture and make sense of a lot of visual information rapidly and simply. It has the marvelous ability to be intimate, direct, and intensely expressive. Drawing lines is the quickest way of visualizing form for most artists, no matter what media they ultimately use to realize the work.

The cliché that there are no lines in nature is a reminder that, more than color or value or texture, line is an abstraction, an invention that allows a mediation between the world as it is seen and its two-dimensional counterpart on a page. We do not have to see a line in nature to find a use for a line in a drawing or design. And many qualities that are called nonlinear can be expressed using line.

Very different kinds of information, from the viscosity of lacquer to the tense balance between the free hand and a controlling pattern, and even the inward curve of a volume are expressed by line in the Chinese cup in **Figure A.**

The agile and responsive line in the drawing by Rembrandt in **Figure B** also does much more than simply outline objects or repeat contours seen on the model. Here line sketches out the big rhythms of the composition and the changes in texture and light. It gives an almost transparent sense of the armature or skeleton inside a form, and can catch the most elusive and fleeting gestures and motions. The line gives life to the drawing, pulsing from thick to thin and enlivening the surface with visual movement.

Beyond this, the line maps out a pattern of forces active in the space and gives clues about near and far. The thrust and counterthrust of shapes, the interpenetration of lights and darks, the shifting feeling of space and movement through it, can all be expressed through line.

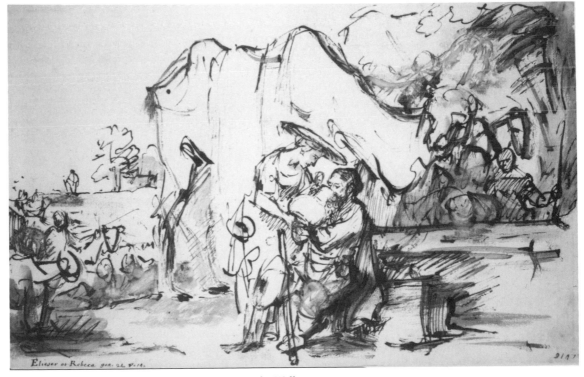

B. Rembrandt van Rijn, *Eliezer and Rebecca at the Well.* 1640s. (The National Gallery of Art, Washington, D.C.; The Widener Collection)

Handwriting

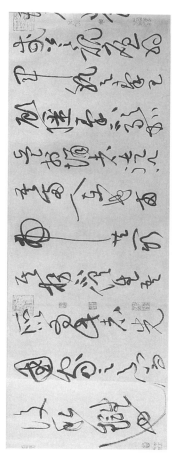

A. Huang T'ing-Chien, *Biographies of Lien P'o and Lin Hsiang-ju* (detail), Sung dynasty (960-1280). (The Metropolitan Museum of Art, New York; bequest of John M. Crawford, Jr., 1988)

A pen, brush, or pencil moving over a page can be like a seismograph, a delicate and precise instrument for recording the tiniest motion or change of pressure in the hand that holds it. More pressure makes a heavier, darker, crisper line. Less pressure makes a lighter, softer line. If the hand moves quickly or slowly, the line will change. All of these changes help to create a line that seems to be inhabited by forces, a reflection of the life of the hand.

The degree of control is part of any artist's style. The penmanship in **Figure A** reflects the quick, lively flow of the writer's hand. It looks very different from the way the same characters might appear if carved on a stone monument, just as your signature looks very different from your name, carefully printed on an application form. As the hand moves more quickly, its natural flow takes over and influences (or even destroys) the individual appearance of each letter. But while the signature might be more difficult to read, it may be more interesting to look at.

Joseph and Melissa Gilbert use the enlivening quality of a handmade and casual-looking line in the poster in **Figure B.** The brush lines flutter down, like windblown ribbons, from the top of the page, a nice contrast to the blocks of type anchored to the bottom edge.

Figure C, a drawing by Lennart Anderson, is a study in control. The line follows the form of the model as closely as possible, and one senses that the changes in its weight and direction are the direct

B. Joseph and Melissa Gilbert, *Bell Gallery, Brown University.* 1982. (Courtesy of the designers)

C. Lennart Anderson, *Male Figure Study for Idylls I and III*. 1977. (Courtesy of Davis & Langdale Company, New York)

D. Jacopo Tintoretto, *Standing Youth with His Arm Raised, Seen from Behind*. (National Gallery of Art, Washington, D.C.; Ailsa Mellon Bruce Fund)

result of the artist's careful observation of the form itself. The action of the hand is subordinated to the description of the form.

In the drawing by Tintoretto in **Figure D,** the motion of the hand becomes more noticeable and less restrained. A series of short, broken curves and dashes, varying from light and ghostly to heavy and muscular, make a sturdily built figure that bulges and ripples with movement.

Finally, in the drawing by Willem DeKooning in **Figure E,** the form of the figure is obliterated by emphasis on the gestural quality of the line. The handwriting of each of these three drawings is entirely different, as unique as a fingerprint or a voice pattern and in each case suggesting something about the artist's attitude toward seeing.

The personal character of line, which we, as children, noticed in those first scribbles, stays visible in the work of mature artists. The intimate quality of a hand-drawn line can create a feeling of informality, a familiar human mark.

also see: Mark Making
Intimate Scale
Overview: Movement

E. Willem DeKooning, *Untitled (Woman)*. 1961. (Hirshhorn Museum and Sculpture Garden, Smithsonian Institution; gift of Joseph H. Hirshhorn, 1966)

97

The Impersonal Line

A. Alexander Calder, "The Catch II." 1932. (The Museum of Modern Art, New York; gift of Mr. and Mrs. Peter A. Rubel)

Sometimes artists will avoid varying the weight of a line in favor of the cooler, more mechanical and impersonal quality of a line of uniform weight. The drawing by Alexander Calder in **Figure A** is built from a wandering line. At first glance it looks as if the hand is strolling almost absently around the page. The drawing is obviously handmade, but the weight of the line is as mechanical and unchanging as a steel wire. Calder did, in fact, use wire to construct three-dimensional forms like the ones in this drawing, and this wirey line draws a connection between his sculpture and his drawing (**Figure B**). It's also a comical image of modern times: an impersonal line used to make a personal and whimsical picture.

The painting by Al Held in **Figure C** goes even further in eliminating the sense of handwriting. There are differences in line weight, but the thickness and thinness are not products of the hand's pressure at all. The line weights here are cooly chosen and executed with ruler, compass, and masking tape. No wandering around is tolerated. The result is an image of powerful clarity and control; the imprint of the body is replaced by impersonal, self-contained forces that move through the canvas in a mechanical ballet.

also see: Mark Making

Monumental Scale

Geometric & Organic Shape

B. Alexander Calder, *The Brass Family*. 1927. (Whitney Museum of American Art, New York)

C. Al Held, *Volta V*. 1977. (Hirshhorn Museum and Sculpture Garden, Smithsonian Institution; museum purchase, 1978)

Materials & Line Qualities

B. Peter Paul Rubens, *Venus Lamenting Adonis.* c. 1612. (The National Gallery of Art, Washington, D.C.; Ailsa Mellon Bruce Fund)

The look of a line is affected by the materials and tools used. Artists have always been able to choose from a wide range of media—ink or paint, heavier-bodied charcoal or pastel sticks, hard and soft pencils, crayons, chisels, and clay—and that range seems even wider today, from dry pigments, soot, and powdered earth to computer-generated lines and laser beams.

The range of available tools is just as broad. Multiply the number of possible media by the number of available tools, and you can see there is a vast smorgasbord of options, as confusing as it is exciting (**Figure A**).

Some materials are more flexible than others. Ink, for example, can be as black as a crow's wing or, mixed with water, can make hundreds of lighter tones; it can be hard and linear, as in the pen drawing by Peter Paul Rubens in **Figure B,** or it can be soft edged and atmospheric as in the Nicholas Maes drawing in **Figure C.**

The material asks to be used in certain ways, and this in turn affects the way the user thinks about the entire work as it evolves and changes. Imagine having to work in mosaic, a medium that cannot be smudged, blended, or made thick and thin. Imagine drawing a line with roofing tar, or with enamel paint thrown off the end of a stick. How much would you be able to control the line, and how much would the medium or tool influence the process, and, by extension, the finished work?

Charcoal is a medium that smudges easily and can be blended from dark to light, from hard to soft edged, from line to tone. It, too, is highly flexible, and skillfully used, can bend to an individual's own style. The drawing by Ernst Kirshner in **Figure D** and the drawing by Henri Matisse in **Figure E** are both made with charcoal on paper. The characteristic look of this medium is recognizable in both, but each artist has developed the drawing differently. Kirshner uses charcoal to make a fat, black, ropelike contour that changes in weight as it slides quickly and decisively around the forms. Matisse uses charcoal to catch subtle changes in light and to make edges so precise they look carved. He sees charcoal as endlessly forgiving, a medium that can be erased again and again.

So establishing the right relationship between the medium and the work becomes a real question. On the one hand, the medium will suggest directions one might take, encourage certain kinds of solutions, inspire new ways of thinking and seeing. Conversely, an artist must find the best medium with which to give form to a particular vision. It is frustrating when the medium is an impediment to vision, and a great pleasure when it seems properly mated to expression. As in many things, there is no right answer. The search for a personal style, or voice, is also a search for the right language in which to make that voice heard.

also see: Mark Making

Texture

A.

C. Nicholas Maes, *The Young Mother*. (The Metropolitan Museum of Art, New York; Rogers Fund, 1947)

D. Ernst Ludwig Kirshner, *Nudes*. 1908? (The Solomon R. Guggenheim Museum, New York)

E. Henri Matisse, *Reclining Model with Flowered Robe*. c. 1923-24. (The Baltimore Museum of Art; The Cone Collection)

Implied Line

A. Russell Tatro, *Invitation*, for Information Science Incorporated.

Careful looking at shape reveals lines of force, those invisible lines that are not drawn but make themselves felt in any configuration or composition. **Figure A** works with this kind of visible yet undrawn line. Like vertebrae in a spine, the letterforms are linked along a visual path that weaves up and down from left to right.

Rembrandt's painting, *The Night Watch*, in **Figure B,** produces a similar kind of visual event. Here, as the eye scans from left to right, the heads form an up-and-down sequence, a complicated, rhythmic line moving like musical notes arranged on a staff.

Line can be implied in other ways. A web of implied lines crisscross and tie together the many elements in Paolo Veronese's *The Finding of Moses* (**Figure C**). The eye follows the direction of glances and gestures that cut across the surface and the space.

Implied line can form a structural axis in three-dimensional form also. The small sculpture by Henri Matisse in **Figure D** has a kind of structural line at its core, like a handrail twisting up and through a spiral staircase. Here is no physical line that can be seen but rather a linear force that is sensed running through the entire mass of the sculpture. What is seen is often different from what the eye feels and understands.

also see: Principles
Grouping
Shape: Overview
Directed Tension
Rhythm

B. Rembrandt van Rijn, *The Night Watch*. 1642.
(Rijksmuseum, Amsterdam)

C. Paolo Veronese, *The Finding of Moses*. Date: probably
1570/5. (National Gallery of Art, Washington, D.C.;
Mellon Collection)

D. Henri Matisse, *Madeleine I*. 1901. (Baltimore Museum
of Art; The Cone Collection, formed by Dr. Claribel
Cone and Miss Etta Cone of Baltimore, Md.)

The Line as Edge

A. Lowell Williams and Lana Rigsby, *Madrigal and Chamber Choir Festival*. (Courtesy of the designers)

B. Felix Valloton, *La Modiste*. 1894.

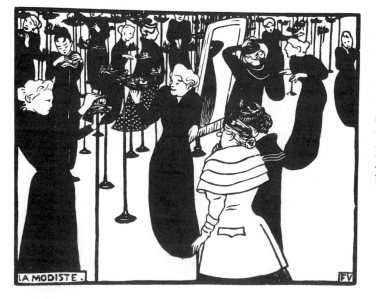

Contour refers to the line that describes the edge of a shape. Contour lines tend to be two-dimensional, even when they are used to describe a three-dimensional form. When a contour line travels entirely around a form, enclosing it, it becomes a container for the two-dimensional forces, the internal pushes and pulls that seem to make the shape bulge out or press inward.

Even when the line doesn't enclose a form, when it picks out only a section of an edge, the push and pull of visual forces can be felt. In the poster by Lowell Williams and Lana Rigsby (**Figure A**), for example, it is difficult to ignore the motion of the contours as they wriggle like ropes or pieces of colored yarn arranged on the surface.

The woodcut by Felix Vallotton in **Figure B** is made of strongly individualized shapes, a field of gently mobile silhouettes. The eye follows their edges like paths, and shapely contours emphasize the thrust and pull of the body inside each dress. At the same time, it is these contours that create visual movement in the composition.

Lines can act as visual fences, drawing simple boundaries between one area and another. In the Mary Cassatt drawing in **Figure C,** lines mark off the figures from the surrounding space. Each figure and form is self-contained and distinct from anything else. The line marks a single and definite step from one shape or space to another.

Paul Cézanne, in his drawing in **Figure D,** thinks of outline in a different way. Multiple rather than single lines are used to mark the edge of a form and to separate one shape from another. Instead of a one-step boundary between the figure and the surrounding space, a series of steps lead the eye across. The multiple lines form a zone of transition in which, for a moment, two spaces flow together. There is no single contour along which the surrounding space ends and the figure begins. Cézanne here draws the constantly shifting edges that are seen as we continually change point of view.

In the drawing by Alberto Giacometti in **Figure E,** edges become even shiftier and more ghostly and the sense of mobile vision more explicit. Giacometti seems to glimpse edges only fleetingly, as if they were constantly in motion. Although lines tend to pile up along the transitions between one space and another, they also move through forms, and space becomes a palpable substance.

D. Paul Cézanne, *Seated Nude*. (Kupferstichkabinett, Basel)

C. Mary Cassatt, *Tramway*. c. 1891. (The National Gallery of Art, Washington, D.C.; Rosenwald Collection)

also see: Shape: Overview
Positive & Negative Shape
Stroboscopic Motion
Interpenetration

E. Alberto Giacometti, *Vase and Cup*. 1952. (Guggenheim Museum, New York)

Line & Three-Dimensional Form

A. BeSong mask, Zaire. Nineteenth-Twentieth century. (The Metropolitan Museum of Art, New York; The Michael C. Rockefeller Memorial Collection of Primitive Art; Bequest of Nelson A. Rockefeller, 1979)

Line can strengthen the sensation of three-dimensionality even in three-dimensional form. When a sculptor carves a piece of stone or wood, the chisel leaves cutmarks across the surface of the material. These lines show how the chisel moved through real space and around the form. When the lines are deliberately left on the sculpture, the direction of every facet of the surface is amplified and becomes easier to see. In the African mask in **Figure A** such lines are purposefully inscribed. They repeat the direction of each surface many times, making the movement of each plane through space more powerful.

Something similar happens in the pen and ink drawing of a stag in **Figure B.** Ink lines travel over the forms of the animal, following the direction of planes as they turn in space and creating volumes as round and solid as any sculpture. Line used in this way and built up in crisscrossing layers is sometimes called *crosshatching*. It can move the eye across planes and around objects while retaining a certain transparency. It can describe dark and light as well as complicated rhythms as it moves the eye across a space (**Figure C**).

Diagonal lines play another, and slightly different, role in making space visible in a flat surface. Vertical and horizontal lines lead the eye up and down, back and forth, across the surface, but diagonals can create a sense of stepping into and out of the pictorial space. In the print by Hokusai in **Figure D,** landscape forms unroll as gentle horizontals. A tree near a decorative pillar makes a vertical accent to answer the horizontal horizon, but the clearest path into the space is marked by the diagonal planks of the footbridge.

also see: Space Moving In
Vanishing-Point Perspective
Isometric Perspective
Vertical/Horizontal/Diagonal

B. Jost Amman, *The Stag.* (German, 1539-1591). (The National Gallery of Art, Washington, D.C.; Rosenwald Collection)

C. Albrecht Dürer, *An Oriental King Seated on His Throne*. c. 1495. (The National Gallery of Art, Washington, D.C.; Ailsa Mellon Bruce Fund)

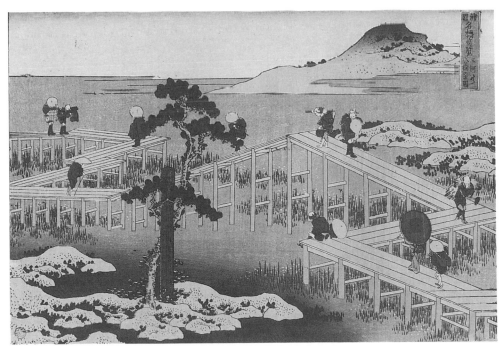

D. Hokusai, *Yatsuhashi (The Eight-Plank Bridge)*, from *Views of Famous Bridges in Various Provinces*. 1833-34. (The Metropolitan Museum of Art, New York; Rogers Fund, 1922)

9 Movement

Overview

A. Race Horse, newsphoto.

The motion that is sensed in a photograph or a painting isn't really motion at all. Pick up a photograph and shake it; shapes and tones do not rattle around. Everything is fixed in place, but still we speak of movement.

It could be suggested that a photograph of a moving object will show movement, but even that is not necessarily true. In **Figure A,** the camera has accurately captured the image of a horse galloping forward, but the photo has no sense of forward movement at all. Rather, the horse seems to be galloping backward.

The photograph by Clarence White in **Figure B** makes the same point in the opposite way. The subject is still: a seated figure, relaxed and self-

absorbed, in a corner of a Victorian sitting room. Yet visual motion is everywhere, from the acrobatic swinging curves of the couch to the broken and fluttering shape of the figure's white dress.

Even in a still photo, the rocking chair by Gebrüder Thonet in **Figure C** beautifully conveys the endless back and forth of the rocker's motion. Rocking or standing still, it is full of pictorial motion, something quite distinct from real movement, but, in many ways, just as vivid.

What is the relation, then, between moving things and pictorial movement? A way to begin to find out is to look at how artists control and organize the elements of a composition to make motion appear to happen on a still page.

B. Clarence White, *Miss Grace*. c. 1898.
(Collection, The Museum of Modern Art, New
York; gift of Mrs. Mervyn Palmer)

C. Gebrüder Thonet, *Reclining Rocking Chair
with Adjustable Back*. c. 1880. (Collection,
The Museum of Modern Art, New York;
Phyllis B. Lambert Fund and gift of
the Four Seasons)

Directed Tension

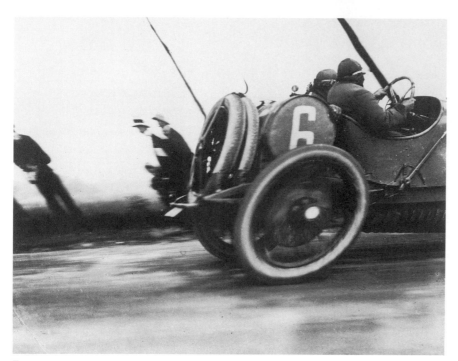

B. Jacques Henri Lartigue, *Grand Prix of the Automobile Club of France, Dieppe*. 1911. (Collection, The Museum of Modern Art, New York; gift of the photographer)

A.

Movement in a still image does not necessarily have anything to do with a photographic likeness of a galloping horse or a bird in flight. A photograph of a form in motion can look absolutely frozen. Movement in a visual pattern is not a consequence of subject matter but comes from the kinds of shapes, angles, curves, and forms that are used. The seeds of motion are already contained in the tensions that are built into every shape and line of a composition.

As long as visual forces are nearly equally distributed, a sense of stillness and balance will prevail. For instance, in a square, the force of the horizontal is about equal to the lift of the vertical. An equilateral triangle is almost as still, the thrust of one point is approximately equivalent to the thrust of each of the other two. A stable balance is achieved.

Symmetry creates stillness, especially when its main structural lines are vertical and horizontal. When a symmetrical shape is made asymmetrical, or when the thrust of one direction becomes stronger than that of the others, the sense of energy or tension increases. In **Figure A** the square has become an arena for tensions that pull it strongly in one direction, and the circle, pulled taut along an axis and tipped in one direction, seems poised to roll and to change its shape. Diagonals, along with this kind of distortion, tend to create visual movement. This is what happens in the dynamic oval of the wheel and the stretched-out diagonals of the spectators in Jacques Lartigue's photograph in **Figure B**.

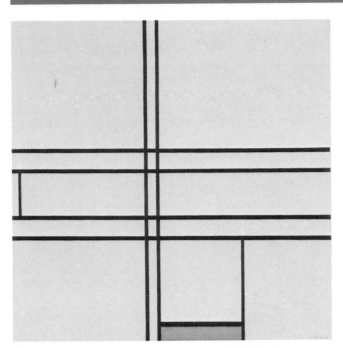

C. Piet Mondrian, *Square Composition*. 1922-25. (The Phillips Collection, Washington, D.C.)

Motion in a design is directed visual tension. Looking back at the photo of the running horse in the previous unit, we can see how backward-pointing diagonals predominate. In fact, the horse and jockey together form a strong compositional triangle that points left and seems drawn to the left-hand edge.

Compare the orderly stillness of the composition by Piet Mondrian in **Figure C** with the arrangement by Jean Arp in **Figure D.** In the Mondrian, the vertical and horizontal grid holds each shape in its grip, and whatever tensions may exist within each shape feel contained and controlled. Arp's composition, in contrast, seems to undulate and swell. The diagonals and the strong asymmetry of the shapes and their arrangement convey movement and a more unrestrained energy.

also see: Grids

Tension & Shape

Balance

Tension

Asymmetry

D. Jean Arp, *Squares Arranged According to the Laws of Chance*. 1917. (Collection, The Museum of Modern Art, New York; gift of Philip Johnson)

111

Movement & Change

A. Serpent, English, c. 1825-30 (The Shrine to Music Museum, University of South Dakota, Vermillion, S.D.)

A gradient is a gradual change in a visual element. It might be a change in direction, like the **S** curve of a swan's neck, or a change in tone or value, like the gradual movement from light to dark. A gradient changes slowly and evenly, leading the eye smoothly and in equal steps without sudden jumps from one point to the next.

Gradients create visual motion. In the musical instrument in **Figure A,** the swelling, tapering, and curving shape generates a series of lively movements and countermovements. If you cover the image with a piece of paper and then slowly uncover it by sliding the paper downward, you can see the pulsing and undulating of movement happening in time.

More than one kind of gradient can be applied to the same form or used in the same composition, and each can enhance the sense of motion. If a taper, and then a gradient of curve and direction, and finally one of light-to-dark is added to the simple shape in **Figure B,** each addition causes it to seem more and more animated.

The circus poster in **Figure C** uses a gradient of size change to move forward through space and a gradient of serpentine curves to move the eye up and down the surface. Notice how the forward motion is slowed down and stopped at the bottom where sizes no longer change, and the widening curve narrows.

In the Cubist painting by Fernand Leger in **Figure D** the eye is led in and out by gradients of value, light and dark changes made evenly across forms. Where the step-by-step change from lighter to darker is broken at the edge, the eye jumps from very dark to very light. The gradient is broken, and we notice a new level or plane in space. A second gradient—a curve—further animates this shallow space, full of lively, staccato movement.

The eye moves in the direction of diminishing intervals. The tendency is also to see movement from larger forms or heavier qualities to smaller, lighter ones as when we look from objects in the foreground to smaller ones farther away or from the near brightness or darkness to the pale or light distance.

B.

C. Poster for John O'Brien's Circus. James Reilley, printer and engraver. 1866.

D. Fernand Leger, *Nude Model in the Studio*. 1912. (Solomon R. Guggenheim Museum, New York)

Vertical/Horizontal/Diagonal

Visual movement in an image often depends on vertical, horizontal, and diagonal relationships. In general, when a shape or line is placed vertically or horizontally in a composition, it will seem stable. Diagonally placed shapes and lines, especially when they are not aligned to an underlying grid, convey movement. Compositions that are full of diagonals tend to look more dynamic than compositions dominated by vertical and horizontal elements. Vertical/horizontal and diagonal, like dark and light, are forces that can be contrasted, balanced, and used contrapuntally.

The windmill diagram in **Figure A** shows equally possible positions for turning blades. The first image feels frozen. The center windmill is a little more dynamic, but the ends of the blades are aligned on vertical/horizontal axes, again forming a square. The blades of the last windmill give the most convincing appearance of movement because of the asymmetrical diagonal axes.

This simple idea, that careful alignment can lock forms in place, can, if taken to extremes, produce unlikely-looking results. Peter Berhens's poster in **Figure B** takes a dynamic image, a rearing horse and rider, for its subject. Instead of conveying motion, the image is stiff and frozen, as elements such as the horse's neck, the torso and arms of the rider, even the torch and flame that he holds, are forced into alignment with the vertical and horizontal.

Stillness is what Frances Johnston was seeking when she carefully posed her models for the photograph in **Figure C.** The strong vertical accents that run through her composition create an image of measured stillness in which the figures have the monumentality and dignity of classical sculpture.

In contrast, the gracefully undulating movement of the Indian figure of Shiva in **Figure D** comes from the predominance of diagonally placed forms and directions. Vertical and horizontal are avoided almost completely except for the stabilizing vertical spine around which motion revolves. Segments of limbs and torso change direction again and again. Diagonals repeat and mirror one another as the figure twists through space.

also see: Grids

Line & Three-Dimensional Form

Isometric Perspective

Tension

Asymmetry

A.

C. Frances B. Johnston, *Agriculture. Mixing Fertilizer*, plate from an album of the Hampton Institute. 1899-1900. (Collection, The Museum of Modern Art, New York; gift of Lincoln Kirstein)

D. *Shiva Nataraja*. Indian, Thirteenth century. (The Nelson-Atkins Museum of Art, Kansas City, Mo.; Nelson Fund)

Stroboscopic Motion

When similar shapes are placed in sequence, we sometimes see movement rather than just a random accumulation of shapes. This is what happens from one frame to the next on a filmstrip, and the term *stroboscopic motion* comes from the stroboscope, a primitive moving picture machine. It happens in still images as well. In Ivan Chermayeff's poster in **Figure A,** the form of the dinosaur repeated three times creates a sense of a single dinosaur turning from left to right. The overlapping of the silhouettes increases the sense of a single motion.

El Lissitzky's poster for an exhibition in **Figure B** is another example of this effect. Two heads share one eye, and each head depends on the other to become complete. Irresistibly, the form flickers back and forth in a restless way.

When the number of shapes increases and a gradient is added, the sense of movement becomes even stronger. The pole-vaulting athlete in **Figure C,**

A. Ivan Chermayeff, *Poster for the American Museum of Natural History.*

B. El Lissitzky, *USSR Russische Ausstellung.* 1929. (Collection, The Museum of Modern Art, New York; gift of Philip Johnson)

a photo sequence made by Thomas Eakins, is part of a continuous and smooth gesture, and the repeated overlapping again strengthens the dynamic effect.

Artists used something like this effect long before the stroboscope or the motion picture camera was invented. Pieter Bruegel's *Parable of the Blind* in **Figure D** arranges a series of caped figures on the diagonal gradient of a hill. The eye moves from the vertical figure on the left through increasingly diagonally pitched figures, until it is stopped on the right in a horizontal tumble. Echoing the fall of the beggars is a linear element, a series of sticks that jaggedly move from upper left to lower right. The figures are similar enough so that it is almost possible to imagine each one as a separate still, or part of a single motion.

also see: Interaction

Repetition & Variation

Rhythm

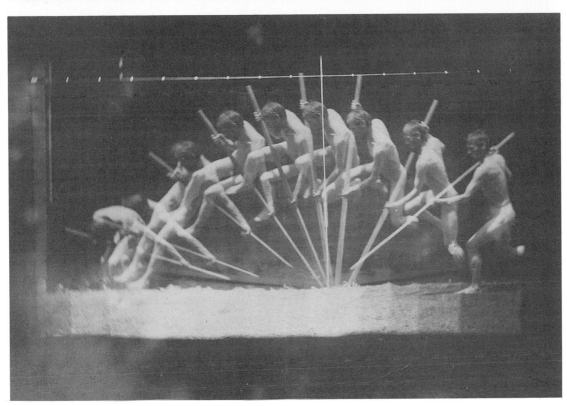

C. Thomas Eakins, *A Man Pole Vaulting/Marey Wheel Photographs of George Reynolds*. c. 1884-85. (Philadelphia Museum of Art; gift of Charles Bregler)

D. Pieter Bruegel, *The Parable of the Blind Men*. (Museo di Capodimonte, Naples)

Time

A. Sassetta, *The Meeting of St. Anthony and St. Paul*. c. 1440. (National Gallery of Art, Washington, D.C.; Samuel H. Kress Collection

B. Leonard Dufresne, *Hamlet*. 1980. (Courtesy of the artist)

Seeing occurs in time as well as in space. When we watch a ball roll across the floor, it moves through a period of a few seconds as well as moving from one side of the room to the other. In a drawing of the same subject, however, the world is entirely still. The illusion of three dimensions can be presented in two-dimensional art, but how is the fourth dimension, time, dealt with in a medium in which there is no time? In the real world one moment is followed by another. In a drawing everything is seen simultaneously. How can this motion be translated into a form in which nothing moves?

Sassetta solves this dilemma in an illogical-seeming but effective way in his painting of "The Meeting of St. Anthony and St. Paul" (**Figure A**). A series of actions that take place over time are brought together in a single space, and it is the structure of the picture itself that shows the viewer the order in which the incidents occur. At the top left we see the dark robed St. Anthony walking along a road that zig-zags down and forward through the space. Next, we see him meeting a centaur at the first bend in the road and, finally, he finds St. Paul at the bottom of the hill, at the end of the viewer's parallel journeys through time and the picture-space.

A similar logic is the basis of another familiar form. Leonard Dufresne's picture story in **Figure B** uses a classic comic strip format to subdivide an event into close-paced moments. Here each discrete box marks a small step forward in time, which is experienced almost as it is in a stroboscope. We see different, progressive aspects not only of an extended movement but of a single, complex action.

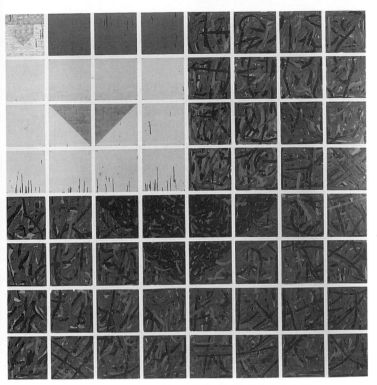

C. Jennifer Bartlett, *2 Priory Walk*. 1977. (Philadelphia Museum of Art; Purchased, Adele Haas Turner and Beatrice Pastorius Turner Fund)

Jennifer Bartlett's painting in **Figure C** uses the subdivided field, but no left-to-right sequence is laid out. The viewer is free to imagine any sequence or none at all for the collection of units. The square-on-square doesn't lead through time by any particular route, but it does create a sense of additive time, separate moments that may add up to a larger experience of seeing.

Early in this century, Cubist painting gave us the image of many moments in time, many glances, many viewpoints, brought together in a single painting. The assemblage of snapshots in **Figure D** captures something of the way things are always seen in time. The image is built up from several little glimpses, the accumulated details and bits of information that might register more and less intensely in the eye and mind of the viewer who has the time to sit and look for more than a few moments.

D. Benjamin Martinez, *Portrait of Stanislava Svecova*. 1992.

also see: Rhythm
 The World of Appearances
 What's Real?

10 Light

Overview: Value as Light

A. Albrecht Dürer, *Young Woman in Netherlandish Dress.* 1521. (National Gallery of Art, Washington, D.C.; Widener Collection)

Movement and depth are words used to speak of images in which nothing actually changes position on the page other than the viewer's glance, nor is there any depth in it that could be entered except imaginatively. Visual forces are real, but they exist in some other reality, with its own rules.

Speaking of light in a design, we are also talking about something different from real illumination. Luminous though it may seem, no one would try to read by the light of an Impressionist painting. Light in a design is a sort of apparition, magical in a way that even balance and movement are not. This chapter is about how value, the range of grays from white to black, works in creating that apparition.

In the following pages, we will, for the most part, put color, the other component of light, to one side. This paints a somewhat false picture, as grays *do* have color. The grays we see appear to be nearly always brownish or greenish or bluish, warm or cool. But imagine, for now, a truly neutral or achromatic gray, a tone with nothing in it that could be called redness or blueness, no trace of color at all, just black and white.

Even though such grays may not grab the eye from a distance, as color will, they become fascinating and sensual when attention is paid. In the beginning, it may seem easier to create an illusion of light by using black, white, and grays. Artists who have

B. Eva Rubinstein, *Two Doorways, Palazzo Ducale, Sabbioneta, Italy*. 1973. (Courtesy of the artist)

the full spectrum of color available to them have often chosen to work with grays simply because they are, in themselves, beautiful.

The play of dark and light, the modeling of an illuminated form from light into shadow, is a straightforward way of rendering volume. In Albrecht Dürer's drawing in **Figure A,** a combination of dark and white inks on grayed paper picks out the tubular folds of the dress and the crisp planes of the headdress. Dürer used light to articulate surface textures; the softness of fur is different from the gleam of beads or the folded fabric of a sleeve.

With another kind of tonal eloquence, Eva Rubinstein uses a velvety palette of grays to create an architecture of light (**Figure B**). Here, seeing light, even while it illuminates surfaces, seems like an end in itself. Walls, doorways, and floor exist only to catch it, or slow it down. It is the light, palpable, lingering on the edge of a doorsill or slowly blooming across the wall and floor, that becomes the subject matter.

also see: Elements of Color: Value

Light: Comparing Values

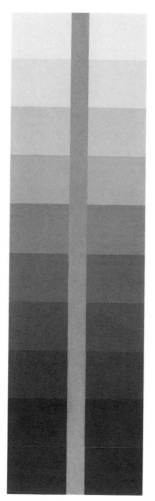

A.

If there is a golden rule of seeing, it is that visual judgments are made by comparing one thing to another. We determine size—large or small—by comparing a form with those around it. Similarly, color, direction, and shape are affected by context. To understand and use value it is also necessary to be especially sensitive to this kind of comparative seeing.

A pale gray handkerchief will look dark when thrown on a white bedsheet, and light when placed against a black background. In **Figure A** the central gray strip bisecting the scale of grays is the same value along its whole length, yet it appears dramatically darker in the context of light grays and lighter when surrounded by dark grays. It is impossible to see that both ends of the strip are the same value unless the gray steps surrounding it are masked out. In fact, we can almost say that judgments about values are entirely relative. Every gray is at the mercy of its surroundings. From that simple beginning can be built a whole system for thinking about value.

When different values are arranged together in the same composition, the mutual influence of tones on one another is evident everywhere, with values looking darker where they come up against light areas and lighter against dark areas, as they do in Anne Ryan's collage in **Figure B.** In general, a larger area will affect or seem to change a smaller neighbor more strongly than one of similar size, but no piece of any value composition can be understood out of context.

In Giorgio Morandi's etching in **Figure C** values are created by a cross-hatching of black lines, built up in layers. The white still-life objects are simply untouched areas of the paper. Prove this by making two small holes in a sheet of paper and isolating the white of the bottle and the one of the blank edges that frame the image. You will find they are the same value. Take the mask away and you'll notice that the bottle appears to be a great deal lighter than the page. This sort of *superwhite* is caused by the darker values that surround the shape of the bottle and affect our reading of its value.

This apparent shifting of value by context has applications not only in a relatively realistic still life, but in any situation in which two values interact. In **Figure D,** the letters seem to become darker and lighter as the background changes. To make them *appear* to be of the same value, we would need to carefully adjust the value of each letter in relation to its context. This "fine tuning" must be considered, whether the subject is type on a page or highlights on a bottle.

also see: Relationships

Interaction

TYPE LAID OVER BACK-
GROUNDS OF DIFFERENT
VALUE SEEMS TO CHANGE
ITS OWN VALUE.

D.

B. Anne Ryan, *Collage #534*. 1953. (The Hirshhorn Museum and Sculpture Garden, Smithsonian Institution, Washington, D.C.)

C. Giorgio Morandi, *Still Life*. 1930. (Instituto Nazionale per la Grafica, Rome)

123

Weight of Value

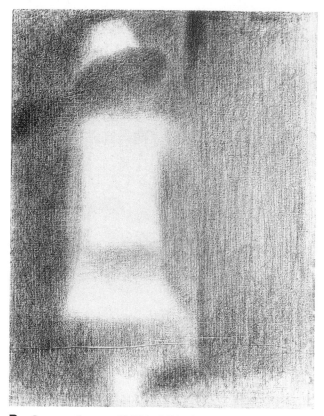

In general, we associate darkness with weight, and think of darker values as heavier looking than lighter values. If two identical shapes are seen against the same ground, as in **Figure A,** a dark or black shape will tend to look weightier and denser than a lighter shape.

Darker value will tend to make a shape feel more tightly packed and visually charged. Light values expand, glow, and pulse outward, just as light itself seems to radiate outward from a source. The effect, which can also be seen in the two circles of **Figure A,** is a slightly contradictory sense of expansion and contraction. The white circle seems larger, inflated with light, while the black one seems both heavier, and at the same time smaller and more compressed. We see the same effect in the radiant shape of the child's dress in Georges Seurat's drawing in **Figure B.**

By *value* we mean not only the flat gray that results from mixing black and white paint. There are numberless ways of generating value using only black marks on a white page. Cross-hatching is one technique that both enhances the sense of volume and also produces a range of value from very dark to very light, as happens in the woodcut in **Figure C.**

Any close grouping of marks, whether it attaches to the surface of forms or not, will produce a sense of increased darkness and density, even where the mark itself is uniformly black, as in Chryssa's lithograph in **Figure D.** In addition to handmade marks, Chryssa uses blocks of printed type to evoke different degrees of darkness. Typographers know that type size and weight will create darker and lighter areas on a page, and this light or dark effect can be enhanced by spacing (**Figure E**).

B. Georges Seurat, *Child in White (Study for "A Summer Sunday on the Grande Jatte").* 1884. (Solomon R. Guggenheim Museum, New York)

A.

C. Woodcut, after Titian, *St. Jerome in the Wilderness.* c. 1525-30. (National Gallery of Art, Washington, D.C.; Rosenwald Collection)

A similar use of type as value can be seen in Picasso's collage/drawing in **Figure F.** Large areas of newspaper text form a grayish background, contrasting with the smaller and more complicated black and white shapes in the center of the composition. Picasso was very aware of the different visual qualities produced by flat grays and the softer values of pages of closely spaced type.

also see: Top & Bottom
Left & Right
Weight
Line & Three-Dimensional Form
Weight & Balance

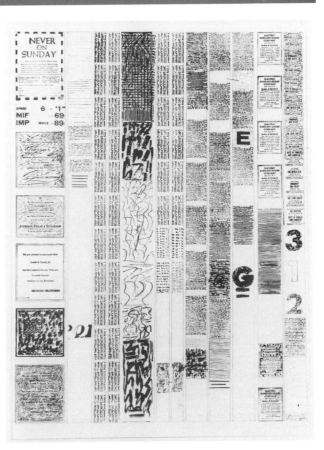

D. Chryssa, *Untitled (Never on Sunday)* 1962. (Whitney Museum of American Art, New York; gift of the artist)

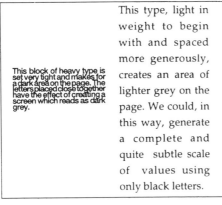

This block of heavy type is set very tight and makes for a dark area on the page. The letters placed close together have the effect of creating a screen which reads as dark grey.

This type, light in weight to begin with and spaced more generously, creates an area of lighter grey on the page. We could, in this way, generate a complete and quite subtle scale of values using only black letters.

E.

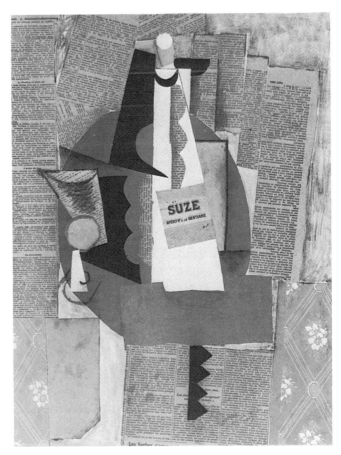

F. Pablo Picasso, *La Bouteille de Suze.* 1912-13. (Collection, Washington University Gallery of Art, St. Louis)

Value Contrast

B. Jacqueline Casey, *Body Language.*

Using most any material, hundreds of different value steps can be generated between black and white, but no medium can reproduce the *range* of light to dark found in nature, from the brilliance of the sun to the black of the darkest midnight sky. The blackest and whitest paint suggest only a small section of this tonal range.

Nonetheless, *effects* like those of light in nature can be created by controlling the relative amounts of contrast between grays. In **Figure A** the same configuration is presented in four *keys*, four different schemes of dark and light. The first uses the full range of value from black to white. The second is in a light, or high key. It uses only values from the light end of the scale; the range is from white down only to a middle gray. The third is a dark or low key design, limited to the dark end of the value scale, and the fourth is in a middle key, using a narrow range of value without any very dark darks or light lights.

In each configuration the value scheme enhances three-dimensionality, but more than that, each different group of values creates a different kind of light, from bright and crisp to soft and dark, paralleling, if not duplicating, the kinds of light we see in nature. Generally, higher contrast creates a more easily legible image and a more brilliant sense of light and dark. A softer contrast will weaken effects of three-dimensionality, but may also suggest other kinds of light or offer other expressive possibilities.

For example, Jacqueline Casey's poster in **Figure B**, achieves a clear and strongly three-dimensional image by using the two values representing the extremes of contrast, black and white, plus the mediating single middle gray. Dramatic light playing over solid forms is the result.

A.

The drawing by Paul Cézanne in **Figure C** is low in contrast, *the whole* in a light value range. This high key makes the drawing look bright and transparent, as though seen through a screen of light. Giorgio Morandi's etching in **Figure D** also draws on a limited section of the value scale. It is built mainly from darker grays. The reduced contrast here creates a thick, dark atmosphere that adds to the effect of density and heaviness in the composition.

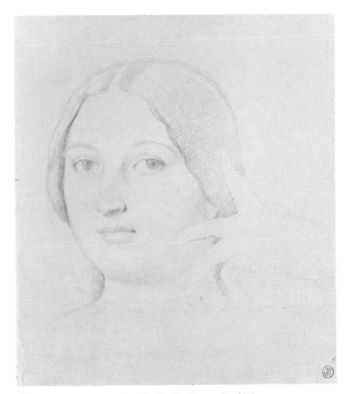

C. J. A. D. Ingrew, *Study for the Portrait of Mme. Moitessier.* c. 1844–1851. (Worcester Art Museum, Worcester, Mass.)

D. Giorgio Morandi, *Still Life with Coffeepot.* 1933. (Instituto Nazionale per la Grafica, Rome)

127

Space & Volume

If, instead of moving suddenly from dark to light, the eye is allowed to move through lighter to darker values in a series of small and even steps, a *tonal gradient* is created, something that can help the eye to move through deep or open space. More contrast pushes forms farther apart in space while less contrast draws them closer together.

In Claude Lorraine's landscape drawing in **Figure A,** space is created by this movement from dark to light, from the black of undiluted ink in the foreground to the white of the paper in the distance.

Forms seem to fade into the pale depths of the drawing. A value gradient used in this way is one element of *atmospheric* or *aerial perspective*. Unlike linear perspective systems, which rely on a set of precise rules involving vanishing points and diagonal lines, aerial perspective depends on the fact that colors and values become more similar with distance. This is a discovery that originated in landscape painting. Trees, hills, buildings, and other landscape forms tend to lose their color and value differences as they recede, blending, near the horizon, into the color of the sky. It is especially easy to see this phenomenon on misty or rainy days.

A tonal gradient is also what is being used when objects are modeled with light. In Lennart Anderson's drawing in **Figure B,** a sense of weight and solidity is created by the eloquent grays, describing a slowly moving light that pours over gently rounded volumes.

A beautiful example of a tonal gradient constructed to create light in non-naturalistic space is seen in Hannes Beckmann's painting in **Figure C.** The careful control of value change and contrast gives the design a light of its own, something that seems to well up from inside the work itself.

A. Claude Gallée (La Lorraine), *View of a Lake.* (Reproduced by courtesy of the Trustees of the British Museum)

B. Lennart Anderson, *Still Life with Mug and Coffee Filter.* 1984. (Courtesy of Davis & Langdale Company, New York)

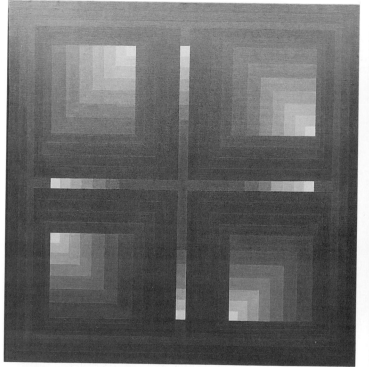

C. Hannes Beckmann, *Plus Four-Red.* 1965. (Harvard Art Museums; Busch Reisinger Museum, Cambridge, Mass.; gift of Mrs. Charles L. Kuhn in honor of Mr. Irving M. Sobin)

D. Pavement mosaic from the villa of Lucus Feroniae. Roman. First century A.D.

E. Relief from Tomb of Ni-Ankhnesut, Egyptian, VI Dynasty. 2470-2270 B.C. (The Nelson-Atkins Museum, Kansas City)

More formal, less literal kinds of space can be defined with value. Whenever different values are placed on a surface, they will seem to lie at different levels, at different distances from the picture plane. By controlling the key, or range of values used, those distances can be controlled. In the detail of a Roman pavement mosaic in **Figure D**, we see this kind of space. Unlike the fluid, volumetric space made by a smooth gradient, the space here jumps back and forth, in and out, in shallow, flat sections. The arrangement effectively destroys the flatness we usually expect in a floor or sidewalk.

Real light enhances and weakens the sense of volume in objects that have real volume. Compare the feeling of space and mass in the two reliefs in **Figures E** and **F,** each clearly articulated in three dimensions. The first is an Egyptian carving so delicate and shallow that it may almost appear to be a pale line drawing. The slightly rounded forms emphasize edges and move lightly across the space. In the Renaissance carving, a much deeper relief creates a controlled structure of light and shadow in deep folds and around full-looking forms. This sculptor's use of light to create value lends weight to a relief that is actually only a few inches deeper than the Egyptian carving.

also see: Making Light

Volume & Atmosphere

Transparency & Reflection

Depth Cues: Gradients

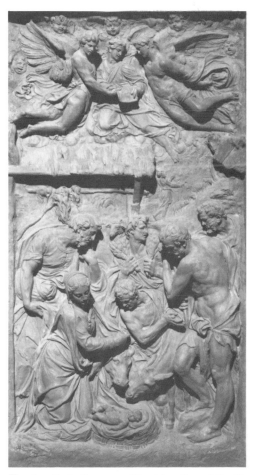

F. Annibale Fontana, *The Adoration of the Shepards*. (The National Gallery of Art, Washington, D.C.; Kress Collection)

129

Transparency

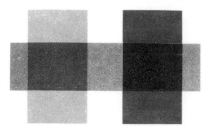

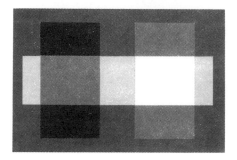

A.

Value and contrast of value can be used to generate a feeling of depth in an image in several ways. The tonal gradient that gives a sense of volume and mass to the modeling of rounded form can also create atmosphere and deep space.

Value can create *illusions* of transparency, of films of light or dark, or of projected light. These are among the more magical effects of value. By adjusting values that lie next to one another, the artist can make a unified light appear to play over forms. The simple rule is that whatever the appearance of a film of light or a shadow does to one area it must do to every other area that it covers; if it darkens or lightens one area to some degree, it must darken or lighten other areas to the same degree (**Figure A**). Probably the most familiar example of this is light and shadow as used in a representational drawing. In the drawing by Simon Vouet in **Figure B,** areas of light and shadow group forms, and parts of forms that would otherwise be separate seem to join to form a second hierarchy of shapes.

When a shadow or film appears to decrease the light in an area, darkening the shape, it could be called *subtractive*. One that seems to lighten or to add illumination, might be called *additive*. In **Figure C,** a painting by Paul Klee, there is a complex use of many illusions of transparency, additive and subtractive films. Klee creates a volumetric feeling that has a lyrical, delicate, and dreamy quality without relying much on realist space.

A similar play between transparency and opacity, space and volume can be seen in James Miho's advertisement for the Container Corporation of America in **Figure D.** Careful control of a limited number of value changes allows us to see the flat projection of the letter *A*, the three-dimensional box, and the pattern of cast shadows their interaction creates, in a design that alternates flatness with volume.

also see: Local Color

Volume & Atmosphere

Transparency & Reflection

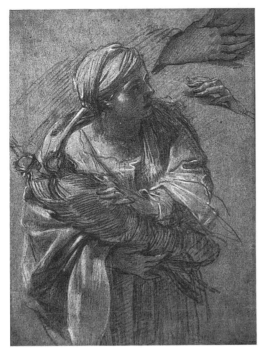

B. Simon Vouet, *Rachel Carrying the Idols.* (The National Gallery of Art, Washington, D.C.; Ailsa Mellon Bruce Fund)

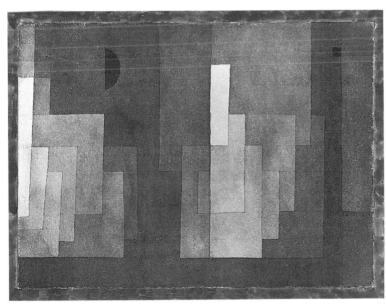

C. Paul Klee, *Green-Orange Gradation with Black Half-Moon.* 1922. (The Harvard Museums; The Busch-Reisinger Museum, Cambridge, Mass.; Purchase, Association Fund)

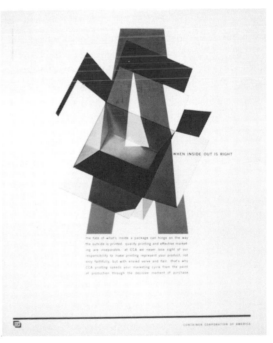

D. James Miho, *When Inside Out Is Right.* (Courtesy of James Miho and the Container Corporation of America)

11 Components of Color

Overview

The power of color is demonstrated in a simple behavioral experiment. A group of young children is shown a collection of bottles of many sizes and shapes. Each bottle is filled with a different colored liquid. Asked to arrange or organize them in any way that makes sense, the children will almost always group them according to color. In other words, they will notice similarities of color before size or shape. Looking at **Figure A,** you will find the same tendency to mentally group by color rather than shape or even proximity.

But what is color? In the scientific sense, it is a range of visible frequencies of light. A beam of white light, when passed through a prism, breaks up into a spectrum of colors—red, orange, yellow, green, blue, indigo, violet—in the fluid progression we see in a rainbow (**Figure B**). Each color and each gradation between colors has a particular frequency or wavelength, like the frequency of vibrations that make different pitches in music. In the physicist's version, every surface, every material, absorbs some of these color frequencies and reflects others back to the viewer. The color of the reflected light is the color we see (**Figure C**). If all of the white light is reflected, the surface will appear white; if all of it is absorbed, the surface we see will be black. In dimmer light, we see color less intensely. In a colored light, such as the red light of a photographic darkroom, the color of an object will appear changed (and, indeed, is changed).

Unless light itself is the medium (and for some artists it is), colored media, whether oil paint or printer's ink or powdered pigment or colored paper, is not color, it *has* color. It reflects and absorbs light in exactly the same way any surface does. Although paint or colored media interact and behave differently from light, artists have always been led on and fascinated by the way that colored materials can create marvelous illusions of light, and by the elusive, poetic, and sensual effects that color can have. Describing a detail in a painting by Delacroix, Cézanne remarked that "the color of the red slippers goes into one's eye like a glass of wine and down one's throat." Such sensations are difficult to quantify and, we discover, often resist all efforts to do so.

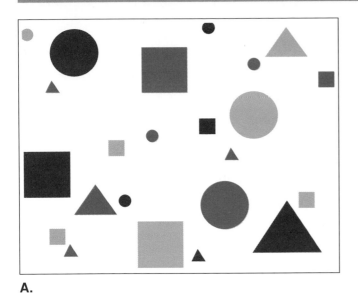

A.

WHITE
LIGHT

B.

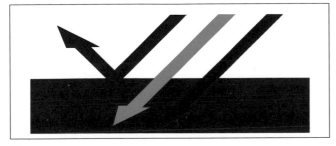

C.

When looking at black and white, value without color, we see how a gray can appear darker or lighter when placed against different backgrounds. The notion that seeing occurs in context, by comparing, is made dramatically clear. When looking at color, the effects of visual surroundings are also dramatic, so much so that we could once again almost say that color is understood only in relation to other color, by comparing, and in the magical and surprising transformations that occur when colors are put together. For the eye and mind, there is no such thing as *a* color, there are only color relationships.

Given this, artists can gain a great deal from an objective examination of color and how it works. Everyone makes practical decisions about color all the time. We choose clothes or the color to paint the livingroom. Sometimes the lovely tan favored in the sample book at the paint store will turn a whole room a hideous fleshy pink when spread across four walls, or a shirt, a ravishing color in the store window, will make your complexion look oddly sallow and green when you try it on. Effects like these are predictable, and can be anticipated by those who understand the volatile and flexible nature of color.

Artists make special claims for color, for its mystery and power. For many it is the emotional element, the ingredient that is most difficult to explain and yet the one that grabs our attention most intensely. In this line of thinking, color is contrasted to drawing, the intellectual or rational element. Like most generalizations, this one is not entirely true. Color has its own rules and principles, some of them quite logical. Van Gogh, the artist who for many epitomizes the personal and intuitive in art, wrote, in a letter to his brother Theo, that "I do not regret that I tried to master the theoretical principles of color." Intuition may work best when grounded in knowledge.

also see: Relationships

Elements of Color

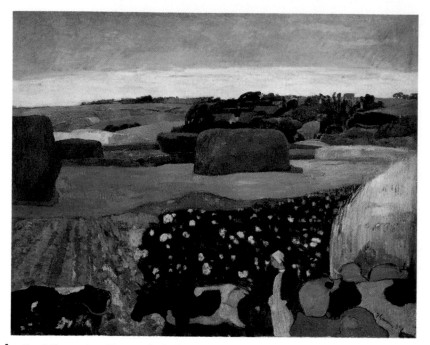

A. Paul Gauguin, *Haystacks in Brittany*. 1890. (National Gallery of Art, Washington, D.C.; gift of W. Averell Harriman Foundation in memory of Marie N. Harriman)

Hue

A beginning painter stands in a landscape looking at the trees and sees green. Gauguin looked at a green landscape and saw bluish greens, black greens, yellow, gold, gray, and brownish greens, deep greens and dull greens, greens with a metallic look to them, and greens that are barely there (**Figure A**). The beginner, understandably, has trouble seeing all these differences and subtle variations. It will take a great deal of looking and working before such discrimination comes naturally.

One way to begin to think about color differences is to break color down into its separate components—hue, value, intensity, and temperature. What the beginning landscapist probably doesn't realize is that every stroke of paint is composed of all these. Examining them one at a time is a first step toward understanding and using them.

The quality usually referred to when identifying a color is its *hue*, the redness or blueness or yellowness or greenness that locates it on the spectrum. Hue differences are the easiest to see. The human eye can distinguish about 150 as distinct. In other words, were a spectrum divided into 150 narrow bands, we would be able to see each band as a slightly different color from its neighbors rather than seeing a smooth, continuously modulated band.

Of the hues, the most basic are the three we call the *primary colors*, red, blue, and yellow. These painter's primaries are the raw material from which all the other hues are made. Orange results from mixing red and yellow, green from mixing yellow and blue, violet from mixing red and blue. The primaries themselves cannot be produced by any mixture. And because we cannot sense them as being made from the combination of colors, they have a quality different from the rest of the hues—unified, singular, irreducible.

The simple mixtures made from each pair of the three primary colors (orange from red and yellow, violet from red and blue, and green from blue and yellow) creates another trio of colors called the *secondary triad*. Here it becomes immediately apparent that nothing about color is cut and dried. Green, orange, and violet, the secondary colors, don't seem to go together in the same kind of clear and balanced way that the primaries do. For instance, most people can see red and yellow in orange, but have a more difficult time analyzing green, which to some has the pure quality of a primary. Children are likely to figure out that you can make orange by mixing red

B.

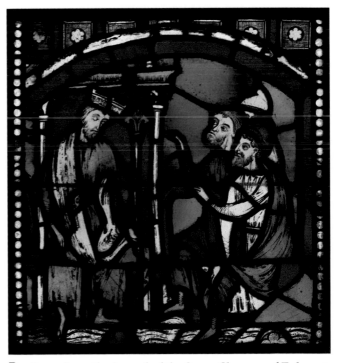

C. Robert Jensen, Poster for *Lutsen Design Conference.*

and yellow, but are puzzled by green. Some color systems even consider green a fourth primary (or an "additive" primary); in others it is granted a visual importance somewhat different from either orange or violet.

To visualize how primary and secondary colors relate to one another, a diagram like the one in **Figure B** can be helpful. This circular color wheel is probably the simplest way to lay out basic relationships. Artists and color theorists have, over the centuries, developed some useful and beautiful variations on this wheel to think about how color behaves and why color combinations look the way they do.

For centuries artists have debated the importance of color versus line and value. Although most artists have been adept at handling both color and drawing, the power and impact of hue were restored to modern Western art by contact with the art of cultures that made more use of highly saturated hue, such as is found in Arabic painting, or in the straightforward and bright harmonies of folk art.

The hues themselves have a potency and richness that has given them a special role in the art of almost every culture. The clarity, brilliance, and sharp visual impact of hue is as appropriately mated to the crisp geometry of Robert Jensen's poster in **Figure C** as it is to the jewel-like viscosity of glass in the stained glass window in **Figure D.**

D. *Scene from the legend of the Seven Sleepers of Ephesus,* France, Rouen Cathedral. c. 1210-20. (Worcester Art Museum, Worcester, Mass.)

also see: Color Systems

Interaction

135

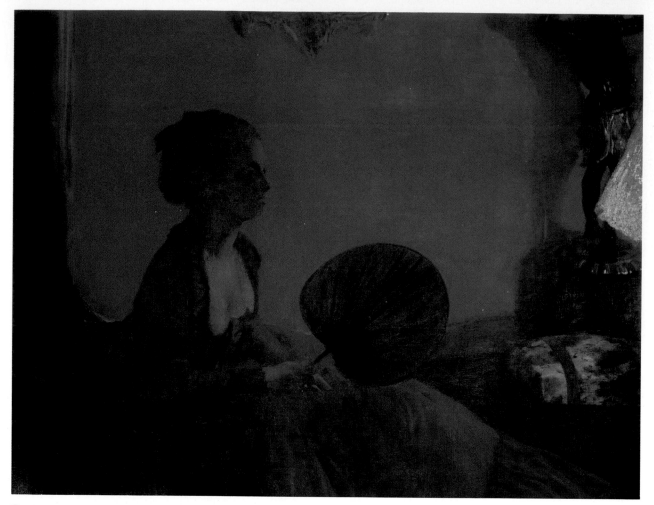

C. Edgar Degas, *Madame Camus*. 1869-70. (National Gallery of Art, Washington, D.C.; Chester Dale Collection)

Value

Value, the range from dark to light, is not only about gray. Every spot of color has a value. A color can be made lighter or darker in value by adding white or black to it, or by mixing it with another darker or lighter color. Every hue in its pure state is dark or light to some degree. By raising or lowering the value of a color, we gain another color dimension and an even more flexible tool. The blue in **Figure A** is made lighter in one direction and darker in the other to produce a range from white to light blue to pure blue through darker blues to black. The hue itself, the blueness of the blue, is unchanged.

When they are made lighter or darker, some hues keep their characteristic flavor more than others. We tend to think of red at a light value as pink rather than light red. This is not just a semantic difference. Pink seems clearly related to red but also clearly

different. Add black to yellow, and we don't call the result yellow at all; we call it olive green. On the other hand, we think of blue as blue whether it is dark or light. It is therefore clear that there is a psychological dimension to consider regarding color and color decisions. In the end, we depend on the judgment of the eye more than on charts or rules.

Remember too, that every pure hue has its own value before we start mixing. No color is as dark as black or as light as white, but pure violet is darker

A.

136

D. Leonard Dufresne, *A Young Family*. 1992. 6 × 7.25 inches. O. K. Harris
 Works of Art.

than pure orange; yellow is lighter than green. By arranging the color wheel as a color-value wheel, according to the value of each hue, we develop a simple curve, with violet as the darkest hue and yellow as the lightest (**Figure B**). Or, you might try placing the six primary and secondary colors next to the gray of the same value on a gray scale. This can be tricky to do. Yellow, for example, despite its brilliance and strong character, has the lightness of value we generally associate with soft pastels. It is so different in value from any of the other hues that it winds up by itself at one end of the scale.

A work that is *monochromatic* uses only one hue and creates contrast by variation of value. The painting by Edgar Degas in **Figure C** is interesting for its emphasis on value rather than hue differences. Throughout most of the picture, the range of hues is small. A yellow note darkens to green and then to black. Otherwise the painting deals mostly with

lighter and darker reds. The lightest happens across the sitter's throat and upper chest. A middle-value brick red blooms on the wall behind and darkens into the wine color of her dress. The stress on a single hue invites us to savor the differences within a single color. At the same time, the near-monochrome scheme beautifully suggests the hooded light of an apartment at night.

In Leonard Dufresne's painting in **Figure D** value differences also count. We are presented with a great variety of colors, and each hue is then modeled, adjusted in value to create heavy, sculptural volumes without muting the distinct personality or individual character of each hue.

also see: Light: Comparing Values
 Color Keys

B.

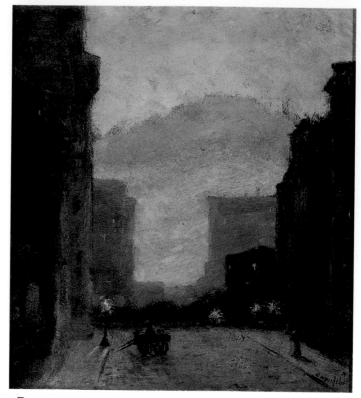

B. Louis Eilshemius, *East Side, New York.* c. 1908.
(Hirshhorn Museum and Sculpture Garden,
Smithsonian Institution, Washington, D.C.)

Intensity

A third characteristic of any color is its *intensity,* its brilliance or dullness (grayness). Any hue is most intense in its pure state, when no black or white has been added to it. Adding black or white or both (gray), or adding the color's *complement* (the color opposite it on the color wheel) lowers the intensity, making a color duller.

A color at the lowest possible intensity is said to be *neutral.* In **Figure A,** red is gradually made neutral by adding more and more gray. In theory, a neutral is the same as a gray, but in practice we find that the neutral made from a color mixture will always have a different flavor from a gray mixed from black and white.

There is a tendency to confuse intensity with value. Often when the intensity of a color is lowered, its value is lowered as well. But the two qualities are not the same. In the painting by Louis Eilshemius (**Figure B**), we see a sky that changes dramatically in intensity, from dull gray to brilliant yellow, without changing much in value. Reproduced in black and white, the sky would appear as a fairly uniform gray.

The eye is most sensitive to value change. The average person can see about two hundred distinct steps in value from black to white before the steps visually blend into an even continuum. For most colors we can distinguish only about twenty steps in intensity, from the pure hue to a neutral gray of the same value. Remember, too, that just as it has its own value, each hue has a different intensity, even in its pure state. Yellow is more intense than blue, violet is not as brilliant as red.

Intensity is perhaps the most subtle of the visual qualities that constitute a color, but it is also a wonderfully rich means for modulating a design. In Geraldine Millham's tapestry in **Figure C** we see the beautiful velvety quality of a color scheme in which all colors are of a fairly uniform low intensity. The painting by Stuart Davis in **Figure D,** on the other hand, demonstrates the vibrant, almost electric energy of high-intensity color.

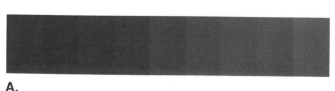

A.

C. Geraldine Millham, chairback tapestry (detail). 1984. (Courtesy of the artist)

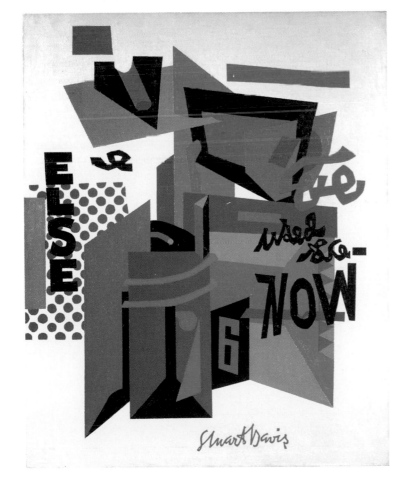

D. Stuart Davis, *Owh! in San Pao.* 1951. (Collection of Whitney Museum of American Art, New York; purchase. Acq. #52.2)

139

Temperature

In addition to hue, value, and intensity, color has another dimension, a psychological one, difficult to measure and diagram, but one that we all feel and respond to. This is the quality we call *temperature*.

Colors can make us feel warm or cool. People coming from the cold into a pale blue-green room will not feel warm as quickly as they will entering a red-brown room heated to the same temperature. Psychologists have even demonstrated differences of several degrees in the body temperatures of people in rooms of various colors, even when the air temperature was the same. Some of this may be a kind of biofeedback, the result of habit and association. We have come, habitually, to expect swimming pools to be painted cool aquamarine blue and fast-food restaurants almost always choose red-orange or red-yellow color schemes. But the psychological effects of warm and cool color are also real effects.

Most of us see the range from yellow through orange and red as warm, and the range from green through blue and violet as cooler (**Figure A**). Although context and personal temperament make a difference, it can be said in general that red or red-orange is the warmest color and blue-green or blue, the coolest.

Temperature is a useful tool when an artist is working without a full palette of color. The painting by Edwin Dickinson in **Figure B** uses warmer and cooler grays to create the impression of color. At the cool end of the scale are blue grays, at the warm end are brownish grays, and in between are a wide range of warmer and cooler neutral tones, made from various proportions of blue, brown, and white. The overall impression is not the same as full-color painting, but there is the feeling of color beyond what a simple black-and-white palette can create.

Just as fire is a release of energy, hot color is often seen as high-energy color. In the same way, cooler colors are thought of as calm or contemplative. This may be because colors like blue and green recall visual experiences like a clear sky or quiet water or the color of summer trees and grass, whereas red and orange are the colors of more active things—flame, traffic, flesh. We can see the vibrance of hot color even when detached from recognizable objects. In Patrica Coomey-Thornton's painting in **Figure C,** hot color is allied with an energetic flurry of expressive brushwork.

also see: Making Space

A.

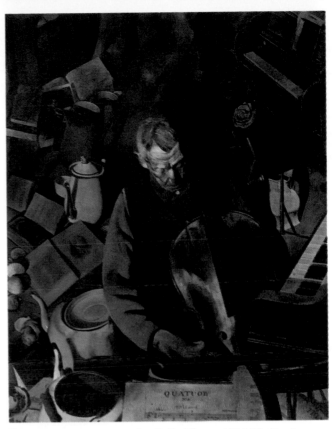

B. Edwin Dickinson, *The Cello Player.* 1924-26. (Jordan-Volpe Gallery, New York)

C. Patricia Coomey-Thornton, *Narcissus.* 1984.
(Courtesy of the artist)

12 The Structure of Color

Complementary Color

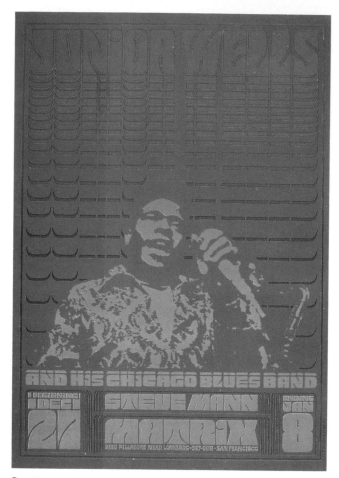

C. Victor Moscoso, *Junior Wells and His Chicago Blues Band.* 1966. (Collection, The Museum of Modern Art, New York; gift of the designer)

Stare at the red dot in **Figure A** for about thirty seconds and then shift your eye to the small black dot in the adjacent square. Most people will see a ghost image, a blue-green circle on a white field. This blue-green is the *complement* of the red, the exact opposite color quality. Where did this color come from? Explained simply, by staring, you have strained your eye's color receptors for red. As these receptors relax, the blue-green receptors are activated as a sort of compensation, much in the way one might restore equilibrium with a cold shower after a hot sauna. A camera would not see the blue-green you are seeing, nor is there any way of recording it, but it is there for the eye none the less.

Psychologists call this phenomenon, a color generating its own complement, *successive contrast*, and the complementary color produced, the *negative afterimage*. That particular blue-green manufactured by our senses is precisely the complement of that particular red. A different red would produce a different blue-green. Were this experiment to be continued using other colors, the result would be a sequence of contrasting pairs, and using them we could generate a color wheel based on absolute visual opposites.

Another way to understand the balance of complementary pairs is to mix the colors physically, as in **Figure B.** Each pair—blue and orange, yellow and violet, and red and blue-green—combined in different proportions, will produce the same neutral, a tone of no particular hue or temperature and of the lowest possible intensity. This neutral is the balanced

 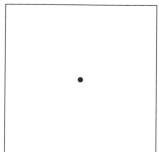

A.

combination of opposites. It is made up of all the colors of the spectrum (as each pair contains red, yellow, and blue. For example, the red and green combination is actually red and blue/yellow) and is the common ground between them. Such exercises seem to demonstrate what is already sensed, that some balance or special relationship is built into these pairs, that together they have a satisfying completeness, that each color contains something of its opposite, even if it is just a memory.

Like many opposites, complementary pairs make lively and interesting partners. Each pair has its own particular character and strikes its balance in a different way. Victor Moscoso uses complementary colors for their vibrancy in his poster in **Figure C.** The opposition of red-orange and blue-green, colors of near equal value and high intensity, creates a visual vibration, an almost unbearable sense of tension between two strong colors. This is a color scheme meant to overload the eye.

The Henry van de Velde poster in **Figure D** puts a hot yellow together with its complement, a dark, low-intensity violet, and the effect is like light and shadow. There is heat here too, but it is the sunlight and cool shade of a tropical day.

also see: Elements of Color: Intensity

Interaction

Harmony & Dissonance

D. Henry van de Velde, *Tropon l'Aliment le Plus Concentre*. 1899. (Collection, The Museum of Modern Art, New York; gift of Tropon-Werke)

B.

Color Systems

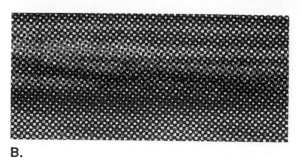

B.

A circle or wheel is often used to organize color and demonstrate the basic relationships between the hues, but before such a wheel can be made, some simple-seeming questions need to be addressed. What exactly do we mean when we say "red" or "blue"? Each of us probably calls to mind a slightly different version of each of these colors. Also, what kind of chart would show the connections between hue, value, and intensity? And most important, even if one could devise such charts and models, what use would they be to artists?

There are several good and not so good answers to each of these questions. What do we mean by red or blue? Well, it depends. When light is passed through a prism and broken up into a spectrum, the colors that emerge are not exactly like the fire-engine red or deep sky blue we might expect. Instead, the red is a violet-red (sometimes called magenta), and the blue (called cyan) has a greenish tinge. A color wheel in which these were the primaries would look approximately like the one in **Figure A.** These odd-looking primaries are also a printer's or a photographer's primaries: When printed as transparencies or as halftone dots, they produce the full range of color we see in commercial color printing (**Figure B**).

A second approach might be to develop a perceptual color circle, one that reflects personal temperament and experience—the reddest red, the bluest blue, and the yellowest yellow an individual

A.

can imagine, arranged with even-looking gradations between them. William Ostwald developed this kind of more subjective color circle (**Figure C**). Ostwald took the visual weight of color into account along with its composition. For example, he gave more importance to green, a color he considered the visual equal of red, yellow, or blue. He expanded the range from yellow to blue, and shortened the one from blue to red. This wheel emphasizes the *rightness*, if not the scientific correctness, of the eye's judgment, and this subjective attitude is reflected even in the color names.

Another very personal and beautiful system for organizing and thinking about color relationships is the color triangle worked out by the German poet and philosopher Johann Wolfgang von Goethe nearly two hundred years ago (**Figure D**). Goethe's simple and ingenious layout frames triads of primaries and secondaries around a group of low-intensity colors mixed from the complementary pairs. Spend some time looking at Goethe's triangle. Use a piece of paper to mask off sections of the triangle, and you will see shifting harmonies and color groupings within. Notice how a primary color dominates when mixed with its complement. Play with it.

Some color theorists have tried to develop systems that would take value and intensity, as well as hue, into account. Albert Munsell devised a color circle based on optically correct complementary colors (the ones your eye would generate through successive contrast) placed opposite one another. He then extended the whole into an asymmetrical solid.

C.

D.

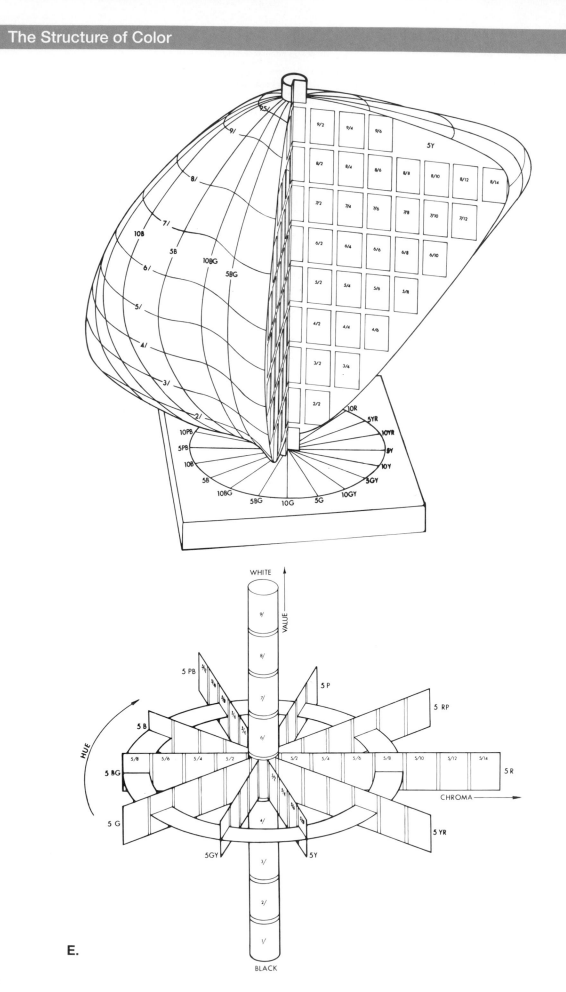

E.

F. Paul Signac, *The Application of Charles Henry's Chromatic Circle.* 1889. (The Metropolitan Museum of Art, New York; Purchase, Mr. and Mrs. Dave H. Williams; gift, 1990)

Hue changes around its equator, value changes from the north pole (white) to the south pole (black), and intensity diminishes from the surface to the neutral core. (**Figure E**) The lopsidedness of the shape results from Munsell's acknowledgment that different hues have different value and intensity ranges.

Color systems like this one have been especially useful for printers, designers, and manufacturers of ink, paints, paper, and dyes, helping to bring some order to a big range of hue/value/intensity. Products such as the Pantone color-matching system replace personal but imprecise descriptions—"bone white" or "pinkish gray"—with standardized and easy-to-find color choices. With such a system a designer can choose a numbered color and be sure that a printer using the same system will be able to match it exactly.

Applying color theory to works of art requires a leap of the imagination. The poster in **Figure F,** by Paul Signac, is an attempt to put into practice the somewhat obscure and mystical color theories of Charles Henry, a nineteenth-century scientist. The charming result is a product of the artist's enthusiasm and intuition rather than a proof of the correctness of a theoretical structure.

Most theorists who have studied color have also been sensitive enough to realize that colors cannot all be squeezed into the same measure. They intuitively understood the only real rule about color: If it looks right, it is right, regardless of what the charts say. Still, these color systems suggest ways to be thoughtful and conscious workers with color. They encourage the user to imagine possibilities and color combinations, to guess the effect of making a color darker or lighter, brighter or lower in intensity, warmer or cooler, to anticipate how colors might affect one another, to muse about and play with the spectrum. In the end, the order of cause and effect that these color systems try to explain must become part of the process of thinking as an artist.

also see: Elements of Color

Complementary Color

Color Symbolism

Hierarchy & Subdivision

Mixing Light

We've established a few things about the nature of color—that it is produced by the different frequencies or wavelengths that combine to form white light, that light *is* color, and things *have* color. Although the results of mixing colored media are to a large degree predictable, color remains mysterious. It resists simple analysis and the easy neatness of diagrams.

But in a way these truths are only partial until the differences between colored things, like paint, and color itself, or light, are considered. This is not mere scientific hair splitting. Paint and other colored materials do not behave in the same way that light does. These two very different kinds of behavior inform one another in our experience of color.

Suppose that rather than working with paint and paper, you were to use beams of colored light as your medium. We know that because all the colors of the spectrum are components of white light, white light itself must be the sum of all colors. A beam of white light passed through a prism breaks up into a spectrum, and, going the other way, the colors of the spectrum combine to form a beam of white light. As each color is added to the mix, light is added, and the result will be a complete, white light. This process of mixing is called *additive* (add color, add light), and it is easy to see that it is quite unlike what happens when we mix paint.

Light mixes in other unexpected ways as well. It is based on a different set of primaries—red, blue-violet, and green. If beams of these colors are projected together, they will produce white light (**Figure A**). Almost more startling, if beams of red and green light are mixed, the result will be yellow. Red and violet produce a lighter magenta, and green and violet make cyan blue. In each case the secondary mixture is lighter (has more light) than the primaries from which it was made. In any combination, though, more color equals more light. This additive effect, familiar to those who work with theatrical lighting, is so different from most other experience of color mixing that it's difficult to believe without seeing.

Remember that a colored surface gives off real colored light. Hold the sleeve of your red shirt close to the white wall of a sunny room, and it will cast a red glow. The possibility that this reflected light and additive mixture, the mixture of real light, could be used as a creative element has been intriguing to artists, especially since the middle of the nineteenth century.

A flat circle, called a *Maxwell Disk*, painted with carefully controlled areas of red and blue-green will,

when spun like a top, produce a white glow, which seems to float just above the surface of the disk. Phenomena of this kind tempted painters like Georges Seurat to try building pictures out of tiny dots of color applied over large areas. When viewed from a distance, the reflected light from these painted surfaces mixes in the eye, generating a transparent shimmer across the canvas. Because optical mixtures blend differently from pigment mixtures, there is always something new and unexpected in these *pointillist* color mixtures. Of course, since we are talking about real light here, effects are delicate and ephemeral, not easily transmitted in a small photographic reproduction in which the image is already broken down into a pattern of halftone dots. Even so, looking at the painting by Georges Seurat in **Figure B,** it is possible to sense the change that the painted dots undergo when seen up close, as in **Figure C,** and then at a distance.

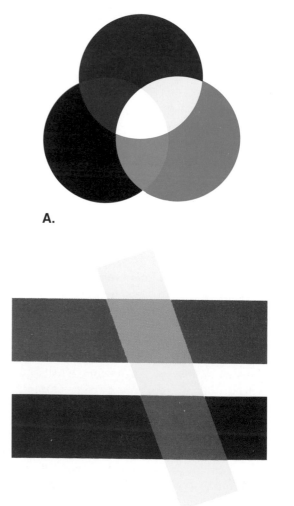

A.

D.

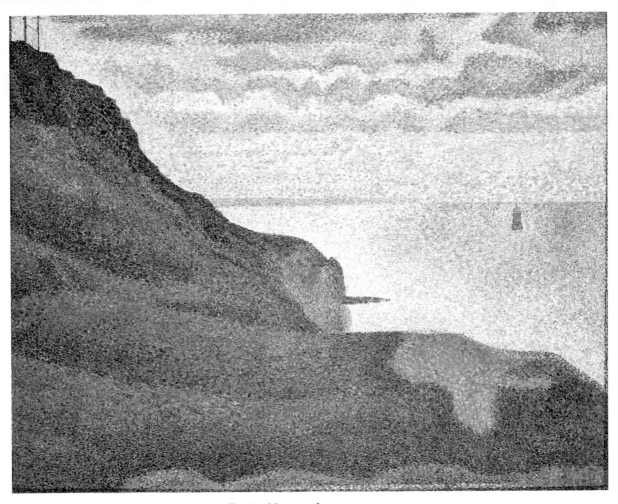

B. Georges Seurat, *Seascape at Port-en-Bessin, Normandy*. 1888. (National Gallery of Art, Washington; Averell W. Harriman Foundation in memory of Marie N. Harriman)

This kind of color mixture also has special relevance to typographic design, where lines and columns of colored type may form transparent fields against colored backgrounds, creating a sort of typographic pointillism and affecting the way we see the color of text close up and from a distance.

A variety of illusions can be created using paint, even including the illusion of something like additive color. In **Figure D** a series of painted areas placed side by side create the appearance of a film of light. In this case, the illusion gives the lightening effect of additive color without following the rules for mixing light. We can duplicate the effect of additive color in paint, but we have to cheat, using the rules of paint mixture to mimic the behavior of light. The basic rule is that whatever a film or a light does to one color, it must do to any other color it touches. If a color film seems to lighten a blue background and make it yellower, it will also have to lighten and make yellower any other background to the same degree.

C. Enlarged detail of Figure B.

also see: Space & Volume
Color Systems
Local Color

149

Mixing Pigment

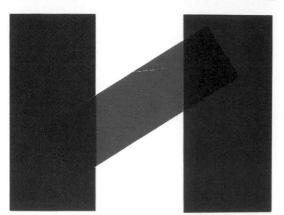

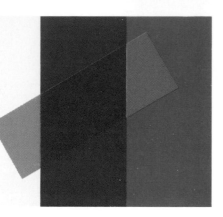

B.

Pigments, paints, or colored inks can be mixed with predictable results. The primary colors—red, yellow, and blue—will produce secondary and other intermediate colors; the value of a color can be raised by adding white and lowered by the addition of black; intensity is reduced by the addition of a color's complement or of gray, and so forth. But there is also a more general principle at work.

Imagine a sequence of sheets of colored glass, dyed red, yellow, and blue, as in **Figure A.** Each would allow some colored light to pass through and would filter out other colors or light frequencies. As these films are layered, more and more frequencies of light are cut out. The light that gets through is progressively dimmer until no light can pass at all. In this series, as colors are added, light is subtracted. The result of filtering out all the colors is the absence of light, or black.

Generally, this is what happens when we mix paint. This kind of mixture, in which more colors mixed together result in less light, is called *subtractive*.

In reality, for a variety of reasons having to do with the way the eye and brain receive and interpret visual information, paint doesn't follow this model exactly. All the colors on a painter's palette combined do not produce black, but rather a dark neutral tone. Still, the principle is basically the same—more color, less light.

The water is further muddied by the fact that pigments combine to produce colors that do not appear on the spectrum of pure light—such as brown, ochre, olive green, and metallic colors. These colors result from complex mixtures of several colors or materials. Furthermore, different kinds of paint (or pastels or printer's ink) behave slightly differently. The most that can be said is that, in general, as more colors are mixed together, the resulting color will be less intense. So, finally, we have to learn about colors in media, as opposed to color in general, by using them, guided by what can be learned from color theory. The painter who tries to lighten red paint by

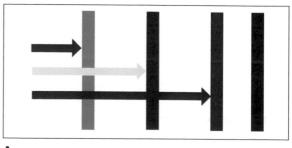

A.

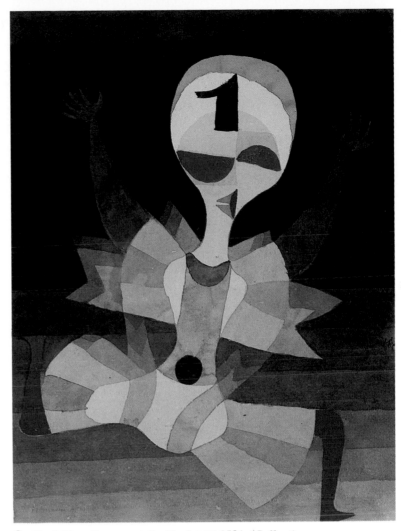

C. Paul Klee, *Runner at the Goal, 105.* 1921. (Collection, Solomon R. Guggenheim Museum, New York)

adding white paint finds that a lighter red is also less red, as if the life had been drained out of it.

Once we understand how pigment mixes, we can use it to create illusions of subtractive mixture and a rich sense of deep color space. This can be seen even in a simple diagram that seems to place a darkening, subtractive film or shadow over several colors (**Figure B**). The basic logic for creating this effect is the same as for additive effects: Whatever a transparency or shadow does to one color it must do to any other color. A piece of pink cellophane laid over red, white, and blue will add the same amount of redness and darkness to each color, so red will become redder, white will become pink, and blue will turn violet. A gray shadow cast over yellow, red, and orange again needs its own special adjustments to make the illusion convincing. Here the gray turns the yellow into a gray-green, the red to a sort of brown, and the orange into a more neutral greenish color.

Artists working with paint rather than with colored films have to use their eyes along with their knowledge of how color and light mix, to adjust each area so that color seems to change uniformly.

Illusions of light and dark films are used eloquently in the painting by Paul Klee in **Figure C.** Here veils of color seem to create layers of transparency as if adding and subtracting sheets of light itself. The poetry of Klee's image is related to the way in which he seems to make the darkness rich and many layered.

also see: Color: Overview

Elements of Color: Hue

Elements of Color: Value

Elements of Color: Intensity

Making Space

151

Color Harmony

F. Robert Delaunay, *Eiffel Tower*. 1924-26. (Hirshhorn Museum and Sculpture Garden, Smithsonian Institution, Washington, D.C.)

Analogous Color is a harmony of hues close to or touching one another on the color wheel, although often of different values and intensities (**Figure B**).

Triadic Harmonies are based on groups of three colors more or less equidistant from one another on the color wheel. The three primary or the three secondary colors form triadic harmonies, but any group of three will serve, if they are evenly spaced around the color wheel (**Figure C**).

Complementary Harmonies involve the pairing of any two colors that sit opposite one another on the color wheel, for instance, red with blue-green or yellow with violet (**Figure D**).

Split Complementary Harmonies group a color not with its complement, but with the pair of colors adjacent to its complement, as red with blue and green or yellow with red-violet and blue-violet (**Figure E**).

Colors close in value or intensity seem also to have harmonious relationships. Finally, one could continue and find a nearly endless string of relationships that seem to link colors.

In truth, harmony is not as simple as any of these. Among other things, the way we see colors depends not only on the colors themselves, but also on the size of each color area, on the shapes that contain the color, and on the interaction between neighboring colors.

The similarity between the way we understand sounds and visual sensations becomes particularly evident when talking about color. Like music, color can be strongly emotive and expressive. The idea of harmony especially is applied to both music and to color. Certain combinations of color, as of sound, have seemed to have a special beauty or be intrinsically pleasing in ways most people recognize intuitively. The notions of balance and resolution are implied in color harmony.

In traditional color theory, harmony refers to clear relationships based on divisions of the color wheel and proximity of value, intensity, and temperature. Some examples follow:

Monochrome Color refers to a harmony of tones all of the same hue but at different values and intensities (**Figure A**).

A.

B.

C.

D.

E.

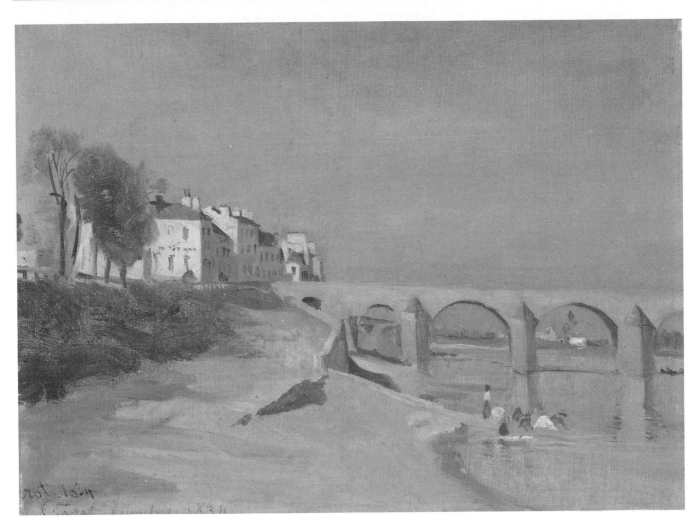

G. Jean Baptiste Camille Corot, *River Scene with Bridge.* 1834. (National Gallery of Art, Washington, D.C.; Ailsa Mellon Bruce Collection)

Then there is another question. Is the traditional definition of harmony—resolution, calm, balance, everything falling clearly into place—necessarily a useful or desirable goal in every situation? Certainly dissonance, the opposite of harmony—the color that surprises, that doesn't fit and disturbs the visual peace—is sometimes desirable. Dissonance in color, as in music, can be jarring or violent. It can be a potent tool for artists who want to express something other than balance and serenity.

In Robert Delaunay's painting in **Figure F,** colors are arranged to clang against one another with the sharp and dissonant clash of cymbals, discontinuous and jarring. There are no gradients of color change, no transitions, only a bright and raw feeling suggestive, for Delaunay, of the freshness and vigor of the new, modern world. Delaunay's vision seems to turn its back on the quiet harmony of the landscape by Camille Corot in **Figure G,** with its blonde palette and quiet radiance. In fact, each picture follows its own logic and makes its own rules.

Finally, it is important not to confuse harmony with beauty and dissonance with ugliness. Is Delaunay's sumptuous color, with its aggressive lack of refinement, ugly? Imagine a color exercise in which each student is asked to make a group of three ugly colors and three beautiful colors. When all the groups are put up on a classroom wall, could anyone tell which is which?

also see: Elements of Color: Value

Color Systems

Levels of Order

Harmony & Dissonance

Color Keys

A. Wolf Kahn, *Barn and Blue Delphinium.* 1979. (Collection, Cecily Kahn)

The same tune can be played at different places on a piano keyboard. If it is begun at the low end, it may sound heavy and rumbling. If played in the treble, light and bright. The different sound qualities produced by the thin and thick strings are called "tone colors" by musicians. The musician knows, of course, that hitting random groups of keys on the piano at once is more likely to make noise than music. Selected groups of notes in combination produce chords, harmonies, and dissonances, sounds that have a clear shape for the ear.

If we think of the gray scale, the range of value steps from black to white, as something like a keyboard, we can see how it is possible to play on either the low or high end. Imagine further a scale of intensity, with dull, neutral colors at one end and high-intensity, saturated, vibrant colors at the other. Superimpose the circle of hues onto these two scales, and you can begin to see how rich the tonal possibilities are.

The simplest design put together in different color-value ranges or *color keys* can look dramatically different. When the painter Wolf Kahn looks at the same building at different times of day, seasons of the year, and weather, he sees not the same thing clothed in different colors, but different things (**Figures A and B**). The changing color keys change the whole character of the picture. In one painting the bright glare of summer sun on a rooftop is a key note, around which darker colors glow. In another, small differences, the change from a rose-tinted gray to a slightly greenish silver, show us the eloquence of color on a foggy day.

To make sense out of the confusing range of color possibilities and combinations, visual artists, composers of visual music, make choices and work with colors in groups. Some media or projects have built-in limitations; a designer or printmaker might be obliged to work with only two or three colors while a photographer or painter might seem to have a much wider range available. The important point is that although choices may be made differently, once chosen, the color key goes a very long way toward defining the flavor, the mood, the tone of a work.

The Persian painting in **Figure C** gives the eye some of the voluptuous pleasure that might be gotten from looking at a brilliant and delicately colored butterfly. As carefully planned and finely drawn as it is, it is the radiance of the hues, their high, light key, that grabs and holds the eye. In any color key, high or low, there will be a dominant note, one or two colors that become the central color motif in the composition. In this image, it is the blue-violet and soft green against the ochre-gold that stays in the eye.

The dark, saturated blackish greens, dull ivory, and murky orange of Giorgio de Chirico's painting in **Figure D** together create a visually dense, almost oppressive color scheme. To choose also means to leave out what is not chosen. No bright yellow, pastel pink, or sky blue intrude. The low key intensifies the loaded and gloomy stillness that flavor the atmosphere of de Chirico's surrealism.

also see: Value Contrast
Weight & Balance

154

B. Wolf Kahn, *Barn Head-on.* 1979-80. (Mint Museum, Charlotte, N.C.)

C. Iranian Painting, *A Princely Hawking Party in the Mountains.* Metropolitan Museum of Art, Rogers Fund, 1912.

D. Giorgio de Chirico, *The Song of Love.* 1914. (Collection, The Museum of Modern Art, New York; Nelson A. Rockefeller Bequest)

Interaction

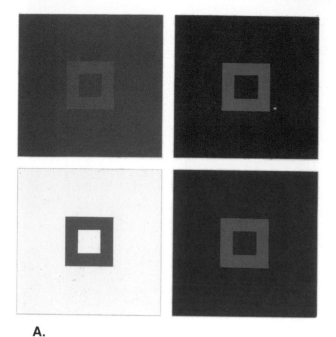

A.

When speaking of hue, value, and intensity, we are, for the sake of discussion, imagining color in a void, but we've already established that there is no such thing as a single and isolated color. Colors are always seen next to other colors. The first spot of color put onto a surface is seen against the color of the surface. A cool white? An ivory white? Black? Green? Color is bound to keep company with other color, and the effects of this, the way colors interact, is the real subject for anyone who studies color.

A gray strip appears to change dramatically when the value of the background is varied. An even more complicated pattern of interactions happens between colors. The hue, value, intensity, and temperature of a color area are all affected by color interaction. In **Figure A** a single, fairly low-intensity color is placed in four different color fields, and it changes its face each time. Here color interaction makes a single color appear hotter, cooler, lighter, darker, redder and bluer. It can make shapes look bigger and smaller.

B.

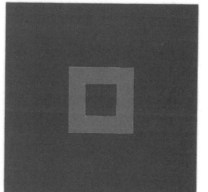

C.

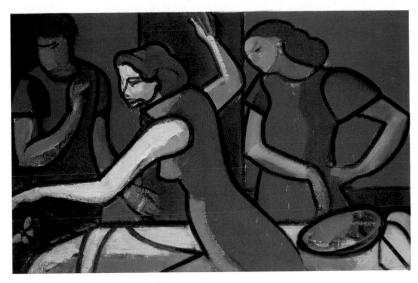

D. Leland Bell, *Dusk (I).* 1977.

(Compare the sizes of the center squares in each field.) It can make the edges of a shape seem harder or softer. (Compare the center square on the top left and bottom left.)

The color of the field will call forth its opposite quality in a color placed on it. This is something that happens in your eye and not on the page; the color is not physically changed. This effect in adjacent colors is called *simultaneous contrast*, and as a principle, applies to all color interactions. A color will appear lighter in value and more intense on a darker, duller ground and darker and less intense on a lighter, brighter ground (**Figure B**). The same green will look more yellow on a field of blue and more blue on a field of yellow (**Figure C**).

The colors themselves make a difference. Pure, intense, primary hues are more resistant to this kind of change. Neutrals and pale colors are more easily changeable. Size is another factor. Generally, larger color areas have more influence on smaller ones. The small green square is changed by the color of the yellow or blue field, not the reverse. And if you look very carefully, you will notice that all the color changes discussed are a bit more dramatic along the edges of shapes.

Crispness or softness, decisiveness or vibration, clarity or ambiguity in an edge can be the result of color interaction. For example, high-intensity colors, especially when they are of equal value and complementary hue, fight for visual dominance, and the result can be an edge that vibrates electrically. Sometimes color interaction is not what we want. When colors are isolated, separated by zones of black or white or gray, each color tends to retain its individual brilliance and vibration at the edge is eliminated. The black line in the painting by Leland Bell in **Figure D** has this effect on deep, clear and enamel-like areas of color.

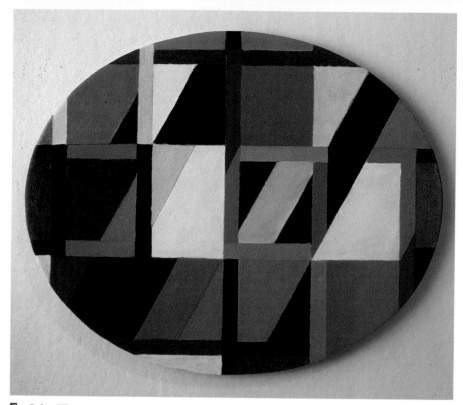

E. John Thornton, *Jack C.* 1987. (Courtesy of the artist)

Color changes where colors meet occur whether we wish them to or not, so it is critical for artists and designers to watch colors interact and to develop an eye for this interaction. It is frustrating (and sometimes expensive) to mix a color for a particular purpose only to discover that it becomes a different color when applied to a white canvas or illegible when printed on green paper. The Italian Renaissance painter Titian recognized the importance of knowing how to manipulate color when he bragged, as he supposedly did, that he could use mud to paint the flesh of Venus. What he meant was that if he could get a dull color into the right relationships with its neighbors, it would appear luminous, brilliant, and rich.

John Thornton uses an oval format and a simple vertical/horizontal/diagonal framework to build a poetic scaffolding for color interaction (**Figures E and F**). Each color is clearly stated and set cleanly against its neighbors. As restricted as this approach may seem, there is a lot to look at. In one painting we are invited to pay close attention to the variations in closely related colors—pinks, lavenders, and pale oranges. In another, areas of deep red, orange, and blue are set against smaller areas of white and mint green. The color groupings in each composition make particular kinds of light and space, and add up to a sort of colored architecture.

F. John Thornton, *Olivia*. 1987. (Courtesy of the artist)

also see: Relationships
The Line as Edge
Light: Comparing Values
Value Contrast
Complementary Color

13 Uses of Color

Weight & Balance

B. Olf Aicher, *Symbol for the International Olympic Committee.*

Darker hues, like darker values, tend to be heavier looking than lighter ones. A spot of dark crimson, for example, will look heavier than the same-sized spot of pale green (**Figure A**). As a general rule this is simple, but in practice it leads to an area in which fine decisions about color weight have to be made. How big a spot of green will it take to visually balance the crimson anyway?

Because color weight is a very subtle thing, it calls for an exceptionally careful eye. Otl Aicher's construction drawing for the emblem of the International Olympic Committee is a beautiful example. The Olympic logo (**Figure B**) is made up of five rings, each of a different color, value, and intensity. Aicher realized that the five rings drawn exactly the same width would, when reproduced in color, appear to be of different widths. To compensate for this, he gave each ring a slightly different thickness. The black ring is thinnest, whereas the yellow ring is noticeably thicker. Reproduced in color, the rings appear to be of equal weight.

Where Aicher works with color weight to create equity in a design, Louisa Matthiasdottir's painting in **Figure C** uses it to achieve another kind of balance. The composition is largely an essay in different kinds of blue, from the soft light blue-violet of the sky to the icy cobalt of the mountains on the horizon and the glowing ultramarine water, its color deepening in the distance. All is transparent and airy. Against this narrow harmony the artist opposes smaller, more concentrated areas of color—a bright yellow, black, cool whites, and a warmer red. The balance she achieves has an oddly sharp edge to it. The colors are all cold and fresh, the light convincingly specific even though rendered in a broad and sketchy way. Contrast of color becomes one of several dramatic contrasts—of near and far, vertical and horizontal, form and space.

We see a similar approach to color organization in Paul Klee's painting in **Figure D.** The space is different, and colors no longer attach to objects. Still, the likeness is obvious; a harmony of many blues set off by small squares and bars of red and brown in a strongly geometric and highly orderly scheme. But Klee's colors are dark and resonant. Differences are sometimes slight, but carefully drawn, the size of each color area finely calibrated. Both Klee and Matthiasdottir seem to know just how much greenish gray is needed to set off a given amount of dark blue. In Klee's design of gently echoing shape and color the red glows, as the work's title tells us, like a fire in the gathering darkness.

A.

also see: Weight

Weight of Value

Balance

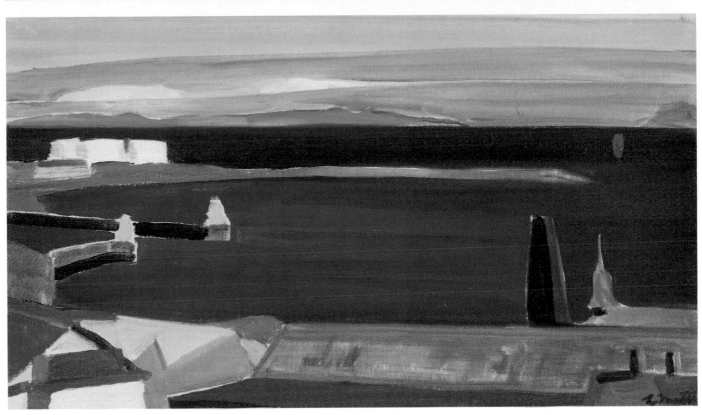

C. Louisa Mathiasdottir, *Reykjavik Harbor*. 1984. (Courtesy of Salander-O'Reilly Gallery, New York)

D. Paul Klee, *Fire in the Evening*. 1929. (Collection, The Museum of Modern Art, New York; Mr. and Mrs. Joachim Jean Aberbach Fund)

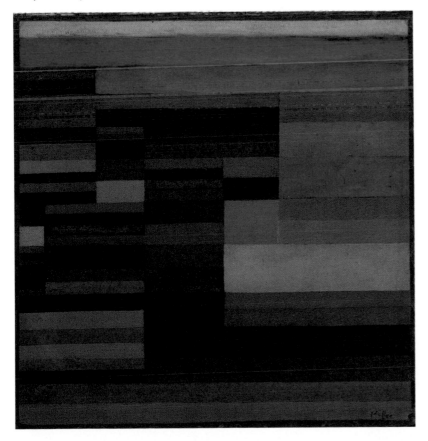

Making Light

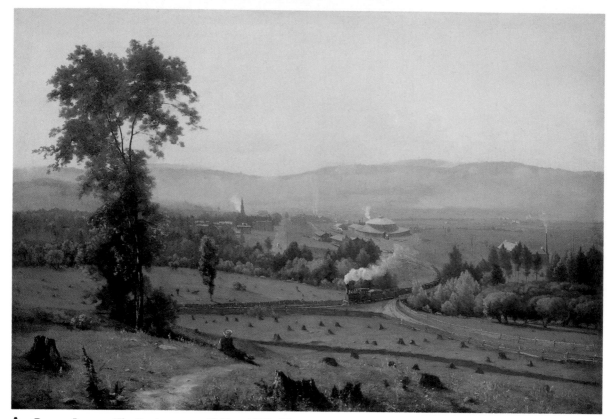

A. George Inness, *The Lackawanna Valley*. 1855. (The National Gallery of Art, Washington, D.C.; gift of Mrs. Huttlestone Rogers)

People who work with color speak of light in a work of art as a kind of apparition, a quality beyond color's four definable elements of hue, value, intensity, and temperature. For an artist, light can mysteriously fuse the parts of an image and infuse them with a specific and sensual quality, something more than the sum of the parts themselves.

The light that results from the interaction of colors is quite different from the shading and monochromatic tone of a charcoal drawing or a black-and-white photograph. Furthermore, when speaking of the light in a work of art, we may mean one of many things—the soft, voluptuous light, built out of the delicate blending of small changes as seen in the romantic landscape painting by George Inness in **Figure A**, the dramatic and stagey light of a picture by Honoré Daumier (**Figure B**), or the trembling, watery-looking light of color-loaded brushstrokes in a painting by Willem de Kooning, which generate energy from the abrupt clash of bright, high-keyed color (**Figure C**).

For light to be convincing in an image, there has

to be a kind of consistency that unifies all the different color areas. In the Inness, color changes, apparently seamlessly, from the bright, warm foreground to the softer, silver/violet distance. Carefully controlled gradients of color and value move in tiny steps, smoothly, through the space, filling it with a soft, hazy light. The Daumier is quite different; details are softened by darkness and the light piles up like snow on the tops or edges of forms. In contrast to the large radiance of the Inness, here the light acts out its drama in a small, close-up space. The picture seems lit by one kind of light only. Shadows and highlights are members of the same family. The de Kooning is equally consistent in its approach to color/light, demanding of each color that it contribute its share of luminosity to the vibrant whole, recasting bright sunlight as painted color.

also see: Overview: Light
Local Color

B. Honoré Daumier, *On a Bridge at Night.* (Phillips Collection, Washington, D.C.)

C. Willam de Kooning, *Door to the River.* 1960. Oil on canvas. 80 × 70 inches. Collection of Whitney Museum of American Art, New York. Purchase with funds from the Friends of the Whitney Museum of American Art. 60.63

Making Space

A. Ivan Chermayeff, *International Design Conference, Aspen 1973*. (Ivan Chermayeff, Chermayeff & Geismar Associates, New York)

Color can work with drawing, perspective, and the other tools at our disposal to strengthen the sense of depth, but color can also create space by itself. In general, cool colors, such as blues, tend to recede from the surface, while warmer hues, such as reds and oranges, tend to come forward. Like all rules having to do with color, this one can be bent to the breaking point by an artist who is sufficiently skillful and imaginative. An electric blue, for instance, can seem to be in front of a dull brownish red if the intensities are carefully balanced against one another.

More important than rules about what moves forward and what goes back is that colors put together will always create levels of space even when perspective or shading or other cues are absent. To see this more clearly, look, from three or four feet away, at Ivan Chermayeff's arrangement of colored tickets in **Figure A**. An in-and-out rhythm occurs as each color area finds its own level in front of or in back of its neighbors.

The fact that colors can be used to make space means that color is more than just a decorative element. It can be architectural, the basic building block that supports a structure of depth and solidity. Where a Renaissance artist might have divided the construction of a painting into three distinct steps—first drawing, then shading with light and dark, and finally an overlay of color, a modern painter like Paul Cézanne began with the idea that as color becomes richer and clearer, forms become more solid looking. Cézanne's forms, in his painting in **Figure B,** are built of small bricklike dabs of color, each spot distinct and definite, whether the artist is painting a boulder or a patch of sky. For Cézanne, the single operation of putting down a paint spot fuses drawing, shading, and coloring into one act, a kind of constructing with color.

Color spots attain another kind of independence in Howard Hodgkin's composition in **Figure C**. Hodgkin lays color on in wet dabs, saturated slabs like lava, and creamy touches. The natural tendency of color to push forward and recede creates surprises. A patch of blue streaked with white suggests a glimpse of distant whitecaps. The carnival colors of cerulean blue and strawberry pink give way to somber greens and a garland of brush strokes like black roses around the edge of the design. Hodgkin's work reminds us of the pictorial perspective box and of the way that fragments of memory wash over us.

also see: Figure & Ground
Depth Cues: Gradients
The Pictorial Box
Space Moving Out

B. Paul Cézanne, *Houses in Provence.* c. 1880. (National Gallery of Art, Washington, D.C.; Collection of Mr. and Mrs. Paul Mellon)

C. Howard Hodgkin, *Goodbye to the Bay of Naples.* 1980-82. (Private collection)

Local Color

A. Pierre Bonnard, *Nude in a Bathtub*. c. 1941-46. (The Carnegie Museum of Art, Pittsburgh; acquired through the generosity of the Sarah Mellon Scaife family, 70.50)

B. Andrea Mantegna, *Judith and Holofernes*. c. 1490. (National Gallery of Art, Washington; Widener Collection)

An object's local color is the color that it appears in clear daylight, that is, in a neutral, white light. But local color is not always what we see when we look at an object. A white teacup may look pink in the reflected glow of a red tablecloth, a white building will turn rosy in the sunset, and a buttercup held up to your chin will make it look yellow. Nevertheless, we still say that the teacup and the building are white. In a strict sense, local color doesn't exist. The colors that bathe an object are, after all, what we see. The fact that the cup might be drawing its redness from the tablecloth doesn't change the way it looks to the eye. Even in clear, midday light, a white cup will take on a bit of the blueness of the sky. To a sensitive eye, objects are always changing color.

All objects, regardless of their local colors, will absorb and reflect some color from the surrounding world, but more intensely colored objects tend to be less easily influenced by environment. A bright green, for example, would have to be bathed in a strong red light before its greenness would disappear. Even then, it would tend to look brown rather than surrendering to the influence of the red light. A pale blue or a white, on the other hand, would be more changeable.

When local color is largely eliminated, as it is in the painting by Pierre Bonnard in **Figure A,** we become more aware of the color of light. In the Bonnard, the color of the floor, walls, and even the color of the nude herself dissolve under the impact of the light. The local color of objects is inconsequential here.

When local color is strong, the light appears to be colorless. The emphasis shifts from atmosphere to form. Objects separate and become part of a different ensemble, one in which the individual character of things is more important. When strong local colors— reds, blues, and yellows—are attached to individual objects, there is a sense of unlike qualities being fitted together, and there is some visual tension in this association of differences. The individuality of strong local colors may threaten the visual teamwork needed to make an integrated composition, but color variety and contrast are satisfying food for the eye.

Local color is largely what is seen in the painting by Andrea Mantegna in **Figure B.** The red, yellow, and blue areas are clear and straightforward. The light that bathes the figures has no color of its own and allows each of the color notes on the costumes to make its own contribution. When a colored form is shaded (the woman's blue overgarment, for example), the hue of the color stays essentially the same from the light side to the dark. Only black is added to darken the blue here.

This kind of color might also be called surface color. We could use this term to stress the nonillusionistic qualities of color. If color is thought of not as sunlight in a landscape, or a shadow cast on a form, we might allow that blue or gray or red can be seen as visual objects, things in their own right, as real as a coat of enamel on a bicycle or a wall. This literal quality, of a layer of paint forming a skin on a simple form, gives Jean Arp's wood relief a striking air of the ordinary and the poetic (**Figure C**).

Paul Rand's logo in **Figure D** also uses the frank impact of local color. Distinct color personalities are presented for their forceful, eye-grabbing qualities. The harmonies and dissonances create a family of exciting differences. Here the terms *local color* or object color are still accurate, as long as we realize that the objects in question are colored shapes.

Jasper Johns thinks of color in this way and uses it to make a point about surface in his painting in **Figure E.** His *Three Flags* is a realistic painting of a well-known object. It is also real in a literal sense, that is, it is meant to be seen as paint applied to a surface. Could Johns have made the same work of art by gluing three flags together? Why bother to make them out of paint, and how is a painted flag different from a "real" one? Here surface color is used to set forth a paradox about the art of depiction and imitation, a meditation on what is real in an object and what is real about a painting.

also see: The Picture Plane
Color: Overview
Elements of Color: Hue
The World of Appearances
What's Real?

C. Jean Arp, *Enak's Tears (Terrestrial Forms)* 1917. (Collection, The Museum of Modern Art, New York; Benjamin Scharps and David Scharps Fund and purchase)

D. Paul Rand, *Logo for NeXT Computers.* 1986-87. (Courtesy of the artist)

E. Jasper Johns, *Three Flags.* 1958. (Collection of the Whitney Museum of American Art, New York; Fiftieth Anniversary Gift of the Gilman Foundation, Inc., The Lauder Foundation, Mr. A. Alfred Taubman, an anonymous donor and purchase. Acq. #80.32)

Volume & Atmosphere

B. Claude Monet, *Waterloo Bridge, London, at Sunset.* 1904.
(The National Gallery of Art, Washington;
Collection of Mr. and Mrs. Paul Mellon)

Color is not only looked *at*, but also *into*. Volume color refers to the way color by itself can make atmosphere and color space.

Think of a large fish tank filled with blue-tinted water. The nearest fish are easy to see—perhaps bright yellow tropical fish. Those deeper in the tank look greenish, taking on the blue tinge of the water, and at the back of the tank the fish almost disappear, blending into the blue distance.

Although it has nothing to do with parallel lines or vanishing points, this kind of space, gently and evenly receding into distance, is often called *atmospheric perspective*. This simply means that objects—landscape forms, trees, buildings, and mountains—take on the color of the light and lose their own, local color as they get farther and farther away. They are absorbed into the colored atmosphere, as shapes are absorbed into the colored background of **Figure A.**

In Claude Monet's hazy view of London (**Figure B**), only the nearest object, the bridge, retains its own color. The city behind is not blue but takes on the color of the shimmering haze.

Pierre Bonnard emphasizes distance and atmosphere by creating two zones in his landscape in

Figure C. The foreground is built from touches of greenish gold. Beyond the valley is a bowl of powdery blues and violets. By the time the eye reaches the distant mountains, landscape forms are as soft as the pearly clouds overhead. The gradient of color change from front to back is so smooth that we are barely aware of it.

Philip Guston's atmosphere comes as much from his palette as from any memory of nature (**Figure D**). His image is the gentle accumulation of color floated onto the canvas. The color flares up into

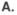

A.

168

apple greens and cool reds toward the center and evaporates at the edges into a blur of lavender and silver. Guston's light is as personal and recognizable as the summer sunshine in the Inness painting on page 162. Like Inness, Guston sees light as an agent that softens and gently dissolves forms in the depths of the canvas.

also see: Gradients
The Pictorial Box
Space & Volume

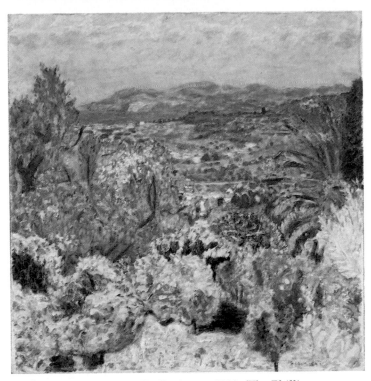

C. Pierre Bonnard, *The Riviera*. c. 1923. (The Phillips Collection, Washington, D.C.)

D. Philip Guston, *Dial*. 1956. Oil on canvas. 72 × 76 inches. Collection of Whitney Museum of American Art, New York.

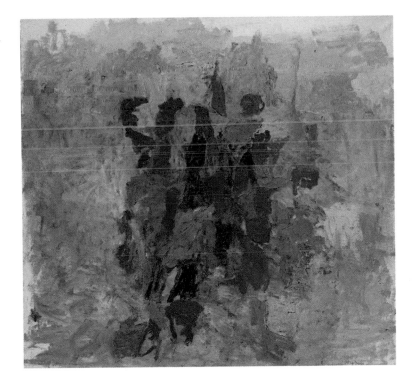

Transparency & Reflection

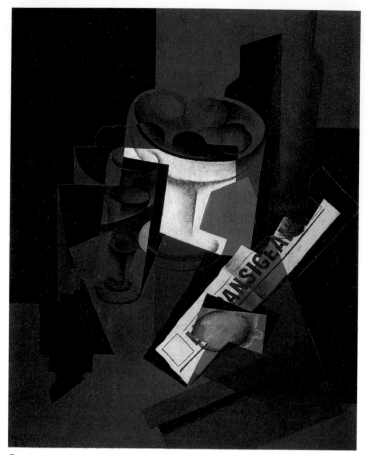

C. Juan Gris, *Still Life with Newspaper.* 1908-16. (The Phillips Collection, Washington, D.C.)

In Richard Estes's painting in **Figure A,** panes of transparent and reflective glass are used in a literal way to create a space of many layers. By alluding to the real transparency of glass, Estes turns the entire painting into a shadowy maze. His glass façade invites the viewer to look through and explore the space farther back. It also reflects a streetscape that, following the logic of the picture, is in back of us as we view the image. Forms and colors from the outside are brought in, creating unexpected juxtapositions. Space is "doubled up," layered with reflections and real objects. Estes recasts a kind of space that also fascinated Baroque painters like Peter Paul Rubens (see Figure A, p. 8): real space as the complement or partner of painted space.

Transparency and reflection offer other ways to construct with color, to make it richer, more complex, and spatially more suggestive. Color can be looked *through,* as if through a series of transparencies. When color areas are carefully juxtaposed and adjusted, the illusion of transparency creates another kind of deep color space.

Transparency makes forms visually lighter, dematerialized. Just as a glass wall in a building opens the structure to the eye, color used in this way allows the eye to move through planes rather than across them. This feeling of light and air is exploited by John Marin in **Figure B.** Planes of light, like panes of glass, fracture and magnify the already light-filled space.

By transparent color, we mean here not only the literal depiction of transparency, but a way of using color that leaves one with the sensation of looking at the world through a layering of color and light. The feeling of depth that is so strong in the painting by Juan Gris in **Figure C** is not the deep space of linear perspective. The space in that sense is quite shallow. Instead, Gris gives a sense of moving through transparent levels of space that form the heart of the picture.

also see: Mixing Light

Mixing Pigment

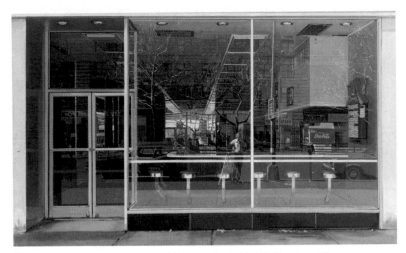

A. Richard Estes, *Double Self-Portrait*. 1976. (Collection, The Museum of Modern Art, New York; Mr. and Mrs. Stuart M. Speiser Fund)

B. John Marin, *Maine Islands*. 1922. (The Phillips Collection, Washington, D.C.)

Descriptive & Subjective Color

C. Paul Resika, *Provincetown Pier, for Joseph di Martini.* 1985. (Private collection; courtesy of Graham Modern Gallery, New York)

Artists often use color to describe appearances—color mixed carefully to match the tones perceived by the eye at a given moment. This calls for an ability to distinguish between subtle hue differences and to gauge things like color value and temperature accurately.

Of course this kind of description can include both local color (the color of objects outside of any context of colored light or reflection), and also the many changes that result from light, shadow, reflections, and other effects of a colored environment.

It is impossible to match the entire range of color in nature with the usual colored media. The whitest or brightest paint or ink does not approach the brilliance of a rosy sunrise, or even of a light bulb. The span from absolute darkness to sunlight is many times greater than the range available on a painter's palette. Descriptive color, as seen in the beautiful landscape by Claude Monet in **Figure A,** is often the result of adjusting, simplifying, and exaggerating to create something that appears neither adjusted, simplified, nor exaggerated.

The Monet is predicated on a sort of mutual understanding between the artist and the viewer: that there is something about the look of a landscape that we can all agree about. In this context, to paint a tree

bright red under a blue sky would violate that sense of common ground.

André Derain's landscape in **Figure B** also owes something to the way the world looks. The brilliance of late summer light, casting long shadows on the ground, is a starting point here, but Derain has other interests. Where Monet gently feels his way into nature, testing his sense of design and color against what he sees, Derain approaches painting as something parallel to nature but built out of different materials. He engineers an interplay of intense primary colors—red, blue, yellow, and green to express light and heat. We are convinced that these colors, neither naturalistic nor arbitrary, do tell something about a moment in nature and suggest another way of seeing it.

Paul Resika's landscape in **Figure C** is the work of an artist influenced by both the tradition of realistic landscape painting and the abstract formalism of modern art. Resika's light is specific. He paints the fading summer twilight of Cape Cod with a warm familiarity. His composition is as severe as his color is lyrical. Broad geometric fields of red, black, and a blue-gray flushed with rose are carefully adjusted and given their proper weight. A small rectangle of warm, bright light establishes a keynote for the larger color

A. Claude Monet, *Argenteuil.* c. 1872. (National Gallery of Art, Washington, D.C.; Ailsa Mellon Bruce Collection)

B. André Derain, *The Turning Road.* 1906. (The Museum of Fine Arts, Houston; John A. and Audrey Jones Beck Collection)

areas, and the red of the sky is pushed to the limit of expressiveness without crossing over to exaggeration.

These are three very different ways of working, and we could find many, many others. Working with color in a subjective way may be advantageous or disadvantageous, depending on the temperament and goals of the artist. Some artists believe that restrictions (such as having to match colors) force them to be more inventive. Others prefer the unlimited possibilities that they see in a more subjective approach. Although Derain's color may seem personal and expressive compared with Monet's color-matching and descriptive emphasis, each approach, of course, expresses a personal and intuitive way of seeing.

Color becomes most completely subjective when it is no longer a response to specific objects. Yet even when color choices would seem to be entirely personal, they are never arbitrary. A lot of what artists do with color is nondescriptive by its very nature. The designer or the typographer, for example, uses color not only as an expressive form, but for its function as part of an ensemble that must please the eye, organize information, create emphasis, or increase legibility. The choice of paper color for a poster or the color of a block of type reflect the internal demands of a composition rather than resulting from a give and take with outside reference points, as in Monet's landscape. Finally, decisions are always made subjectively, in the sensitive eye of the artist.

also see:

Color Symbolism

A. Gerard David, *The Rest on the Flight to Egypt.* c. 1510. (National Gallery of Art, Washington, D.C.; Andrew W. Mellon Collection)

Kandinsky wrote, "many colors have been described as rough or prickly, others as smooth or velvety, so that one feels inclined to stroke them" (such as deep, brilliant blues; intense, cool greens; and dark red-violet). "Some colors appear soft" (rose or pink), "others hard" (cool, whitish greens), "so that fresh from the tube they seem to be 'dry.' . . . The sound of colors is so definite that it would be hard to find anyone who would express bright yellow with base notes, or dark lake [rose] with the treble."

It's difficult to decide whether Kandinsky was on to some objective truth or whether he is simply offering up a very personal view. Some of his observations have to do with color qualities that we can all agree exist—like temperature, weight, and so forth. In other places he seems to be speaking of a world of personal or poetic responses to color. This is as it should be. Any creative person needs to cultivate some territory that is private, some preserve in between the categories and definitions found in design books. Perhaps the most that can be said about color symbolism is that it has always interested artists, and not just romantic artists. It may be a way of establishing common ground between artist and audience, a way of communicating. For artists like Kandinsky, it is a way of experiencing color more intensely.

In a typical sixteenth-century European painting like the one by Gerard David in **Figure A,** the blue of the Virgin's robe was universally understood to symbolize her serenity and virtue, as the red of the gown beneath stood for the Passion, and the grapes a prefiguration of the Last Supper. These meanings, although they may originally have derived from some visual quality, became part of a standard pictorial glossary. In a Picasso from the early part of this century, a "Blue Period" painting (**Figure B**), the color blue is used in a very different way, to evoke the sad and chilly isolation of the actors in his drama.

All of our perceptions come with strings attached, echos, associations, remembrances that are aroused by the things we see. These associations resonate strongly when color is placed in the hands of a sensitive artist. In Balthus's painting, *The Golden Days* in **Figure C,** the light of the fireplace radiates through all the color, making an intentional and powerful connection between its warm flush and the warmth of the girl's body. The color changes from left to right bring us from daylight, from the visible and open, to the encompassing warmth of a room at night, with echos of the campfire and the cave.

Sometimes we tend to attach symbolic meanings to colors. They can be seen as standing for certain emotions or states of mind. For example, in Western cultures red is considered a color of anger or passion, and white is associated with purity. These connections seem logical to anyone who has grown up with them. Other cultures, however, may make totally different connections. In parts of Asia, white is traditionally the color of mourning, worn at funerals as most Westerners would wear black. The colors of a monk's habit in the West are often brown or gray, understood to be colors of quiet meditation, but Buddist monks, no strangers to meditation, wear orange or saffron robes. The yellow that we associate with warmth and the sun in so many Van Gogh paintings was the color of the six-pointed star that marked the clothing of persecuted Jews in Hitler's Germany. The green often associated with growth and renewal is also the symbolic color of envy.

Some color theorists and artists, like the Expressionist painter Wassily Kandinsky, believed that specific links can be drawn between the way we experience color and other sensory experiences.

We are used to being told that bright colors seem bold, that dark colors are mysterious, that pastels are light in the sense of gaiety. Responses like these may be nearly universal, or they may be learned associations. But whenever color is used we find not only an inherent logic and structure, but also a surprising autonomy in its tendency to astonish, misbehave, and delight in unexpected ways that, finally, expand our vision and imagination.

also see: Signs & Symbols

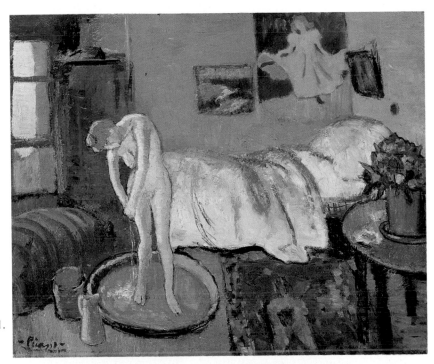

B. Pablo Picasso, *The Blue Room*. 1901. (The Phillips Collection, Washington, D.C.)

C. Balthus, *The Golden Days*. 1944-46. (Hirshhorn Museum and Sculpture Garden, Smithsonian Institution, Washington, D.C.)

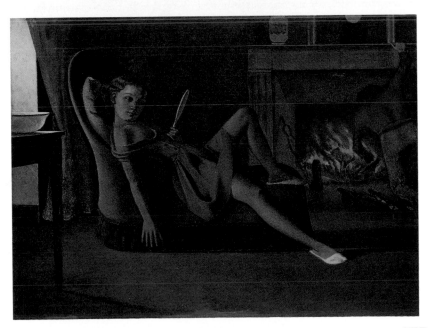

14 Unity and Variety

Overview

In addition to physical needs such as the needs for food, clothing, and shelter, human beings have psychological or emotional needs. One of these is the need to establish a balance between sameness and variety in what we experience. Long days spent repeating the same task are dull, but a life in which every day is chaotic and patternless would be just as bad. We need both expectability and surprise, order and variety.

Unity and variety are two sides of the same coin, and ideally keep company in the same object. This chapter will look at situations in which opposite qualities can be easily seen, such as symmetry and asymmetry. It will also look at ways in which they can be more subtly expressed. What does visual harmony look like? Or visual dissonance?

Throughout this book we have focused often on

A. Constantin Brancusi, *Muse*. 1912. (Solomon R. Guggenheim Museum, New York; gift of Ardé Bulova)

B. Francesco da Laurana, *A Princess of the House of Aragon*. c. 1475 (National Gallery of Art, Washington, D.C.; Mellon Collection)

C. Belt mask, Court of Benin, Nigeria. Sixteenth century. (The Metropolitan Museum of Art, New York; The Michael C. Rockefeller Memorial Collection; gift of Nelson A. Rockefeller)

contrasting qualities not only because comparing differences makes it easier to see them, but because making visual objects is always an act of balancing and contrasting visual forces.

If we were to choose twenty or so very different examples of heads, and arrange them on an imaginary scale from simple and unified to complex and varied, we might place the Brancusi sculpture in **Figure A** near the "unified" end and the Picasso in **Figure E** nearer to the "varied" end of the spectrum. One looks simple, all of a piece, while the other brings together many different forms, sizes, and shapes. In between and to either side we might propose a range of things that could include a poster combining text and photographs, a central African sculpture, an eighteenth-century French portrait, an early Flemish one, a classical Greek head, or one from New Guinea.

The difference between each work and the one next to it on this scale would be gradual, a sort of shading off, a difference of degree. If matters of style could be ignored in locating objects along such a scale, then the end result might be a series of unlikely seeming neighbors—a seventeenth-century African carving bracketed by a fifteenth-century Italian sculpture and an eighteenth-century French one (**Figures B, C, D**). A conversation might begin to develop between different styles. In each object, the artist responds to a particular set of conditions, possibilities, and limitations. Where one artist produces a work full of straight lines, another deals mostly with curves and roundness. Some works seem to be made of many separate shapes, others of only one or two big forms. Still, we can begin to think about all of them in terms of unity and variety.

D. Jean-Antoine Houdon, *Jean Louis Leclerc, Comte de Buffon.* 1782. (Hirshhorn Museum and Sculpture Garden, Smithsonian Institution, Washington, D.C.)

E. Pablo Picasso, *Head of a Woman.* 1909. (Hirshhorn Museum and Sculpture Garden, Smithsonian Institution, Washington, D.C.)

177

Levels of Order

A. Cathedral of Notre Dame, Paris. 1163-1250. (Photo, Susan Paul)

It is easy to see that a strict order or set of laws governs where windows, doors, sculptures, and other decorations go in the façade of a Gothic cathedral like Notre Dame (**Figure A**). Not only is the cathedral front highly orderly, but there is a very specific kind of order ruling its design. It is organized in a hierarchy. Things are located, grouped, and assigned a size in accordance with their relative importance to the thematic whole. At the bottom are the portals, whose decoration tells the story of the Virgin's life, her ancestors, and her progeny. Next are the kings of Judah and the obvious association to the kings of France. Above them the Virgin herself, focus of the whole and to whom the whole was dedicated, is centered and framed in the enormous halo of the rose window. The two towers and the spire visible between, the strong divisions into three zones, both vertically and horizontally, give tangible form to the idea of the Trinity. The whole design proposes a celestial and worldly order in which all parts fit into predetermined levels or niches, acknowledging their place in the entire scheme.

The kind of order involved in **Figure B,** a Chinese ornamental garden, is less strict and far more flexible, as well as less hierarchical. Masses of plants, different kinds of trees, and irregular rock formations are carefully placed into precise positions, but then are left to grow, to change with the seasons or the shifting light and weather. It is a more casual looking kind of order, and it has more than one focal point and a center that shifts with the viewer's point of view. It can be seen as a series of different systems of order, with rocks, trees, and architecture arranged to complement one another and nature invited to participate. It is an orderly arena for the interaction of nature and human design.

What these two kinds of order have in common is that they both arrange different elements—shapes, colors, and textures—to play dominant or subordinate roles, like actors in a play. In the cathedral, the great portal occupying the center of the large horizontal band at street level and the rose window above it, framed by the entire façade, are clearly the stars of the ensemble. Imagine, if you can, the rose moved off to one side. The ingredients of the Chinese garden work more like a company of actors whose roles are constantly shifting. From one angle, a bridge or pavilion may be visually dominant. From another spot, a viewer may see a beautiful grouping of trees and stone as a centerpiece, with the same bridge serving as a backdrop. Change and the motions of time are factored in.

B. Chinese garden.

Both these kinds of order are fairly complex. In the cathedral, systems and subsystems are created to deal with the many different shapes, sizes, textures and, originally, colors. In the garden a constellation of more or less equal and complementary systems is created, each of which contains its own hierarchy, as a large rock mass may contain smaller constellations of shape.

The breakdown of order from complex, or easily visible to simple, or random seeming is graphically demonstrated in **Figure C.** The "out-of-order" sense of a bad emotional relationship and its possible effect on health is visualized as a clear geometric order losing its legible form. Could the image have been made (even partly) by throwing the shapes over one's shoulder without looking? In visual art even when the sense of disorder is the theme, it is conveyed by organization and choice, that is, by order.

In our sense of the word, disorder does not exist. There are only levels, or kinds, of order, more and less easily visible as complex webs of relationship and connection. The cathedral has many, obvious, interlocking tiers of order. In a small child's room, covered with an even scattering of toys, books, and clothes, there are also relationships, but they are one on one. Every object, whatever its size, shape, or color, has approximately the same visual importance as every other object. The scattering creates a visual equality of position and subsumes everything into a single system. No subsystems or large groupings are intended. Rather than the viewer's seeing differences, everything becomes, in a sense, the same.

It is worth noting that one thing artists do is *find* order—in the tangled growth of a forest, in the structure of the human figure, in the apparent chaos of a child's room—and they also *create* order, out of the materials at hand—form, shape, and color. Most works of art do a little of both, and both of these activities are highly conscious.

The roots of marital tension

Patterns of Tension No. 6

C. Gottscalk & Ash Ltd., Brochure Cover. (Courtesy of Hoffman-LaRoche Ltd.)

179

D. Goerges Seurat, *Sunday Afternoon on the Island of La Grande Jatte*. 1884-86.
(Courtesy of the Art Institute of Chicago; Helen Birch Bartlett Memorial Collection)

The designer of Notre Dame imposed an easily visible order to convey an ideal vision of permanence, order, and stability, with a place for everything and everything in its place. Levels of order differently used can communicate other things. Georges Seurat's *La Grande Jatte* in **Figure D** deals with a wry and modern view of social levels. Seurat's late nineteenth-century city people are part of a society whose strict social divisions are beginning to come apart; the older, orderly pyramid of an agrarian society is being replaced by the democratic mix of an urban population whose members have no particular social ties to one another, new arrivals to Paris from many villages and suburbs. One theme here is the breakdown of a society from a hierarchy in which everything has a predetermined place, a niche in which to fit (as on the cathedral), to a shifting order of more random, sometimes one-on-one relationships (like the garden, or even the child's room). Figures are scattered rather than formed into ranks. Still, the design is highly organized and geometric. Seurat stresses the spaces between figures as emblems of emotional and social apartness, and he uses a system of modular proportions (the space between two figures, for example, might be twice the length of another figure). Even without explanation and analysis, it is easy to see that the arrangement of the figures is very self-conscious. The sense of disorder that is one theme of the picture is conveyed by an orderly arrangement.

also see: The Center

Proportional Systems

Symmetry

Asymmetry

Hierarchy & Subdivision

Harmony & Dissonance

A. Nicholas Poussin, *Holy Family on the Steps*. 1648.
(National Gallery of Art, Washington; Samuel H.
Kress Collection, 1952)

In music, when the notes C, E, and G are played together, they form a harmonious sound called a chord. The chord is like a "fourth sound," different from the three notes that comprise it and having a feeling of satisfying completeness. The notes seem to go well together, forming a musical sound structure. If we play C, E, and F instead of G, a dissonance results; the combination seems incomplete, feels restless. Often when talking about purely visual objects, the terms harmony and dissonance are borrowed from music to describe similar evocations.

In visual art there are shapes, colors, and sizes that, when put together, seem to form configurations or units that appear stable and complete. *Harmony* in visual art refers to this feeling of restful resolution. It is not necessarily or always desirable, but it is certainly a recognizable quality. Harmony and its opposite, *dissonance*, sometimes go by other names as well. Art historians are discussing this contrast when they speak of a classical or expressionistic feeling in art. The harmony of classical art can be seen in a work such as Nicholas Poussin's *Holy Family on the Steps* in **Figure A.** Here an architectural setting, a solid supporting stage of horizontal and vertical forms, contain the figures of the Holy Family. The family group is set back from the viewer by a step, and the

step is marked and emphasized with a still life—basket, chalice, and ornate chest—which creates a small distance or separation between viewer and the thing observed, and gives the whole a feeling of reserve.

In the figures themselves, movement is restrained, although each figure is delicately animated by small gestures—the gentle leaning of St. Anne on the left, the quiet playful crisscross of the children's arms and legs, Joseph's intent concentration as he writes. The figures together form a nestled group of pyramidal shapes, solid as a mountain range. The light seems to caress the scene, making uplit planes and shadowy valleys in the heavy folds of cloth. It lingers in unexpected places, as on the foot at far right or the still-life objects in the foreground.

Picasso's *Demoiselles d'Avignon* in **Figure B** is totally different, not only in style but in feeling. The platform that Poussin builds for his family is discarded as the figures are pushed up close to the front edge of the picture, tottering perilously, as if they might fall out of it toward us. At the bottom, the small still life of fruit on a table performs a very different function from the still life in the Poussin. Instead of creating a discrete barrier, fencing off and protecting the scene behind it, this tabletop is cut off

by the "front" of the picture and tilted at an angle toward the viewer. Its far corner pokes violently in at the group of nudes. Picasso invites the viewer to imagine that the near corner, sliced off by the bottom of the canvas, thrusts aggressively forward into "our" space.

In some parts of the picture it's difficult to see where one form ends and another begins. Pieces of the background or drapery seem to sweep right into the bodies of the women. Picasso abruptly shifts styles as he moves from one head to another, from simplified, flattened heads on the left to complex mask-faces on the right. The light jumps around quickly, too; it flares up on the edges of the drapery and darkens unexpectedly. All over the design, shapes look like broken glass. Where Poussin will unify a figure by wrapping it in a heavy skin of drapery, Picasso outlines an arm or breast so harshly that it seems cut off from its body. Where Poussin's goal would seem to be to achieve an ultimate balance, solid, calm, and gracefully contained within the canvas, Picasso's offers surprising distortion in every section and spills out toward the viewer with barely contained energy.

Lonn Beaudry's invitation in **Figure C** balances the tendencies toward harmony and dissonance more evenly. It uses different type weights and styles to emphasize another kind of dissonance: the noisy, cheerful and loosely structured atmosphere of an informal party. The changing sizes of letterforms create the effect of near and far. The oversized *T*, like Picasso's still life, spills out of the page and onto the viewer's lap. But the design must also be harmonious enough to be readable, to convey information about time and place. The vertical/horizontal alignment of the smaller text helps to do this. Because only a short piece of text needs to be read, the viewer can enjoy size changes and shifts of position that would be chaotic and illegible in a longer text. Here harmony and dissonance, like dark and light, are qualities to be balanced.

also see: Grouping
Space Moving Out
Tension & Shape
Color Harmony

B. Pablo Picasso, *Les Demoiselles d'Avignon.* 1907. (Collection, The Museum of Modern Art, New York; acquired through the Lillie P. Bliss Bequest)

C. Lonn Beaudry, *Invitation: Party.*

Balance

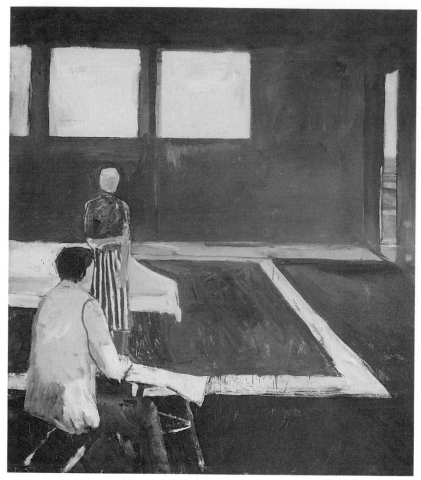

A. Richard Diebenkorn, *A Man and Woman in a Large Room*. 1957. (Hirshhorn Museum and Sculpture Garden, Smithsonian Institution; gift of Joseph H. Hirshhorn Foundation, 1966)

What Balance Is

Most people, asked to come up with a simple visual image for balance, might suggest two dishes on a scale, each holding equal weight, or perhaps two teams of equal size and power engaged in a tug of war, a rope stretched taut between them. In both instances the picture that comes to mind is not only still but also symmetrical. However, just as a small piece of lead will balance a huge pile of feathers on a scale, or two adults equal the strength of a dozen children pulling on a rope, balance can, in subtle and complex ways, be built out of inequality.

Visual balance is always dynamic and lively. What is being balanced is not dead weight, but lively forms and forces, movements and countermovements, combinations of unequal qualities that compensate for one another in the larger visual pattern. Size, color, value, shape, orientation, and location all affect our sense of the visual weight of form. Except in cases in which an image is absolutely

symmetrical, the forces being balanced are always different. Just as we sense the tense play of forces at work on a circus performer immobile on a thin high-wire, we feel the exciting tension created by forms delicately poised and carefully balanced.

The eye enjoys difference, even in fairly simple images. Richard Diebenkorn's painting in **Figure A** is a case in point. A broadly brushed image that simplifies a scene down to a handful of shapes, it organizes those shapes to balance dramatic contrasts. A big shape is answered by a small one, a chunky square by a long, thin rectangle, the close-up figure in the lower left by a distant landscape out the door on the right. The small, dense area of the striped dress becomes a focal point, balancing the much larger flat areas of wall and floor. Although the technique is fluid and brushy, and intuition and accident may play a role, the process of arranging these forms and forces into a balanced whole is still decisive.

What we mean here by visual balance is this final, overall resolution of opposing forms and forces, the establishment of what psychologists call a *gestalt*, a *configuration* of forces that on the one hand seems complete and ordered, but on the other clearly includes the lively variety of different forms, shapes, and colors, brought together to create something different from the simple sum of the parts. Visual balance can look as elegant, reduced, and refined as it does in Edgar Degas's dancer in **Figure B,** or as agitated and visually and psychologically complex as in Peter Paul Rubens's painting in **Figure C,** in which figures, shapes, directions, colors, and spaces relate in a frenzy of powerful rhythms.

also see: Principles

Weight

Weight of Value

Weight & Balance

Symmetry

Asymmetry

B. Edgar Degas, *Dancer, Arabesque over Right Leg, Left Arm in Line*. c. 1882-95. (Hirshhorn Museum and Sculpture Garden, Smithsonian Institution, Washington, D.C.)

C. Peter Paul Rubens, *Rape of the Daughters of Leucippus*. c. 1616. (Alte Pinakoteck, Munich)

Tension

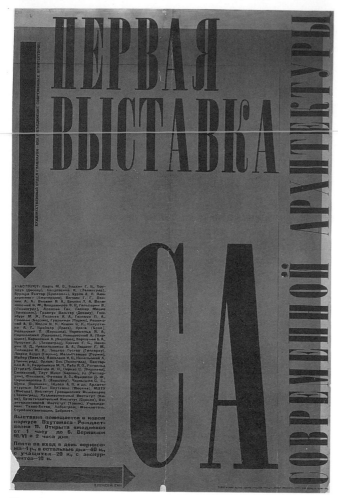

B. Alexei Gan, *First Exhibition/Contemporary Architects/S.A.* 1928. (Collection, The Museum of Modern Art, New York; gift of Alfred H. Barr, Jr.)

When looking at any visual structure, we see visual forces that can be described in physical terms. Shapes and colors seem to push and pull and twist, even though there is no real pushing or pulling going on. This sense of active opposition and resolution is the life pulse of any work. When the feeling of such visual forces at work is increased, made to seem more powerful or emphatic, there is an increase in *visual tension*. This tension can be expressed in several ways, all involving some degree of distortion, deformation, or resistance. Some examples will help to clarify this idea.

Compare the circle and the oval shape in **Figure A.** The circle is perfectly symmetrical, while the other shape is like a rubber circle, a circle subject to some force pulling it out along one axis. The eye feels this force at work on the form. This "distortion" of the round form produces a tenser, livelier shape with an implication of movement.

In Alexei Gan's typography in **Figure B,** the same sort of visual deformation is visible in letterforms that seem to be pushed and pulled. This squeezing in and pulling out creates visual tension. The big letterforms look stretched to the breaking point. The block of text in the lower left is crowded into a corner and then pushed down from above by an arrowlike shape, and the horizontal type on top is hemmed in right and left. This sense of shapes expanding and being compressed creates a whole composition of barely contained forces locked tightly in a vertical/horizontal grid. Even the spaces in between the type—the intervals between the capital letters and blocks of type—seem to be affected by this compression. Everywhere on the page, shapes and spaces are felt to be pushed and pulled out of their expected proportions or positions.

Tensions are unleashed in Lyubov Popova's painting in **Figure C.** On the right, a four-sided shape, like a square being yanked in four directions at once, is contrasted with a triangle, shakily balanced on one point, stretching toward the upper left. Following these shapes, an entire composition of subsidiary forms joins the dance, every one going its own way.

A.

Notice too how visual tension can be enhanced by the placement of forms in a composition. Certain areas in any visual field, such as the center or the edge, have a visual magnetism that seems to attract shapes. When a shape or a line is placed near such an area, the pull between the shape and the position it seems to "want to be in" creates a sense that forces are pulling the forms from their normal position. Shapes within a composition can exert similar forces on one another, attracting and repelling each other as intervals between them narrow and expand.

In the drawing in **Figure D,** Auguste Rodin creates tension in several ways. The oval formed by the figure's torso, arm, and leg is stretched nearly to the breaking point. The entire figure is tipped at an unsteady angle and delicately balanced on the supporting leg. The tension of the pose itself, the twists and strains of the torso, from the side view of the hips to the three-quarter rear view of the back, convey Rodin's vision of strength, suppleness, and momentary balance.

also see: The Field

The Edge

Top & Bottom

Right & Left

Grids

Tension & Shape

Directed Tension

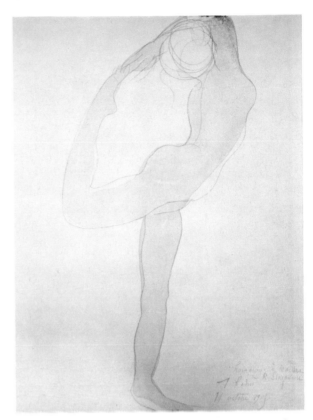

D. Auguste Rodin, *Dancing Figure.* 1905. (National Gallery of Art, Washington, D.C.; gift of Mrs. John W. Simpson)

C. Lyubov Popova, *Architechtonic Painting.* 1947. (Collection, The Museum of Modern Art, New York; Philip Johnson Fund)

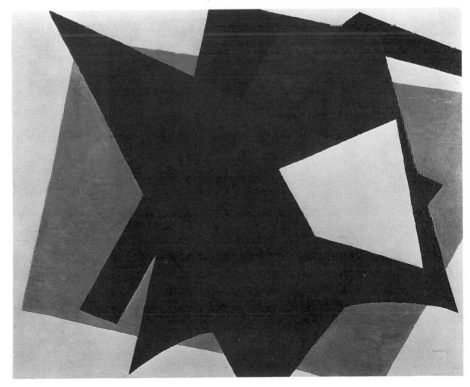

Symmetry

A. Rose Window, Church of S. Agostino, Palermo, c. 1300.

When the visual elements on one side of a composition are mirrored on the opposite side we have *symmetry*. If this mirroring happens in all directions around a central point or area, as can be seen in a daisy, or in the round window of a Romanesque cathedral in **Figure A,** it is called *radial symmetry*. Radial symmetry has a dynamic quality of a particular kind. The rose window suggests a continual rhythm of pulsing or unfolding out from its center. Permanent-feeling, orderly, and focused, it may also call to mind the steady and mechanical motion of a wheel.

Bilateral symmetry is what we call it when the right side echoes the left or the top echoes the bottom, but not both. This is what we see in **Figure B,** or in a Rorschach test, or the reflection of its bank in the water of a still pond. Symmetry is a powerful and sometimes rigid way of organizing a design. Bilateral symmetry tends to seem static, and this sense of immobility can be understood in several ways. The symmetry of the African relief plaque in **Figure C**

creates an image of royal formality, of dignified stillness and poise. This is an image of a king, and the dignity, composure, and self-control of a ruler is appropriately expressed in the deliberately symmetrical composition.

Right/left symmetry, even in a figurative design like the Benin plaque, is an obvious way of creating a sense of balance and resolution, as in a pair of hanging scales balancing two equal weights. If symmetry is applied in situations in which we normally expect movement, the static or frozen look that it creates may be equally striking and even disturbing. We read the frozen symmetry of the faces in Edvard Munch's print in **Figure D,** for example, as eerily and unnaturally motionless, lending a staring quality to the crowd of strollers that turns them into a gallery of ghosts.

It is worth noting that neither the Benin plaque nor the Munch use symmetry inflexibly. In the plaque, the overall composition is strongly symmetrical, but individual elements, details of garments, and even the gestures and positions of subsidiary figures do not adhere to the demands of symmetry. To have made this image rigidly symmetrical would have drained it of all animation. The Munch, by contrast, is not symmetrical in its general arrangement. The main forms are shifted over to the right and pressed down beneath the sky. Here the odd symmetry of each individual head is dramatically opposed to the nervous vitality of the undulating landscape and sky.

In his self-promotional poster in **Figure E,** Tadanori Yokoo employs elements of both bilateral and radial symmetry, and to darkly comic effect. The hanging man against the rising sun, mechanical efficiency, and the sometimes dry rationalism of modern design are parodied in this comically stiff composition.

also see: The Center

Left & Right

Top & Bottom

Directed Tension

B. *Tree of Life*. Indian. Sixteenth-seventeenth century. (Nelson-Atkins Museum of Art, Kansas City)

C. Plaque, Court of Benin, Nigeria. Nineteenth-twentieth century. (The Metropolitan Museum of Art; The Michael C. Rockefeller Memorial Collection; gift of Nelson A. Rockefeller, 1978)

D. Edvard Munch, *Anxiety*. 1896. (Collection, The Museum of Modern Art, New York; Abby Aldrich Rockefeller Fund)

E. Tadanori Yokoo, *Made in Japan, Tadanori Yokoo Having Reached a Climax at the Age of 29, I Was Dead*. 1965. (Collection, The Museum of Modern Art, New York; gift of the artist)

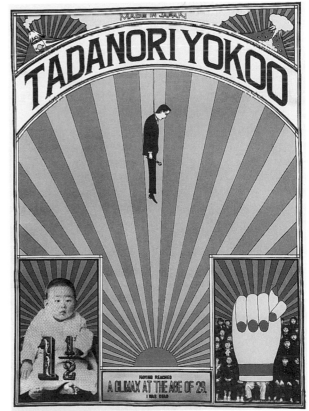

Asymmetry

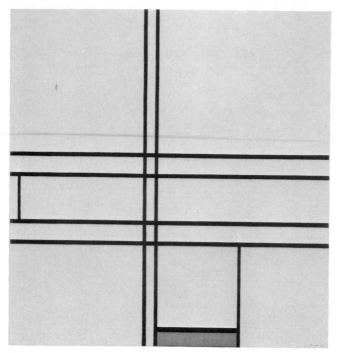

A. Piet Mondrian, *Square Composition.* 1922-25.
(The Phillips Collection, Washington, D.C.)

If symmetry is about sameness and stillness, its opposite, *asymmetry*, is about differences, tensely resolved contrasts, and lively (rather than mechanical) movement. This is not necessarily an effect of using irregular or complex form. For instance, in Piet Mondrian's painting in **Figure A,** different, very regular shapes answer one another. A small area, packed with color, counterbalances a larger empty area somewhere else. A square is dramatically contrasted with a rectangle, and a wide interval with a narrow one. Rather than blending blue into red, or black into white, or vertical into horizontal, each element is conceived as a separate, self-contained unit of color, shape, and direction to be balanced by some contrasting element. The unity achieved is a bringing together of differences that complement but do not mirror or duplicate one another. The final effect is orderly and harmonious, but the balance obtained by the use of strongly asymmetrical elements gives it a livelier flavor.

Asymmetrical organization points up the individual identities of shapes and colors. Although they make differences between top and bottom, right and left, easy to see, such arrangements are still composed, deliberate, planned, and balanced, and suitable to expressive purposes and specific uses.

Sassetta used an asymmetrical composition to move the viewer's eye from one episode to another in the painting in **Figure B.** This composition refuses to hold still, tottering back and forth along zigzag diagonals. The eye seesaws down from a high point on the

left to a low point on the right. Along the way, individual figures and small groups form several focal points, smaller vignettes of action and event within the big picture until the eye finally comes to rest on the two embracing saints in the lower right. The saints create a narrative focal point, a symmetrical and solid island of stillness at the end of the visual journey.

Because asymmetry is a less rigid or centralized method of organization, it is often used to suggest the informal or accidental look associated with the causal glance. This snapshot quality is given a refined form by Bernice Abbott in her photograph in **Figure C.** The composition, aggressively asymmetrical, contrasts near, large and dark forms on the left with distant, small and scattered figures on the right, all delicately balanced around the formal and graceful horse in the center.

also see: Simple & Complex Shape

Directed Tension

Balance

Repetition & Variation

B. Sassetta, *The Meeting of St. Anthony and St. Paul.* c. 1440. (National Gallery of Art, Washington, D.C.; Samuel H. Kress Collection)

C. Berenice Abbott, *The El at Columbus Avenue and Broadway, 1929.* 1929. (The Metropolitan Museum of Art, New York; Ford Motor Company Collection; gift of the Ford Motor Company and John C. Waddell)

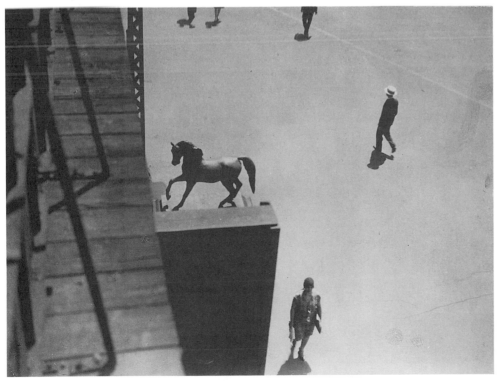

Clarity & Ambiguity

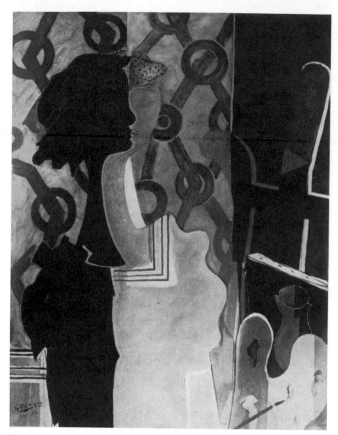

E. Georges Braque, *Woman Painting*. 1936. (Courtesy, Collection of Consolidated Food Corp.)

The eye seeks clarity in a visual pattern, that is, we intuitively prefer to see the choices and decisions made by the artist clearly. Is the shape in **Figure A** a square, badly made, or is it intended to be an irregularly shaped trapezoid? Is the circle in **Figure B** meant to be centered in the box? Are the two shapes in **Figure C** supposed to be different or are they simply ineptly made, but intended to be identical?

Each of these visual patterns is ambiguous and, more than that, unsatisfying, even disturbing, as they seem to waver between two possible interpretations. In situations like these the forms seem to be out of place and wanting to shift just a little bit. It is as if some correcting hand is needed either to push **Figure A** into a square or to lengthen two of its sides and to move the circle in **Figure B** either closer to or farther from the center.

The problem with this kind of visual uneasiness is that in each case, rather than implying some clear movement, the direction of motion is ambiguous. The shapes might move either way, toward regularity or away from it. It's a toss-up, either possibility likely and unlikely at the same time. The viewer has no way of knowing what the artist is trying to do.

If any of the patterns in **Figures A** to **C** were flashed for an instant onto a screen, each of us would remember it unambiguously as either perfected or clearly irregular (**Figure D**). The eye/brain has a built-in bias toward clarity. It will make us see things clearly even when they are not clear.

On the other hand carefully controlled, multiple or alternative readings, like metaphors in speech, can at times add levels of meaning and enrich the image. In the painting by Georges Braque in **Figure E,** both the full face and the profile of the model can be seen, two distinct and unambiguous images that seem simultaneously to occupy the same space. It is important to note that each of these readings alone is unambiguous in the sense that we have been using the term. There is no confusion about which reading is intended. We are meant to see both.

Some artists, looking for clarity in their work, have sought to capitalize on the straightforward and

A. B. C.

pure feeling of geometric shape, legible, clean, and organized looking. This search for an unambiguous and immediately accessible reading has been a powerful force in painting, design, and architecture in this century. Systems for creating order within a geometric framework, such as the grid, rules and tools for making this kind of form, have seemed to answer a widely held perception that geometry reflects our own highly mechanized society. On the down side, the growing interest in computers as design tools has, if insensitively handled, resulted in form that has a hard-edged look, at times inappropriately boxy and brittle, more like diagrams than anything else.

Perhaps responding to this, many artists in the last twenty years have rediscovered complexity and ambiguity as expressive tools. Where Mies van der Rohe stresses unity, simplicity, and clarity (**Figure F**), Frank Gehry uses a variety of materials and surprising juxtapositions of shape, color, and angle to suggest the lively and serendipitous variety of a village in a single residence (**Figure G**).

Extreme clarity does not necessarily guarantee anything good. By itself it may not even be all that interesting. The qualities of "soft design," organic or irregular shape, the sense of a handmade object, of irregularity, the play of intuition, and the lively surprises that sometimes result are being reexplored. If a circle is what's wanted, there are rules that can be followed for its construction. The form is, to some extent, anonymous. However, to design an irregular shape, personal choices about degrees of clarity and complexity, about angle and direction take on a different degree of importance.

Because each attitude toward design has its own uses and limitations, and because geometric and organic approaches are both ancient ways of thinking about form, both are worth a careful look. A certain amount of intuition is always necessary, just as a sense of structure and order is a critical component in the organization of any visual object.

also see: Geometric & Organic Shape

Modes of Presentation

F. Mies van der Rohe. Lake Shore Drive Apartments, 1952. (Ezra Stoller © Esto.)

G. Frank Gehry, *Wosk Residence*. 1982-84. (Frank O. Gehry & Associates)

D.

Hierarchy & Subdivision

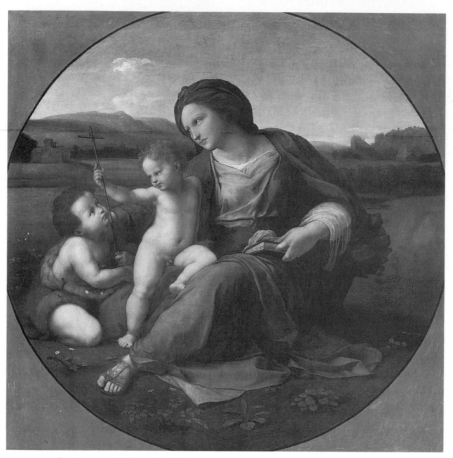

A. Raphael, *The Alba Madonna*. c. 1510. (National Gallery of Art, Washington, D.C.; Andrew W. Mellon Collection)

In most works of art, different things are put together: a large shape and a small one, a yellow against a blue, a line and a soft smudge of tone. Although every piece of a composition may be important, there is a need to establish degrees of importance, from primary visual elements to secondary to tertiary. If intentions and ideas are to be clearly communicated in a configuration made up of many unequal elements, organizing things by grouping them into divisions and subdivisions must be a basic requirement.

A visual hierarchy allows us to see the whole structure, the large organization that determines where every part fits, while also permitting each individual part to retain its identity as a discrete unit with a place in that whole.

One kind of hierarchical structure can be seen in the way nature organizes form and growth. For example, a tree can be broken down into a main unit (the trunk), which supports smaller limbs (the large boughs), which support smaller branches, which, in turn, carry twigs and leaves. We don't necessarily look at trees by moving from larger limbs to smaller ones; we can look anywhere we like on a tree. Still, the order of large to small is present regardless of how we look.

A somewhat different kind of hierarchy can be found in *The Alba Madonna* of Raphael in **Figure A.** Here a triangular mass is created by the grouped figures. The area of greatest prominence, the peak of the triangle, is occupied by the head of the Madonna. As the eye moves down the longer, left-hand slope of the triangle, it comes to the Christ child, the secondary element in this group, and then to the infant Saint John, the subordinate character.

The hierarchy in the Raphael is different from but almost as obvious as that in the tree. Perhaps less obvious is the hierarchy in Robert Jensen's poster in **Figure B.** Here, a scale of changing weights, a large-to-small movement through the forms, from the

heavy "Yale" to the less heavy "Norfolk" and so on down to the small text, gives order to the whole, and shows the order in which the visual information is to be read.

Still another kind of hierarchy is established in Paul Cézanne's painting in **Figure C**. The most important visual division is the one between foreground, a table loaded with a clutter of objects, and background, a subdivided wall. The foreground then subdivides into drapery, fruit, and bottles, and each of these subdivisions contains its own smaller units of direction and color. The drapery can be broken down into lighter and darker material. The bottles can be subdivided into body and neck, and these areas too contain smaller color zones, each of which contains still smaller shapes, colors, and textures.

Cézanne's highly orderly approach is what allows the viewer to find a way through what might otherwise be a tangle of information. As in any hierarchy, this natural-seeming organization helps the viewer to see the whole and the parts in the right order. You do not read through a two-dimensional image in the same linear way that you are now reading through this page—first one word, then the next, in order, until a complete idea or sentence is formed. To read as you are doing now implies moving through time, rather like a burning fuse. A photograph or a painting does not reveal its forms in this way. Rather, its hierarchies and subdivisions allow us to see the whole all at once, simultaneously, and at the same time the parts, separately and in order.

also see: Grids
Figure & Ground
Structure & Scale
Shape: Overview
Levels of Order

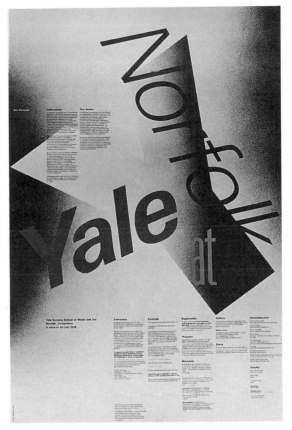

B. Robert Jensen, *Yale at Norfolk*. (Courtesy of the designer)

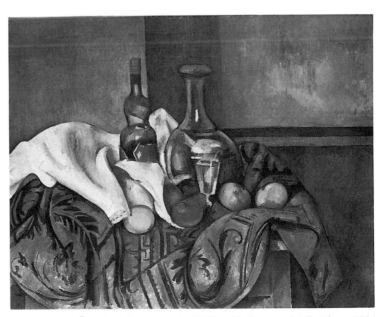

C. Paul Cézanne, *Still Life with Peppermint Bottle*. c. 1894. (National Gallery of Art, Washington, D.C.; Chester Dale Collection, 1962)

Families of Forms

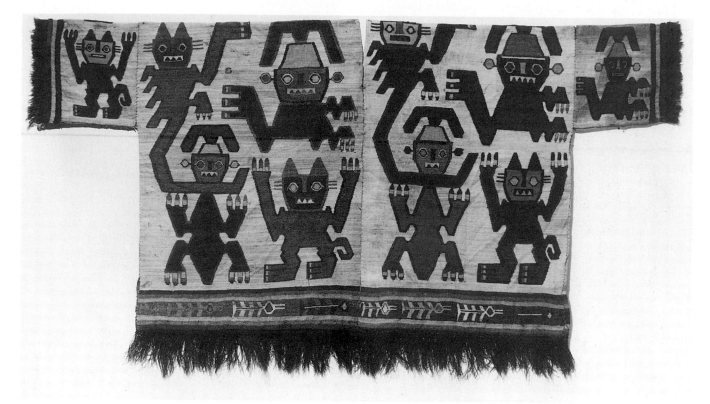

A. Ica poncho. Peru. Pre-Columbian. (The Metropolitan Museum of Art; The Michael C. Rockefeller Memorial Collection; Bequest of Nelson A. Rockefeller, 1979)

The kinds of connections and variations that can exist between a group of shapes, colors, and textures seems limitless. There are vast collections of forms, such as leaves or seashells, in which all the members have a sort of family resemblance. In visual art, a family may be created when a single technique or medium is used. For example, the shapes in the woven poncho in **Figure A** are generated, at least in part, by the vertical and horizontal weaving of the loom, which gives them a certain likeness to one another. Here the medium determines the form to some degree, and this quality would be recognizable in any tapestry woven on a similar loom. But a loom is not needed to achieve unity through likeness of mark. The painting by Paul Cézanne in **Figure B** is made with a single kind of squarish brushstroke. This gives a similar look, a kind of family resemblance, to sky, trees, and mountain even though they are all different shapes and colors.

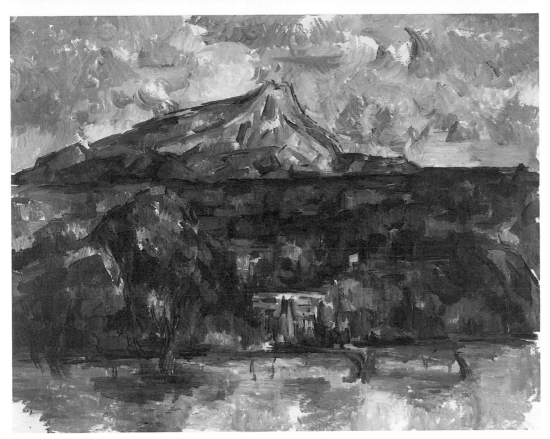

B. Paul Cézanne, *La Montegne Sainte-Victoire*. ca. 1902-1906.
(The Nelson-Atkins Museum of Art, Kansas City)

Even forms that seem different from one another become part of visual families merely by virtue of being part of the same design. This kind of relatedness can forge connections between the most diverse shapes and colors. The associations may be forced, created by the confines of the frame, but they are no less powerful. We are reminded that a work of art is an enclosed unit, containing its own hierarchy of connections and comparisons. The relationships between the shapes, colors, and textures all occur within the frame or unit, and the balanced whole depends on the active participation of every part. Simply put, when something is done in one area of a design, all of the other areas are affected. In a well-made work, every mark will have repercussions throughout the whole. To recognize this, to work relationally, is something that all artists aspire to do.

also see: Grouping
Mark Making

Repetition & Variation

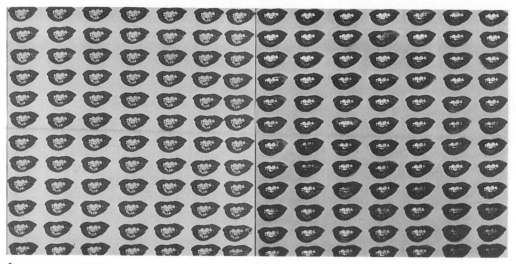

A. Andy Warhol, *Marilyn Monroe's Lips*. 1962.
(Hirshhorn Museum and Sculpture Garden,
Smithsonian Institution; gift of Joseph H. Hirshhorn,
1972)

B. G. Klutsis, *Fulfilled Plan Great Work*. 1930. (Collection,
The Museum of Modern Art, New York; Purchase Fund)

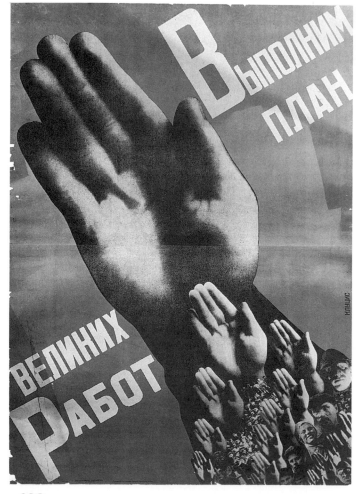

Repetition, which is related both to time and rhythm, is one of the most effective ways to create unity in an image. The danger, though, is that it can also seem to diminish the individuality or uniqueness of a form. Handled in a mechanical way, repetition can easily become boring. Looking, for instance, at evenly spaced ranks of identical tract housing, we may become famished for the flavor of variety. **Figure A,** a lithograph by Andy Warhol, comments on the dehumanizing effects of mechanical repetition. The deadening sameness of the repeated image is barely countered by small variations—changes in light or darkness from one pair of lips to another, slight shifts in position—all signs of life for the hungry eye to fasten on.

Repetition can be used for its cumulative effect, the impact of a single form multiplied, as in the Russian poster by G. Klutsis in **Figure B.** Repetition here is like the echo of a great shout, peaking and dying away as the eye moves from left to right.

In the Cambodian carving in **Figure C,** repetition seems to transform visually a small number into a much larger one. The figures seem too many to grasp in a single glance, and the repetition of heads added to the even more numerous legs, arms, and other features turns a relatively modest number of figures into a virtual army. Small deviations from the pattern of repetition, such as the serpent's head or the exaggerated backward twist of the last figure, enliven and shape the whole.

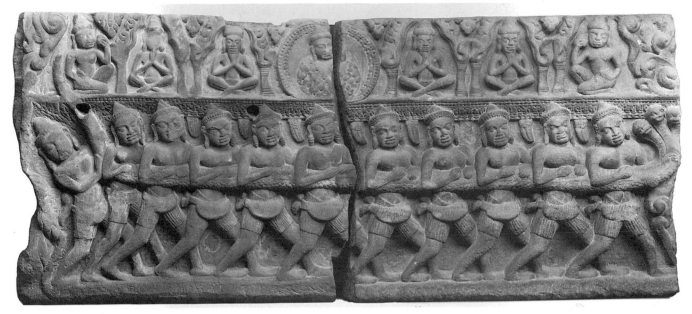

C. *Gods Bearing a Serpent.* Khmer, Cambodia. Eleventh century. (Nelson-Atkins Museum of Art, Kansas City)

also see: Mark Making

Grids

Time

Rhythm

Rhythm

C. Pont du Gard. Near Nîmes, France. Roman. First century B.C.

Rhythm in music is a way of structuring time, giving it shape and form by organizing and subdividing it: 3/4 time has one kind of form; 2/2 time has another. Any waltz sounds different from any tango. These rhythms might be visualized as diagrams like those in **Figure A.** But as the beats in a musical piece become more irregular, time becomes less clearly structured. Obviously, rhythm includes elements of repetition, but the repetition is of patterns, groupings of beat and interval (but not necessarily repetition of the notes themselves). Where the pattern is clear and strong, even a slight deviation is immediately noticeable, as in **Figure B.**

Visual rhythms are ways of structuring visual motion. Based on repeating patterns of shape, color, or interval, visual rhythms of great flexibility and variety can be created. Where music happens primarily in time, with sounds and silences following one another in a line, visual art—especially when it is two-dimensional—does not. In a painting or a poster the entire work is before us at once. We may glance from one area to another, but the order of looking is not prescribed, and all the shapes and colors are immovable and there. This means that many things can interact at the same time and a single work can contain several subtle and complex kinds of visual rhythm at once. A design may have a linear rhythm that goes up and down or across, a smooth or angular

rhythm in and out, the staccato rhythm of a machine gun in one area, and the graceful back and forth of a waltz in another. A rhythm may be precise and mechanical, or irregular and organic. It may be consistent throughout or change—speeding up and slowing down.

The Roman aqueduct in **Figure C** steps through the landscape at a stately pace. The elegance of its proportions and the reassuring expectability of each

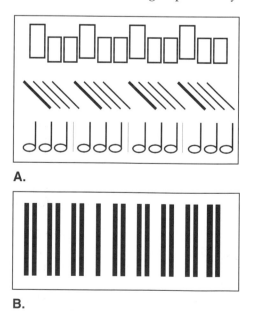

A.

B.

E. Christopher Ozubko and Robert Meganck, *Double Bill Jazz Concert.* (Meganck Ozubko Design, Seattle)

F. Henri de Toulouse-Lautrec, *Troup of Mlle. Eglantine.* 1896. (Collection, The Museum of Modern Art, New York; gift of Abby Aldrich Rockefeller)

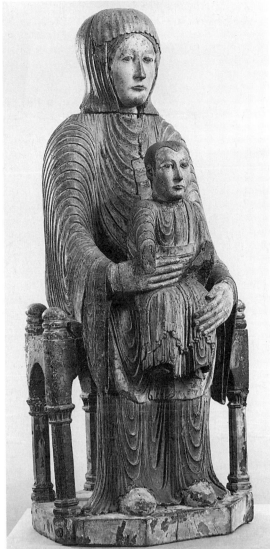

D. *Virgin and Child.* School of Auvergne, France. c. 1150-1200. (The Metropolitan Museum of Art; gift of J. Pierpoint Morgan, 1916)

arch have the same hypnotic regularity and echoing quality as the sound of the ocean washing onto the beach. There is a sameness to the shape and interval, but it is saved from becoming dull by the perceptual changes that happen as it marches into the distance. Intervals appear to diminish, forms become smaller to the eye and lighter in color.

Another regular although less strictly geometric rhythm is created by the drapery of the French twelfth-century sculpture in **Figure D.** The curved folds are repeated at approximately equal intervals, gradually expanding in a fluid, wavelike pulse across the form. The beat is repetitive, but the form of the arc is flexible.

In the Ozubko/Meganck poster in **Figure E,** the broken phrasing of jazz is visualized in a subtle way. The delicate diagonal is repeated at the same angle but at varied intervals from left to right. The weight of the diagonal is varied too, from the most ghostly line

of white type to a heavier white bar. Against this constant but changing baseline, the large letters create a series of irregular angular gestures, a stacatto melody ending with the large **Z** that repeats the angle of the small type.

Henri de Toulouse-Lautrec, in his lithograph in **Figure F,** uses a repeated diagonal, in this case formed by three legs, as a visual metaphor for the beat of music. The not-so-subtle rhythm of the cancan is spelled out for the eyes, and Lautrec makes a wry comment about the coordination of the dancers in the angle of the left-hand dancer's leg.

also see: Stroboscopic Motion

Movement & Change

Time

Repetition & Variation

Curve

A. Frank Stella, *Shoubeegi*. 1978. (Private collection)

Curves suggest movement, change, liveliness wherever they appear. Used generously, curves can be sensual and buoyant. Used sparingly they can provide a lyrical or delicate gesture to balance and animate more static and architectural forms in a design.

The flexible curved line can be a visual symbol of forces interacting. In the painted relief sculpture by Frank Stella in **Figure A,** shapes seem to act on one another. The long curve swooping down from the upper left corner rears back sharply like a wave breaking on a rock, a reaction to another curve that blocks its path. The small **S** curve in the lower right corner sags under the visual weight of the larger shape above it. Two large question mark shapes appear to rub up against each other and curl away. The design is an ensemble in which forms do things to other forms.

Curves will almost always suggest motion and will also lend an organic, rather than synthetic, feeling to forms. The less regular the curve, the stronger the effect. Hector Guimard's poster in **Figure B** is an example of that enlivening characteristic of irregular curve applied to letterforms. The sinuous shapes seem to be invaded by visual forces that make them swell, compress, bend, and stretch. The sense of

growth and change that we understand in the tendrils and leaves of a plant is conveyed here by the constantly changing rhythmic curves.

The painting by Charles Sheeler in **Figure C** could have been drawn with a ruler, and perhaps it was. There is not a curved line visible, yet the most powerful and immediately visible form in the picture is the muscular three-dimensional **S** curve of the staircase as it twists up. Here the interplay between straightness and curve, between static forms and movement, lends terrific visual drama to what might be an ordinary visual event.

By contrast, Aristide Maillol finds no straight lines at all in the beautifully swelling figure of a woman in **Figure D.** All the shapes are softly convex. The rhythmic curves are relatively shallow and tightly controlled. Still, the sense of the figure as alive, relaxed, and yet full of potential movement is unmistakable.

also see: Geometric & Organic Shape

Handwriting

Movement & Change

Rhythm

Arabesque

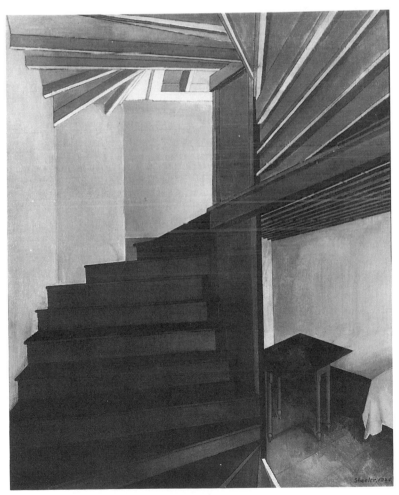

B. Hector Guimard, *Exposition Salon du Figaro le Castel Beranger*. 1900. (Collection, The Museum of Modern Art, New York; gift of Lillian Nassau)

D. Aristide Maillol, *Nymph*. 1936-38. (Hirshhorn Museum and Sculpture Garden, Smithsonian Institution, Washington, D.C.)

C. Charles Sheeler, *Staircase, Doylestown*. 1925. (Hirshhorn Museum and Sculpture Garden, Smithsonian Institution, Washington, D.C.)

Arabesque

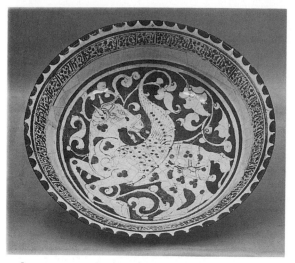

A. Bowl, Iran. Late twelfth-early thirteenth century. (Metropolitan Museum of Art, Rogers Fund, 1916)

C. *Dancer*. Attributed to Torii Kiyonobu. (The Metropolitan Museum of Art; Harris Brisbane Dick Fund, 1949)

B. Casket, probably southern Italian. Eleventh or twelfth century. (The Metropolitan Museum of Art; gift of J. Pierpoint Morgan, 1917)

A special form of the curve is the arabesque. *Arabesque* is a word originally used to describe a complicated, interweaving linear composition often found in Arabic art (**Figure A**), but the term as used here, in a more general sense, describes the sinuous, enclosed line found in the art of many periods and cultures.

A beautiful example is in the carved box in **Figure B.** As gracefully as in any brush drawing, the line waves across the box's surface apparently independent of the foresquare framing in which it is so carefully contained. Whether the line is used to draw animals or simply serve as decoration in the long horizontal bands at top and bottom, a characteristic of an arabesque is this contained feeling. The line may wander and waver, but it curves back in rather than breaking through the frame. The undulating curve of the arabesque may not itself be well suited to describing objects in a realistic way, but its abstract quality, its own visual interest, has appealed to artists who worked by symbolizing rather than by accurately depicting. The rhythm and serpentine movement of an arabesque is also an attractive alternative to the right-angled look that might result from use of a grid.

D. Hector Guimard, Metro entrance, Paris. (Photo, Susan Paul)

E. Clodion (Claude Michel) *Model for a Proposed Monument to Commemorate the Invention of the Balloon.* 1784. (The Metropolitan Museum of Art; Rogers Fund aided by anonymous gift, 1944)

Art Nouveau, a movement in the visual arts at the turn of the twentieth century, is probably best known for its frequent use of the curvilinear arabesque, although the artists were influenced as much by the flowing arabesques of Japanese woodcut compositions like the one in **Figure C,** as by Arabic art. Each of Hector Guimard's many Metro entrances in Paris is a fantasy of twisting vines and tendrils, the fluid, inward curving forms seeming to grow out of the ground (**Figure D**).

It is easy to see how all the forms refer back to and depend on an internal structure to give shape to the arabesque in a work like the Clodion in **Figure E.** In Henri Matisse's *Dance* in **Figure F,** we see the same pairing of forces—the one centrifugal, seeming to pull everything out and away from the center in big swinging curves, the other centripetal, like the force of gravity, holding it all together, keeping the tense and electric arabesque from flying apart.

also see: Enclosed Space
Tension & Shape
The Line as Edge
Movement & Change

F. Henri Matisse, *Dance* (first version). 1909. (The Museum of Modern Art, New York)

Straightness

A. César Domela, *Construction*. 1929. (Hirshhorn Museum and Sculpture Garden, Smithsonian Institution; gift of Joseph H. Hirshhorn, 1966)

The rhythmic and flexible curve, especially where it is irregular, seems to be constantly acted on by visual forces that push and pull. In contrast, straightness is a visual symbol of noninteraction, a line that doesn't change but rather ignores the forces around it.

In César Domela's wall relief in **Figure A,** straight lines pass through one another without any sign of interaction. Neither slowed down nor pushed off course, each line is a solitary journey, visually isolated from the rest even though it contributes to the overall ensemble of colored areas.

The isolating quality of straightness can be a useful tool when the artist's aim is to highlight individual parts that make up a composition. Straightness gives visual autonomy to the pieces in Gerrit Rietveld's chair in **Figure B.** The chair is broken down into separate planes so clearly that the parts could easily be counted. The sense of individual planes in space as the raw material of the designer is made concrete.

Straightness and noninteraction are given a different meaning in Edvard Munch's *Self-Portrait* (**Figure C**). Here the rigidity of the forms creates a sense of emotional isolation. Straitjacketed by the furniture and the verticals of the walls, the room is pervaded with a tense and frozen stillness. The feeling that time has stopped is emphasized by the faceless clock, which echoes the stiffly bracketed figure of the artist.

also see: The Impersonal Line
 Vertical/Horizontal/Diagonal

B. Gerrit Reitveld, *Red and Blue*. Chair. c. 1918. (The Museum of Modern Art, New York; gift of Philip Johnson)

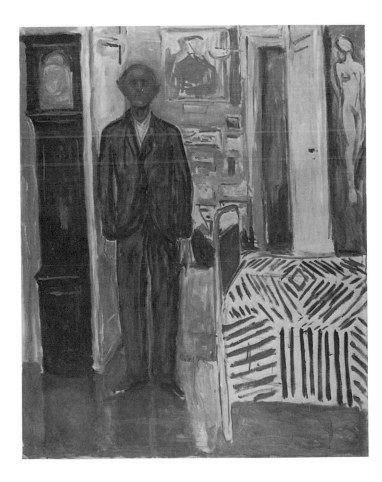

C. Edvard Munch, *Self-Portrait Between the Clock and the Bed*. 1940-1942. (Munch Museum, Oslo)

207

15 Meaning and Communication

Overview

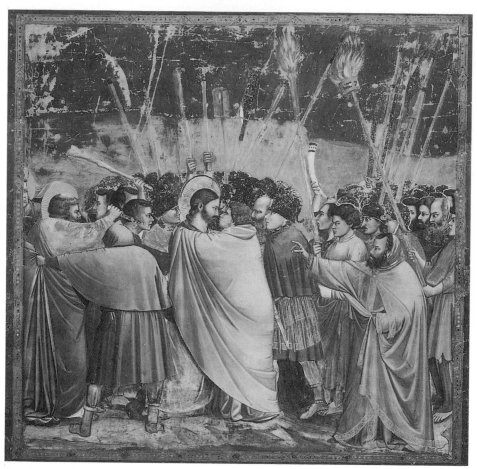

A. Giotto, *The Kiss of Judas*. c. 1304 (Arena Chapel, Padua)

The painter Henri Matisse said, "When I see the Giotto frescos at Padua, I do not trouble to recognize which scene of the life of Christ I have before me but I perceive instantly the sentiment which radiates from it and which is instinct in the composition in every line and color. The title will only serve to confirm my impression" (**Figure A**).

While Giotto might not have understood a way of looking that separated storytelling from color and drawing, in a certain sense, he and Matisse would agree. Most often, art is the result of a congruence or a rhyming between the way an object is thought about and the way it is put together.

Rudolph Arnheim, a writer and psychologist of art, described works of art as "the carriers of messages about things that are not visual." By this he meant those things we experience in the world around us and within ourselves, like tension, relaxation, rising and falling, movement and stillness, what he called patterns of forces or structural themes. In this view, what art does is to make these themes visible by arranging shape, color, and form into patterns that suggest or evoke these forces.

Works of art carry meaning through this arranging and ordering. At the same time they communicate through signs, symbols, or recognizable images of people and things. In other words, art is deliciously impure. Different kinds and ways of meaning can coexist and echo one another in a single work.

In the preceding chapters we have tried to isolate and analyze aspects of this visual stew, as though works of art were cooked up by tossing together separate ingredients in varying proportions. Examining form and organization in this way, seeing them as distinct from other kinds of content, like symbolism or storytelling, is called *formalism*. This approach, though useful, is bound to leave things out. It is not within the scope of this book to examine thoroughly the complexity of meaning in art, but we will try to redress the imbalance a little by looking at a few ways in which we can think about the meanings of images.

Biases

A. Tandy Belew, *All Occasions*. (Tandy Belew Design, San Francisco)

B. Rectangular tray, Japanese. Seventeenth century. (Seattle Art Museum; Eugene Fuller Memorial Collection)

We all have biases—habits of thinking, ways of seeing (or not seeing) so ingrained they go unnoticed. For example, to most people the difference between a Stradivarius and an ordinary, factory-made violin is quite difficult to detect by appearance alone. Yet to an instrument maker, telling features, small differences, are immediately evident. It is not that the violin maker's eyes are sharper, but that the habit of looking for certain characteristic details is well established. In the same way that many people have a special vocabulary of words that describe aspects of their professions, so we all have particular ways of focusing on the visual world that reflect our own interests and concerns.

In other words, we see what we pay attention to. This may, in part, be conditioned by our surroundings. Arctic peoples have many words for snow where we have one word. The differences between soft drift snow, the stinging needles of fine dry snow driven by wind, or the heavy wet flakes that come with relatively warm temperatures, are things a hunter or traveler in such a climate would need to spot immediately.

Habits of seeing, whether they come from the demands of a culture or an environment, are learned responses. Our visual biases, the things that each of us look for in art, our expectations, may be habits of seeing learned so long ago that they have come to seem natural.

When we come upon art from cultures other than our own, the products of different biases, we sometimes fail to catch the visual logic, and that goes both ways. Western anthropologists were astonished to find that tribal people in New Guinea didn't see the resemblance between themselves and the black-and-white snapshots taken of them. Typically, these viewers, unfamiliar with Western conventions of seeing, would point to differences that we have learned to overlook—the image of a five-foot-tall person was two inches tall, it was flat instead of three-dimensional, it had no back, it was without color. To a viewer with different expectations, our idea of realism might seem less compelling.

Part of the value of learning about visual forces is that they help us to see beyond these biases. Formal elements work in similar ways even in very different styles and cultures. Diagonals in a design, for instance, create movement, whether that design happens to be a Baroque painting or an Indian sculpture. The power of the center in a visual field, the directness of the hand, the weight of a shape are universals. In the same way, similar forms suggest buoyancy and balance whether in a piece of late twentieth-century graphic design like Tandy Belew's in **Figure A** or a seventeenth-century Japanese plate (**Figure B**). A fluid and sinuous S curve suggests the same snaky rhythm whether in a German musical instrument (**Figure C**) or an African carving of a mythical serpent who traced the courses for rivers (**Figure D**).

The language of form itself is a broadly understood tongue spoken in all periods and places. Knowing how to decipher it allows one to make connections and see the common ground as well as the differences on which visual art is based. Knowing how to speak it allows one to join the discourse as an artist.

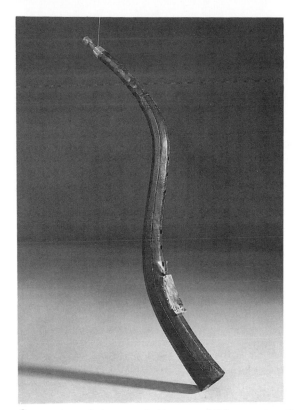

C. Tenor zink (cornetto), German. Mid-seventeenth century. (The Shrine to Music Museum, Vermillion, South Dakota)

D. *Snake*, Baga people of Guinea. (Museum of Primitive Art, New York)

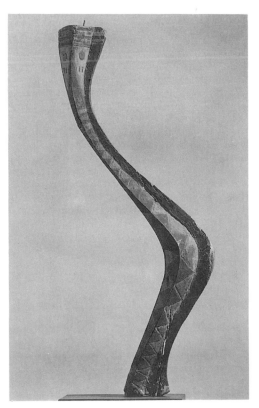

Modes of Presentation

Compressed onto a small, flat surface, art can convey information about the vast visible world. A drawing, for example, might tell about the shape of a tabletop, or how one tree is larger than another, or about a person standing nearby while another stands farther away.

There are many ways of doing these things, and a special problem in two-dimensional art is that some kinds of visual information are conveyed better by one approach than by another. For example, Massimo Vignelli's subway map in **Figure A** is not a realistic picture of the subway in the same way that a photograph would be. A great deal of visual information is left out: All the small turns a train takes to go from one station to another, the tunnels themselves, supporting beams, electrical wiring, and even the tracks. The map concentrates on communicating, in a clear and orderly way, the kind of information most needed by a subway traveler: Which trains go to which stations? How many stops between one station to another?

In the Egyptian painting of a pool in **Figure B,** forms are presented, each in a view that clearly shows its most characteristic shape: the bird's-eye view rectangle of the pool, the almond shaped profiles of the fish, the sideways silhouettes of birds and trees. An artist in the European tradition would probably render the same subject very differently, perhaps as in **Figure C,** with perspective, size changes, and other space-making devices.

The Egyptian image may seem unrealistic, but how does the realism of **Figure C** compare? The rectangular pool is distorted into a trapezoid with four unequal sides. The trees and animals are also wrong by Egyptian standards; some are large, and some are tiny. The fish do not appear at all. In contrast to the traditional Western aim, which was to extend the world into the picture in an illusion of the depth and distance, the Egyptian might have seen perspective and viewpoint as things that distort the real shapes of objects. The Egyptian artist tried to show things as they actually were—the squareness of a square, the equal heights of the trees, and so on. To do this the artist felt free to see each object from whatever angle best conveyed that information.

The rejection of a fixed viewpoint has its pros and cons. The clarity with which visual information is presented may be paid for with a certain sameness of vision. In Egyptian art a square is always a square, while in other traditions the intersection of fact and appearance permits all kinds of new and surprising shapes on the surface, depending on viewpoint. The search for clarity has led artists to realize that what might be labeled "distortion" may depend on what must be communicated by a work, the result of dealing with the logic of the flat surface and the requirements of translating information into the language of flatness.

Neither of these strategies for describing a three-dimensional world on a flat surface is wrong. They are simply not comparable, just as an accurate map of Paris is not comparable with what a color photograph tells about the city. They tell different things. Good solutions, effective ways of presenting information, come from the choices that artists make, and from the expectations that viewers bring to the work.

also see: The Picture Plane

Vanishing-Point Perspective

Surface & Space

A. Vignelli Associates, *New York City Subway Map.*
(Designer: Massimo Vignelli, Unimark International,
1970)

B. *A Pond in a Garden.* Fragment of an Egyptian wall
painting. c. 1400 B.C. (Reproduced by courtesy of the
Trustees of the British Museum)

C.

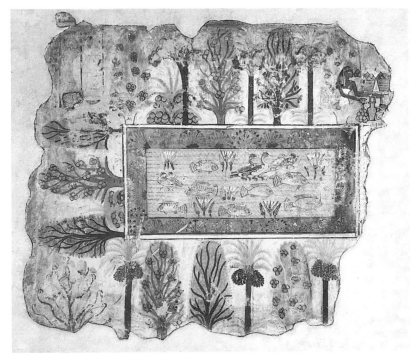

Signs & Symbols

A sign is something that stands for something else. The ringing of a bell may signal lunchtime, or a fire, or the correct answer on a quiz show. A red circle displayed at a train crossing may mean that a train is coming. In drawing a map, red circles could stand for cities and blue ones for airports.

Visual signs, such as the red circles, do not have to tell us much about the appearance or any other quality of the things for which they stand. A blue circle or a red triangle could serve equally well to indicate cities on a map, so long as a map key is included to explain what each colored shape stands for.

A symbol, unlike a sign, is a graphic equivalent of some object, activity, or idea. For instance, as it was used in ancient China and by Native Americans, the swastika (**Figure A**) gave visual form to a concept; its dynamic crisscrossing and implied rotation made it a potent symbol of change and movement. The same configuration, as the emblem of the Nazi party is, for us, a *sign* that has come to be associated with fear and oppression almost in the same way that a red light means stop.

Obviously, in the simplest sense, making a sign doesn't place any great demand on the artist. Making a *symbol*, however, requires thought of another kind.

A vast and complex set of symbols is found in the characters that are used for writing the Chinese language. Developed over thousands of years, these characters derive from pictures of the words they represent. The beautiful character for the word "horse" (**Figure B**) contains in itself the visual memory of the flying mane and legs of a galloping animal. Picture writing was used in other ancient civilizations, but the Chinese characters, originally fairly realistic images, have evolved into uniquely effective graphic symbols. They elegantly combine a concrete image with the simplicity, legible structure, and recognizability necessary to any alphabet.

A graphic symbol can be as simple as a geometric shape or as complex as a realist portrait. The triangle might be an effective symbol for the social organization of ancient Egypt—firmly planted on a broad base of peasants, narrowing as it rises to a point that could represent the singularity, distance, and dominance of the pharaoh. It's also a nice shape for a diagram of the food chain, with many plants and one-celled animals at the bottom and a few predators at the top, or the recommended foods in a healthy diet (lots of carbohydrates at the bottom and not much fat on top) (**Figure C**). The same shape in another context and orientation could be used to represent equality among three subdivisions whirling around a new dominant point: the center (**Figure D**).

Simple geometric shape can be used to create powerful symbols, but geometry tends to express the general, and we must often depend on context to know how to interpret the image. When El Lissitzky pierces a white circle with a red triangle in his poster in **Figure E,** we see a generalization. We understand the image of two forms in opposition; we see that one shape is invading another, and that conflict is given visible form. But Lissitzky's message of specifically political conflict comes across only if we read the text of the poster. Here text can help to transform signs into symbols that embody large and complex ideas and interactions.

A.

B. Chinese character for the word "horse."

C. The Food Guide Pyramid, U.S. Department of Agriculture

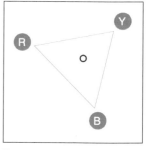

D.

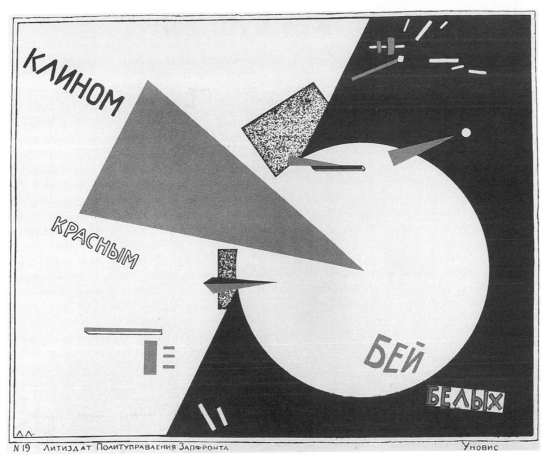

E. El Lissitsky, *Beat the Whites with the Red Wedge*. 1919.
(Stedelijk van Abbemuseum, Eindhoven, the Netherlands)

Every culture develops its own vocabulary of signs, universally understood in that culture yet needing translation in another. Looking at Jan Van Eyck's wedding portrait of Giovanni and Jeanne Arnolfini in **Figure F**, we need to be told, as contemporary audiences would not have, that the small dog in the lower right was a sign that commonly stood for fidelity, or that the abandoned shoes signified a sacred event. There is nothing in these objects themselves that visually suggests these kinds of meaning. Yet other forms in the picture—the gently coupled hands that seem clearly to symbolize a tender relationship, or the delicate light entering from the left and blessing the union it illuminates, seem universal.

also see: Color Symbolism

F. Jan van Eyck, *Wedding Portrait of Giovanni Arnolfini and Jeanne Cenami*. 1434. (Reproduced courtesy of the Trustees, National Gallery, London)

Form & Content

In a picture like Giovanni Bellini's *Feast of the Gods* (**Figure A**), form and content seem perfectly mated. The softness of the forms, gently round, the warm, golden color, caressing light, and composition that is still without feeling rigid, seem exactly suited to express the quiet, meditative, and elegiac mood of this idealized vision of the ancient world. It is easy to like this painting, easy to think of it as beautiful.

But imagine an admiring artist talking about a picture like Nicholas Poussin's *Martyrdom of St. Erasmus* (**Figure B**), describing it to a person who has not looked much at visual art. The artist might describe this painting as beautiful too, asking the viewer to notice the organization of the composition or the bold sweeping diagonal of space, the architectural clarity and beauty of the figures, the burnished color, the wonderful contrast between violence and calm, or the dazzling spectacle of the light.

A. Giovanni Bellini, *The Feast of the Gods*. 1514. (National Gallery of Art, Washington, D.C.; Widener Collection)

216

The hypothetical viewer might just blink and say, "But this is a horrible picture, an image of torture, graphically portrayed and nearly unbearable to look at." Such a response would not be wrong. It would certainly be, in part, what Poussin intended. In terms of what it depicts, the picture *is* quite difficult to look at, much more so than the Bellini.

What does it mean to call such an image beautiful? Can we appreciate a horrifying image in aesthetic terms? Can it be beautiful and horrible at the same time? Trying to consider what happens when we respond to violent or unpleasant images in aesthetic terms brings up several interesting and possibly unanswerable questions. Is it possible for form and message to be from two different universes, even when in the same picture? Can we speak of content as something different from "subject"? Can the formal message be indifferent to or subversive of content? What might such discontinuity mean when applied to art, for example, graphic design that must communicate very specific content?

It's clear that it is possible to understand pictures in more than one way. We respond to subject matter. What is it an image of? How does it refer to the world of things? We also talk about strategies of presentation and the formal elements that work in all styles. The links between form and content can be mysterious. The danger of a too formalist approach, the concentration on composition or color alone is that it can lead to the assumption that the *process* of making art is its only content. We may concentrate so much on the *how* that the *what* is overlooked. The parallel danger of an opposite, or purely literary approach, is that the work that results may be a pallid kind of literature, offering little food for the imagination and lacking the vital energy that comes from visual forces actively engaged.

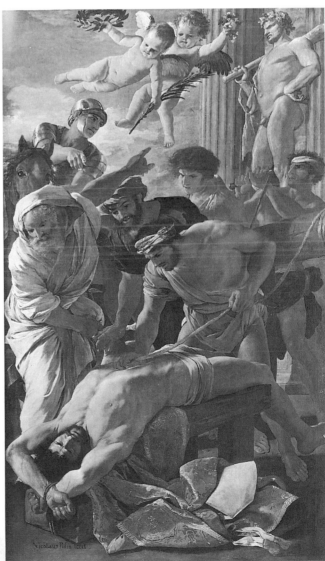

B. Nicholas Poussin, *Martyrdom of St. Erasmus.* 1628-29. (Picture Gallery, The Vatican, Rome)

The World of Appearances

A. Titian, *The Rape of Europa*. 1559-62. (Isabella Stewart Gardner Museum, Boston)

Sometimes it may seem tempting to divide the world of visual art into easy classifications or categories, like those of "real" and "abstract." But the way in which appearances play a role in visual art is not as simple as it may seem. There are artists who work directly from a model or reference point such as a landscape. There are photographers whose work would seem to deal strictly with the appearance of things, graphic designers whose work might mix recognizable imagery with type and other nonrepresentational elements. On the other hand, there are artists who avoid even a hint of realistic or figurative imagery, no matter how slight.

It could be argued, though, that it is actually this last type makes an art based on reality, the reality of paint, metal, or clay as they really are, treated only as physical facts, an art of the real rather than illusion. A painter of landscape, in this view, deals with the opposite of reality, with tricks, slight of hand that makes a scene seem to appear from a pattern of colored tones. Even a photograph is less than honest when it convinces us of space on a flat piece of paper.

If, as was said earlier, works of art carry messages about nonvisual things, then it might be said that what is common to all art is that all art is about feeling in this largest sense. Feeling needs form. Most people can recall, at one time or another, having a vague or unformed feeling or thought, and the frustrating sensation that comes with such moments, as if one were locked in a small room chasing something that can't be caught.

All visual artists are form makers in that they search for content through elements such as line, color, and composition. The kind of art that alludes directly to the appearance of things, real and imagined, has a special ability to clothe disembodied feelings, natural forces, and personal insights in recognizable and tangible forms.

When Titian painted the *Rape of Europa* (**Figure A**), he was able to conceive a personal vision of a well-known story. His rendering, a late painting, clothes an elemental tale of trickery and lust in carefully selected forms: a fleshy, upper-class Venetian woman with sun-bleached hair, a white bull whose challenging gaze betrays an intelligence beyond that of any barnyard animal, a wild wind, a deep, blue distance. The white-whiskered bull seems to become a stand-in, a self-portrait of the old painter who has lost neither his eye for the sensual nor his visual appetite.

Nature shows the artist how to look at art, and art, in turn, informs reality. The gravity, serenity, and symmetry of Classic art (**Figure B**) may have suggested to J. A. D. Ingres a way of looking at the even features of Madame Moitessier (**Figure C**), but his portrait, in turn, suggests a new way of seeing the idealized form of Greek sculpture as real. It is no contradiction to say that for an artist like Ingres viewing nature through the veil of art was the means for looking at it more incisively.

But making pictures of things is not just storytelling. For the artist dealing with appearances, the great structural themes, the forces that convey gravity, movement, interaction, and relationships between visual elements, and that carry meaning, are embedded in things—people, objects, and landscapes. To an artist so inclined, looking at an object and translating its appearance into a two- or three-dimensional equivalent is a way of trying to find out what lies behind illusionism and surface appearance.

B. Female Head, Greek. Fourth century B.C. (Nelson-Atkins Museum of Art, Kansas City)

C. J. A. D. Ingres, *Madame Moitessier*. 1851. (The National Gallery of Art, Washington, D.C.; Samuel H. Kress Collection)

219

What's Real?

Abstraction is a term sometimes used to mean a distancing from reality. For instance, we might say that justice is an abstract idea, which exists independent of all possible concrete examples of legal justice. Or, that triangularity and roundness are abstract concepts, existing apart from all the triangular and round objects to which we can point.

But abstraction in visual art, by which we can mean art that is not primarily concerned with imitating the appearance of things, is not a mode of opposing reality. Art that depends on appearances and art that doesn't are not in conflict with one other, but exist side by side, now, as they always have. The purist style of geometric form seen in the pyramids and obelisks of Egypt coexisted with a range of refined realistic styles found in portrait, figure, and animal sculpture, just as, for instance, type and other formal elements coexist casually with photography everywhere we look. What has puzzled people more have been the numerous styles that fall between the extremes, that blend observation of the world with geometry or pure form.

Whether an artist was aligned one way or the other, with the world of appearance or of form, as we call it here, has sometimes been an issue and sometimes not. In Europe early in this century, for example, some artists believed that modernist styles such as Purism or Constructivism would make recognizable imagery old-fashioned or obsolete (**Figure A**). For many in this period, it seemed that museums and galleries were too full of storytelling pictures illustrating history or mythology in what they saw as a worn-out visual language. By comparison, pure abstraction seemed to offer something really new. Instead of focusing narrowly on subject matter or narrative, artist and viewer could begin to pay more attention to shape, color, and compositional movement. The language of form and color interaction was seen as a cleaner, more refined language for art. Because it was not cluttered with imagery, it was argued, it was more able to express universal physical, emotional, and psychological forces.

Whether or not such ideas have proved true, this reeducation of vision made two important points that needed to be made. First, that all the things we make and look at—paintings or books, furniture or tapestries, whether based on appearances or not—are governed by the same laws, affected by the same forces, and bound to communicate through formal relationships. Also that the most important thing the visual arts must do is to communicate a sense of being alive. The figures in a wax museum are lifelike in every detail but not alive in feeling. Despite skill and realism, they lack a core of vital energy, the spark that turns the illusionistic into the real. And it is this spark that is at the very center of all art.

The artist whose work is not based in appearances or narrative is not without a subject. People used to looking at pictures with stories may find art without narrative empty or annoyingly mysterious. Abstraction at its best does deal with mysteries. Gravity, balance, and tension are all mysterious. At the same time they are familiar mysteries, things that we all experience every day. Most art rejects any simple dichotomy between absolute realism and pure abstraction, and strives to capture both a connection to the world of things and the vitality of form and color interacting.

A. Vasily Kandinsky, *Dominant Curve, no. 631.* 1936.
(The Solomon R. Guggenheim Museum, New York)

Style

A. Pablo Picasso, *Girl with a Mandolin (Fanny Tellier)*. Early 1910. (Collection, The Museum of Modern Art, New York; Nelson A. Rockefeller Bequest)

When talking about meaning, about communication in visual art, we are speaking not so much of the shock of discovery, of something new, but the shock of recognition, the sense of things known diffusely or vaguely at some level, becoming known clearly and more intensely. This concept brings us back to the beginning point of the book. Artists don't feel more deeply than other people, but they have a special ability, as a result of instinct, inclination, and training, to communicate their experience of the world to others by making things.

Making images always means inventing or translating, finding form that conveys essence, whether with or without reference to the world of appearance. Cubist styles, for example, had as their subject matter specific objects, even portraits. But these images were dramatically transformed by artists conscious of the way time, motion, and change are perceived (**Figure A**).

The emotional atmosphere sensed in the painting by Chaim Soutine in **Figure B** suggests a vision of reality quite different from the cerebral calm of Cubism. For Soutine, observation was not an objective activity in which shared perceptions of the world are verified, but a strongly subjective one in which we see the artist's reaction to what is seen as well as the objects themselves.

It could be said that style is the necessary and particular form a given idea takes in the hands of an individual artist or culture. We can, for example, easily recognize the style of Imperial Roman sculpture, but it is a style broadly understood in that culture, and we can with only the greatest difficulty recognize in it the work of individual artists. Later centuries have tended more and more to allow for personal styles as art has become a means of individual as much as cultural expression.

There can also be special conditions to address in a work. For example, designers often have to communicate very specific information via words that must be reinforced and made clear by visual means. Here a balance must be struck between objective and subjective presentation, between the force of words and the power of forms, between the concrete and the abstract. A chair is not a chair if it can't be sat on, and a vase becomes something else if designed with holes that would leak water. Here, too, style must develop within some pretty objective limitations.

In some sense artists come to a style because of the choices they make. When Jackson Pollock (**Figure C**) was drawn to working by dripping paint onto a canvas laid out on the floor, he was establishing a loose set of rules for the way he worked and the way

B. Chaim Soutine, *Profile (Femme de Profil)*. 1937. (The Phillips Collection, Washington, D.C.)

C. Jackson Pollock, *Number 3, 1949*. 1949. (Hirshhorn Museum and Sculpture Garden, Smithsonian Institution, Washington, D.C.)

his paintings would look. Pollack's tangled, stringy paint would be grossly out of place in the Cubist Picasso in **Figure A,** where different tools, processes, and a different feeling for materials operate.

It would seem that an artist would be able to *choose* a style, or manner and method of work, but generally, that's not the case. An artist, involved in the work, is taken over, swept away, drawn inevitably to images that satisfy a personal vision of how things look and feel. It's more accurate to say that style chooses the artist, that training frees the artist to be open to a style. Much as we may not like to admit it, we are led on by instincts stronger than any choosing, and it may be worth remarking at the close that a conscious approach to art will not inhibit instinct or sensibility, but liberates them to develop unimpeded.

Bibliography

The first and best way for students of the visual arts to learn is through looking. Before anything else, you must be prepared to use your eyes and to experience as much visual art as you can. Regular visits to museums, galleries, and exhibitions, an awareness of contemporary crafts, graphic, and industrial design in the workaday environment, and an inquiring and conscious eye will help you to clarify your own intentions. Another important source lies in the writings of artists and critics. The reading list that follows contains suggestions from all of these areas.

Mechanics of Vision

The books in this section examine vision and how the eye works in a more scientific way than books written by artists or about art usually do. The information they contain can be most useful to artists, however, and is presented in a clear, nontechnical way.

GREGORY, R. L., *Eye and Brain: The Psychology of Seeing* (3rd ed.), World University Library. New York: McGraw-Hill, 1977. An entertaining and well-written introduction to some of the scientific research on perception, with some thoughts on the connections between perception and art.

— *The Intelligent Eye*. New York: McGraw-Hill, 1970. A discussion of perception especially as it relates to three-dimensional illusions, such as stereoscopic photographs.

Perception

Perceptual studies—investigations of how the brain organizes the information gathered by the eye—are an increasingly important part of basic visual education. These books contain information on visual perception as it applies to art.

ARNHEIM, RUDOLF, *Art and Visual Perception: A Psychology of the Creative Eye, the New Version* (2nd ed., rev. and enl.). Berkeley: University of California Press, 1974. This is the classic text on perception and visual art. A densely woven and fascinating book which uses familiar examples to demonstrate why we perceive art as we do. It applies the principles of Gestalt psychology to visual art.

— *Film as Art*. Berkeley: University of California Press, 1971. The special aesthetic requirements of film—a combination of words, images, and sound—and a discussion of the artistry of black and white films before the advent of sound. Still a timely and relevant book, written without jargon.

— *Visual Thinking*. Berkeley: University of California Press, 1980. A collection of essays by this leading thinker in the field of Gestalt psychology and visual perception. Clearly written chapters on a range of subjects from What Abstraction Is Not to Vision in Education.

GOMBRICH, ERNST H., *Art and Illusion: A Study in the Psychology of Pictorial Representation* (2nd ed.). Bollinger Series: Vol. 35, A. W. Mellon Lecture No. 5. Princeton, NJ: Princeton University Press, 1965. Another theory of perception written by a well-known pioneer in perceptual studies. Large and well-illustrated, Gombrich's writings sketch out an interesting alternative to the writings of the Gestalt theorists.

ZAKIA, RICHARD, *Perception and Photography*. Rochester, NY: Light Impressions Corp., 1979. Gestalt perceptual principles are presented simply and clearly. The context is photography, but the explanations and illustrations are so good that this book will be of interest to anyone dealing with two-dimensional imagery.

Design Principles

These books combine elements of art criticism, studio practice, and theory. Some may be used as guides to useful procedures in addressing specific problems in the studio, while others focus on general approaches.

DONDIS, DONIS, A., *A Primer of Visual Literacy*. Cambridge, MA: MIT Press, 1973. A clearly laid out introduction to the grammar of visual form, presented in a compact book. Relies more on diagrams than examples from the visual arts to illustrate the text.

GOMBRICH, E. H., *The Sense of Order: A Study in the Psychology of Decorative Art*. Ithaca, NY: Cornell University Press, 1979. A study by a pioneer writer about art and perception in which the emphasis is on design and decorative arts, this large book discusses how we have thought about design in the past as well as assessing it today.

KEPES, GYORGY, *Language of Vision*. Chicago: Paul Theobald and Company, 1961. First published in 1944, this book weaves together elements of Gestalt perceptual theory, Bauhaus design, and classic European modernism to frame a methodical approach to visual education that has come to be accepted in America, as it had been for some time in Europe.

MARTINEZ, BENJAMIN and JACQUELINE BLOCK, *Perception, Design, and Practice*. Englewood Cliffs, NJ: Prentice Hall, 1985. A short primer on perceptual and design principles and their use in the studio. Illustrated with examples from art, architecture, and design.

PYE, DAVID, *The Nature and Aesthetics of Design*. London: Barrie and Jenkins, 1978. An expanded and updated version of David Pye's earlier small classic (*The Nature of Design*). A wide ranging intelligence surveying the spectrum of influences that shape the design process in two- and three-dimensional design. Gracefully written.

RYDER, JOHN, *The Case for Legibility*. New York: Moretus Press, 1979. A wonderful little book, barely the length of a lecture, about the value and canons of classic typography and their relevance to the new computer-aided typography.

THOMPSON, D'ARCY, *On Growth and Form* (abr. ed.), ed. John Tyler Bonner. Cambridge, England: Cambridge University Press, 1961. An interesting study of natural form as the byproduct of growth processes.

TUFTE, EDWARD R., *Envisioning Information*. Cheshire, CT: Graphics Press, 1990. A brilliant study of how we represent and transform complex, dynamic, three-dimensional information in the making of maps, charts, diagrams, graphs.

WOLFFLIN, HEINRICH, *Principles of Art History*, trans. M. D. Hottinger. New York: Dover Publications, Inc., 1950. A formal analysis of the underlying links and basic differ-

ences between classic and baroque art. Abundantly illustrated.

Color Theory

Each of these books outlines a complete theoretical system for color, its organization, interaction, physics, and use. All of these are books that have had particular pertinence to visual artists.

CHEVREUL, M. E., *The Principles of Harmony and Contrast of Colors*. New York: Van Nostrand Reinhold, 1981. This pioneering nineteenth century work was known and admired by many Impressionist and Post-Impressionist painters, among them Georges Seurat. It continues to be an influential work for artists and designers.

GOETHE, JOHANN WOLFGANG, *Theory of Colours*. Cambridge, MA: MIT Press, 1970. An early and very poetic attempt to examine color systematically by the nineteenth century poet, philosopher, and sometime painter.

ITTEN, JOHANNES, *The Art of Color*. New York: Van Nostrand Reinhold, 1973. An important teacher at the Bauhaus, Itten offers a simple but complete theory of color which includes both rationalist and more mystical approaches to color organization and meaning, as well as examples of color use in works of art.

MUNSELL, ALBERT H., *A Grammar of Color: A Basic Treatise on the Color System of Albert H. Munsell*, ed. and with an intro. by Faber Birren. New York: Van Nostrand Reinhold, 1969. Munsell's extremely thorough system of color organization and identification is still the one used by many paint, color, and printing companies.

OSTWALD, WILHEIM, *The Color Primer: A Basic Treatise on the Color System of Wilheim Ostwald*, ed. and with a foreword by Faber Birren. New York: Van Nostrand Reinhold, 1969. Another interesting and very complete attempt at organizing the many, sometimes contradictory, qualities of color into a single, comprehensive system.

ZELANSKI, PAUL and FISHER, MARY PAT, *Color*. Englewood Cliffs, NJ: Prentice Hall, 1989. A thorough studio guide to color, its structure and use in media. Clear discussions of the physics of color and of historical theories of color relationship, briefly summarizing the main thrusts of each of the books listed above.

Applications

These books we generally consider to be studio manuals or textbooks. Some outline a complete course of study; others may be used as general reference guides inside or outside of coursework.

ALBERS, JOSEF, *Interaction of Color*. New Haven, CT: Yale University Press, 1971. A hands-on, non-theoretical approach to color, centered on close observation of color effects and interactions (especially simultaneous contrast). A number of specific exercises are outlined, based on those Albers developed for his influential color course at Yale. This small, accessible paperback is an abridgement of a much larger work, reproducing ten of the original one hundred fifty screened plates and all of the text.

BAUMGARTNER, VICTOR, *Graphic Games: From Pattern to Composition*. Englewood Cliffs, NJ: Prentice Hall, Inc., 1983. A series of specific exercises which use a simple grid as a point of departure from which to explore the design possibilities of repetition, variation, pattern, direction, scale, and texture.

CHEATHAM, FRANK R., JANE HART CHEATHAM, and SHERYL A. HALER, *Design Concepts and Applications*. Englewood

Cliffs, NJ: Prentice Hall, Inc., 1983. A primer of working concepts, and an examination of processes involved in design planning. Illustrated with a wealth of visual material.

ITTEN, JOHANNES, *Design and Form: The Basic Course at the Bauhaus*. New York: Reinhold, 1964. A description, outline, and history of the basic curriculum for all students at the Bauhaus, perhaps the most influential early-modern school of design, written by one of the artists who designed and taught in the program.

LEWIS, JOHN, *Typography/Basic Principles*. New York: Reinhold, 1966. A good introduction to the history, variety, and techniques of designing with letterforms as they are used in printing.

SIDELINGER, STEPHEN J., *Color Manual*. Englewood Cliffs, NJ: Prentice Hall, Inc., 1985. A useful studio manual outlining concepts of color vision and use, this book is based on the Munsell system of color organization and includes a good number of color plates illustrating that system. There are also exercises outlined at the end of each section.

General Histories of Art

These books outline the growth and shifts in style and emphasis in the arts. They also locate their subjects in time and place, relating them to other events and forces in the larger culture that have affected their development. These books are good places to begin, but don't replace the many volumes about specific styles, media, periods, and artists.

GERNSHEIM, HELMUT and ALISON GERNSHEIM, *The History of Photography, 1685-1914*. New York: McGraw-Hill, 1969. A large, encyclopedic, and readable history of the early days of photography, from experiments with optical devices and lenses in the seventeenth century up to the first appearances of photography in newspapers. Good explanations of the development of different processes—daguerreotype, photography on film, color, and photomechanical printing processes.

HONOUR, HUGH and JOHN FLEMING, *The Visual Arts: A History* (3rd. ed.). Englewood Cliffs, NJ: Prentice Hall, 1991. A general survey of the visual arts—painting, sculpture, architecture, and the craft areas—this book balances coverage of developments in European art from prehistory to the present with more thorough treatment of the art of non-European cultures than one usually finds. Elegantly written and enhanced by useful timelines and glossary.

MEGGS, PHILIP B., *A History of Graphic Design* (2nd ed.). New York: Van Nostrand Reinhold, 1992. A thorough overview of the roots of graphic design, from Egypt up to the present day. In addition to examining broad trends such as the influence of Russian Constructivism or Art Nouveau, the work of particularly influential designers is examined in more detail.

NEWHALL, BEAUMONT, *The History of Photography*. New York: Museum of Modern Art, 1964. Covering the period from 1839 to the early 1960s, this book is less encyclopedic than the Gernsheim, but it offers an excellent introduction and overview.

Artists on Art

These are works by artists, writing about their own work, their general or philosophical approaches to making art, or about particular visual problems. Also included are several anthologies containing shorter writings and other statements by artists.

CHIPP, HERSCHEL B., *Theories of Modern Art: A Source Book by Artists and Critics*, contributions by Peter Selz and Joshua C. Taylor. Berkeley and Los Angeles: University of California Press, 1969. A large anthology of theoretical writings, letters, and statements by modern European and American artists, beginning with Cèzanne.

DÜRER, ALBRECHT, *Of the Just Shaping of Letters*, trans. by R. T. Nichol. New York: Dover, 1965. A Renaissance artist's elegant musings on the role of proportion and geometry in the formation of beautiful letters.

HERBERT, ROBERT L., ed., *Modern Artists on Art*. Englewood Cliffs, NJ: Prentice Hall, 1964. Ten unabridged essays by twentieth-century artists, among them Mondrian, Klee, Malevich, and Le Corbusier.

HOLT, ELIZABETH B., ed., *A Documentary History of Art* (2nd ed.), 3 vols. Garden City, NY: Doubleday, 1957. Available in three paperback volumes, this is a valuable anthology of theoretical writings, personal letters, reminiscences, and contracts between artists and patrons, from the Middle Ages to the nineteenth century. Introductory remarks and notes help to explain the stylistic and philosophical concerns of the artists.

KANDINSKY, WASSILY, *Concerning the Spiritual in Art*, trans. and intro. by M. T. Sadler. New York: Dover, 1977. Creator of some of the first purely abstract painting, Kandinsky as a writer on art reveals a poetic spirituality.

KLEE, PAUL, *Pedagogical Sketchbook*, trans. and intro. by Sibyl Moholy-Nagy. New York: F. A. Praeger, 1953.

— *Paul Klee: The Thinking Eye*. New York: G. W. Wittenborn, 1964. Klee was an influential teacher at the Bauhaus. These two books are collections of notes drawn from his experience as a teaching artist. Suffused with a combination of mysticism and rigorous formalism, they offer some insight into the mind and methods of a major modern artist.

LYONS, NATHAN, ed., *Photographers on Photography*. Englewood Cliffs, NJ: Prentice Hall, 1966. Written statements and personal views from twenty-three pioneers of photography, ranging from Peter Emerson (1899) to Minor White (1963).

NELSON, GEORGE, *Problems of Design*. New York: Whitney Library of Design, 1957. Twenty-six essays on a wide variety of subjects—Perception, Wright's Houses, Good Design, Design as Communication—by an influential American designer.

RAND, PAUL, *Thoughts on Design*. New York: Van Nostrand Reinhold, 1970. Thoughts on a number of design-related areas, from symbolism in visual communication to the role of play in design strategies, by an American graphic designer.

TSCHICHOLD, JAN, *Designing Books*, English ed. New York: Wittenborn, Schultz, Inc., 1951. Problems of and approaches to book design by one of the great book designers of the twentieth century in the classic modernist tradition.

VAN GOGH, VINCENT, *The Letters of Vincent Van Gogh*, ed. Mark Roskill. New York: Atheneum, 1967. Van Gogh's letters document not only his emotional intensity and commitment to his work, but a methodical and thoroughly sane approach to the formal disciplines of drawing, color, and composition.

Meaning and Criticism

These are generally books of interpretation and criticism. They examine works of art in light of the notion that art points beyond itself toward other meanings.

BACHELARD, GASTON, *The Poetics of Space*, trans. Maria Jolas, foreword by Etienne Gilson. Boston: Beacon Press, 1969. A consideration of the mystery and beauty of enclosed spaces, houses, forests, shells, and rooms and their human value, by a twentieth-century philosher.

BERGER, JOHN, *Ways of Seeing*. London: British Broadcasting Corporation and Penguin Books, 1972. A series of short essays about how art contains meaning, and how the meanings of great works of art are related to the pressures of history, consumerism, mechanical reproduction, and advertising publicity.

JUNG, CARL GUSTAV, *Man and His Symbols*. New York: Doubleday, 1969. An early psychotherapist examines the existence of universal and subconcious symbols that emerge spontaneously in the art of different periods and cultures as evidence of common human hopes and fears.

LOURY, BATES, *The Visual Experience: An Introduction to Art*. Englewood Cliffs: NJ and New York: Prentice Hall, and Harry N. Abrams, 1961. A graceful and simple introduction to how we look at and understand works of art and design linking formal organization to other kinds of meaning. Well illustrated.

PANOFSKY, ERWIN, *Meaning in the Visual Arts*. Chicago, IL: University of Chicago Press, 1983. Written by an art historian with a special interest in iconography, this book studies symbols, poses, and imagery that make up a cultural tradition.

WHITE, JOHN, *The Birth and Rebirth of Pictorial Space* (2nd ed.). New York: Harper and Row, 1972. A fascinating and carefully reasoned investigation of the development of two-dimensional strategies for representing three-dimensional space, with examples drawn particularly from art of the Renaissance.

Periodicals

Periodicals are uniquely useful in that they contain information about contemporary artists that may not appear in books. Periodicals also present recent historical and critical writing. Listed below is a small sampling of the many interesting publications that are broadly available.

Art in America; Artoforum; Art International; Arts; Sculpture. These magazines look at contemporary art from painting to environmental sculpture. They also regularly review exhibits by contemporary artists.

Communication Arts; Graphics; Print; U&lc; Visible Language. The magazines listed deal with printed visual communication and graphic design via articles on individual designers and particular problems in and aspects of visual communication. There is, in addition, a vast and growing array of periodicals devoted to the burgeoning field of computer graphics.

Aperture. Contemporary and historical photography.

American Craft; American Ceramics; Fiberarts. Contemporary crafts in all media—wood, glass, metal, fiber, and clay.

Architectural Record; Progressive Architecture. Contemporary architecture as design.

Design Book Review. Excellent contemporary survey of design in all media: architecture, industrial design, crafts, decorative arts, typography, and graphic design. Also a fine ongoing source of new books on art and design history.

Index